MANUEL QUERINO (1851–1923)

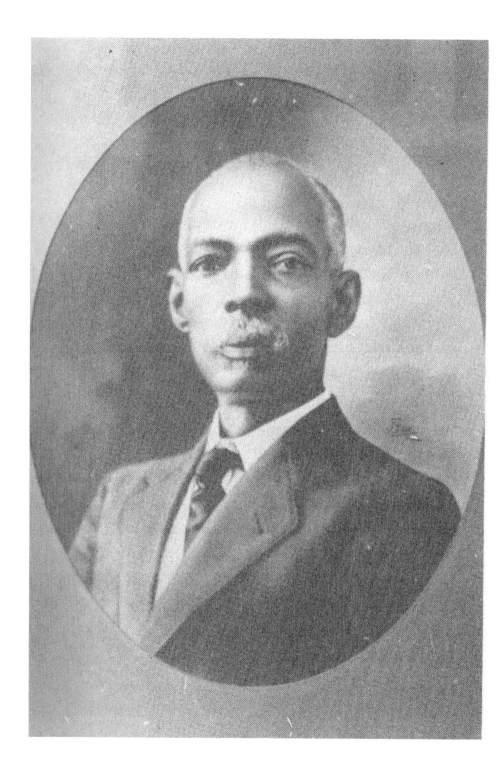

MANUEL QUERINO (1851–1923)
AN AFRO-BRAZILIAN PIONEER IN THE AGE OF SCIENTIFIC RACISM

Edited by Sabrina Gledhill

Editora **Funmilayo Publishing**

Crediton, UK, 2021

Cover design by Miriã Santos Araújo

Cover photo and frontispiece: Calmon, Jorge. *O vereador Manuel Querino*. Salvador: Câmara Municipal de Salvador, 1995.

Back cover photos: Querino, Manuel. *Costumes africanos no Brasil*. Preface and notes by Arthur Ramos. Rio de Janeiro: Civilização Brasileira, 1938.

This book is dedicated to the memory of historian and Brazilianist E. Bradford Burns (1932-1995). Any resemblance to the character "Professor Levenson" in Jorge Amado's novel *Tent of Miracles* is purely coincidental.

"Brazil has two real claims to greatness: the fertility of its soil and the talent of its mixed-race people."

Manuel Querino

"The world of the Negro scholar is indescribably lonely; and he must, somehow, pursue truth down that lonely path while, at the same time, making certain that his conclusions are sanctioned by universal standards developed and maintained by those who frequently do not even recognize him."

John Hope Franklin

CONTENTS

Brief Note Disguised as a Foreword

Manuel Querino (1851-1923) was an avant-garde intellectual. He broke with the prevailing racialist paradigm in contemporary Brazilian studies of Africans and Blacks. In life, he had friends and admirers, but his publications did not carry their merited cultural impact. For a considerable time after his death, the plaudits he received for his research were accompanied by serious caveats.

Querino was seen and praised as a tireless self-taught polymath but pigeon-holed as a scholar who lacked the scientific methodology which supposedly supported the predominant paradigm. From this standpoint, it was inconceivable that his works could shake the theoretical foundations of prevailing ideologies. However, nothing prevented him from being recognized as producer of preliminary research and a major informant. At the same time, it was assumed that he could not be the one to set the tone for discussions of fundamental concepts. They should naturally be guided by those with superior scholarly credentials. Querino did, however, gain access to certain privileges of the literate elite. He was a founding member of the Geographical and Historical Institute of Bahia (IGHB), and therefore a confrere of several of those celebrated scholars. But his color, class, and background set him apart. He lived his life in ambiguous territory, both close to and far from the hubs of prestige without ever being regarded as one of those hubs himself.

Paternalism and patronage are the "tail" of the coin whose "head" is, undisguisedly, social and racial discrimination. In the bets he made in his career, Querino was able to benefit to some extent when the coin came up "tails." It is not surprising that he made use of this in the historical context in which he lived. That was one of the many complexities of his personal story. He was an extraordinary man, yet inextricably rooted in the praxis of the Bahian society of his time.

In recent decades, a remarkable movement of scholars have dedicated themselves to extensive research on Manuel Querino. The

chapters and bibliographical references in this anthology attest to the productivity and the broad scope of those investigations.

Sabrina Gledhill, the editor of this book, is a highly active figure in the reappraisal of Querino's legacy. Her previous work (*Travessias no Atlântico Negro: Reflexões sobre Booker T. Washington e Manuel R. Querino*) is an important step forward on that path, as well as an invaluable comparative study of the careers of Booker T. Washington and Manuel R. Querino.

This anthology offers its readers an itinerary through the reappraisal of Querino and his work that is still in progress. At the same time, it contributes fresh data and new approaches to that essential task. Anyone who reads it will see that, as a thinker, Querino was truly at the forefront of the society in which he lived.

Paulo Fernando de Moraes Farias

Fellow of the British Academy
Honorary Professor at the University of Birmingham

Editor's Introduction:
(Re)introducing Manuel Querino

Over the past few decades, numerous scholars have written about Manuel Querino in works published in English and Portuguese.[1] However, for many, he has been immortalized by one of Brazil's most renowned writers. The novelist Jorge Amado drew inspiration from Querino's life and works when creating Pedro Archanjo, the quixotic protagonist of *Tenda dos milagres* (English title: *Tent of Miracles;* Amado 1969 and 2003), which has been translated into several languages and adapted as a film and a mini-series in Brazil. Although placing his life in a different period and considerably romanticizing Querino, the novel serves to perpetuate the Bahian intellectual and activist's central philosophy: Black and mixed-race people are essential parts of Brazil's national heritage.[2]

This book brings together several scholarly essays that analyze different aspects of the life and work of an Afro-Brazilian who was always ahead of his time, particularly in his approach to the culture of the Africans and their descendants who made a major contribution to the unique culture of Brazil in general and his home state of Bahia in particular. Today, for example, preference is given to the term "enslaved" when referring to the people who were forced into the holds of ships on the African coast and, if they survived, their descendants, condemned to generations of bondage. Instead of being labeled "slaves," they are referred to as "the enslaved" – the condition imposed by those who used a social-Darwinist ideology to justify turning people into property. However, many readers will be surprised

[1] These include E. Bradford Burns, Jorge Calmon, Pedro Calmon, Jaime Nascimento, Jaime Sodré, Maria das Graças Andrade Leal, David Brookshaw, Emanoel Araújo, Luiz Alberto Ribeiro Freire, Eliane Nunes, Kim Butler, Vivaldo da Costa Lima, Antonio Sergio Alfredo Guimarães and Waldeloir Rego, among others.

[2] According to Amado, Pedro Archanjo is a composite of several real-life figures, including the author himself (personal communication and Amado 1992, 139).

to learn that in the early twentieth century, Querino was already referring to the Africans transported to Brazil as "the enslaved" in *O colono preto como factor da civilização brasileira* (The Black Colonist as a Factor in Brazilian Civilisation, also published as *O africano como colonizador,* The African as Colonist*)*, which confronts scientific racism and underscores the positive role that African "colonists" played in the construction of Brazilian society.

My interest in Querino began in the 1980s, when I was looking for a subject for my MA in Latin American Studies at UCLA, under the supervision of the historian E. Bradford Burns. I came across a quotation – "Brazil has two real claims to greatness: the richness of its soil and the sharp wits of its mestizos*"* (Amado 1971, vii; Querino 1954, 41)[3] – an epigraph in *Tent of Miracles*, and asked Professor Burns if he had heard of Manuel Querino. It turned out that my supervisor had not only highlighted Querino's work in his *History of Brazil* (see Burns 1993) but translated and published *O colono preto* as *The African Contribution to Brazilian Civilization* (Querino 1978) and written a bibliographical essay on Querino published in the *Journal of Negro History* (Burns 1974, see Chapter 1 of this book).

Instead of suggesting that I write a biography of Querino, Prof. Burns encouraged me to use the Bahian scholar's anti-racist perspective as an approach to African studies in Brazil prior to 1930, when intellectuals in that country began to recognize that Africans and their culture were worthy of study. Therefore, my MA research covered a gamut of attitudes toward Africans and their Afro-Brazilian descendants, from the most pessimistic (Nina Rodrigues) to the most positive (Querino), with Sílvio Romero, Euclides da Cunha and Brás do Amaral ranging between them.

I feared that, as I was following in the footsteps of several prior studies, such as works by Artur Ramos (1934), Donald Pierson (1942),

[3] The original quotation reads "O Brasil tem duas grandezas reais: a uberdade do solo e o talento do mestiço." My preferred translation is the one used in the epigraph to this book: "Brazil has two real claims to greatness: the richness of its soil and the talent of its mixed-race people."

Roger Bastide and Florestan Fernandes (1955) and Edison Carneiro (1964), among others, it might be superfluous to produce yet another study demonstrating that Brazil's much-vaunted "racial democracy" was a myth. However, my paper was well received and I was awarded my MA – without departmental honors. Shortly thereafter, I was stunned to learn one possible reason for this. A member of the MA degree committee commented that, although he had approved my paper, naturally we both knew – of course – that there was no such thing as racism in Brazil! The "zombie idea" of Brazilian racial democracy was still refusing to die.[4]

When I arrived in Salvador, Bahia, in 1986, I found that Nina Rodrigues – a firm believer in scientific racism, or racialism – was revered as the founder of Afro-Brazilian studies and Querino was still being overlooked or belittled by academia. Even the seemingly incontrovertible fact that he had inspired Amado's famous and well-loved protagonist Pedro Archanjo was cast into doubt. Then, in the 1990s, I joined in a long but ultimately successful campaign to rehabilitate and do justice to his memory. Leading the charge was the Afro-Brazilian historian Jaime Nascimento, who is now a familiar figure on Bahian television channels, explaining the background of the city of Salvador's rich panoply of festivals, from Dois de Julho (Bahia's own independence day) to the cleansing of Bonfim church. In addition to organizing a number of seminars about Querino and other Black intellectuals, Jaime has edited several publications about Querino, including two books, one of which is a collection of his writings, accompanied by explanatory essays (Querino 2009).

Until the first decade of the twenty-first century, no full biographies of Querino had been published, apart from a few brief eulogies and essays. In Brazil, Maria das Graças Andrade Leal in 2004

[4] The term "zombie idea" – "an idea that should have been killed by evidence, but refuses to die" – was used by the economist Paul Krugman in an opinion column for the *New York Times* entitled "Jobs and Skills and Zombies" (March 30, 2014). Accessed June 30, 2021.
<https://www.nytimes.com/2014/03/31/opinion/krugman-jobs-and-skills-and-zombies.html>

successfully defended her PhD thesis, which focused on Querino's work as a labor leader and politician. It was later published by Annablume (Leal 2009). Prior to her research, the only scholar to focus on that aspect of his activities was Jorge Calmon, a prominent journalist who for many years was editor-in-chief of Bahia's largest newspaper, *A Tarde,* as well as a professor at the Universidade Federal da Bahia and Honorary President of the Instituto Geográfico e Histórico da Bahia (IGHB), of which Querino as a founding member. A translation of his essay, based on a lecture entitled "Manuel Querino the Journalist and Politician," can be found in Chapter 3 of this book. In 2020, two works on Querino brought him back into the spotlight once again – one that compares and contrasts his experiences with those of Booker T. Washington (Gledhill 2020) and another which focuses on his culinary studies (Bacelar and Dória 2020). This anthology, which contains snippets of the first book and a synopsis of the second (in Chapter 8), is both a continuation of that movement and a direct result.

/ /

Manuel Raimundo Querino was born on July 28, 1851, a year after the definitive abolition of the transatlantic slave trade in Brazil. He came into this world in Santo Amaro da Purificação, a major town in the Recôncavo Baiano, the sugar- and tobacco-producing region of what was then the northeastern province (now state) of Bahia, where there was a large population of enslaved Africans and Creoles (people of recent African descent). According to his birth registry, Querino was the son of a carpenter, José Joaquim dos Santos Querino, and a housewife, Luzia (or Luiza) da Rocha Pita, both of whom were free and presumably Black or mixed-race (Calmon 1980; Leal 2009). However, a handwritten note on his death certificate stating that he was the "illegitimate son of Maria Adalgisa" casts doubt on his biological parentage.

At about the age of four, both of Querino's presumably adoptive parents are believed to have died in the cholera epidemic that scourged the region in 1855, killing 25,000 people in the entire province, including most of Santo Amaro's population (Tavares 2001, 273). He was sent to Salvador, the provincial capital, and placed in the care of a white guardian, Manuel Correia Garcia,[5] who taught him to read and write. Because Querino was Black,[6] Correia Garcia might have put his ward to work as a servant. Instead, he decided to apprentice him as a painter and decorator. However, Querino's aspirations went much higher, leading him to become a teacher, labor leader and politician (Leal 2009), folklorist, Africanist and Black vindicationist (Burns 1974; Gledhill 2020), as well as a pioneer in art history (Freire 2010) and food studies (Dória and Bacelar 2020).

The next major milestone in Querino's life came in 1868: his recruitment – most likely by force – into the Brazilian army during the War of the Triple Alliance (1864-1870). Because he was literate and his handwriting was good – rare accomplishments for most Brazilians in his day – the young man was assigned to work in the clerical department at his battalion's headquarters in Rio de Janeiro. It is also possible that this decision was based on his frail physique. In any event, he was spared from being sent to the front, from which – as he himself pointed out in his book on Bahian folklore, *A Bahia de outrora* (Bahia of Yesteryear) – many soldiers came back maimed and broken, if they returned at all.

[5] A retired teacher, politician and journalist with a law degree from a Brazilian university and a PhD in Philosophy from the University of Tübingen in Germany, Correia Garcia was a state deputy for the Liberal Party. He co-founded Bahia's first teacher training school and organised the province's primary education system in 1842. It was probably through him that Querino enjoyed the protection of a powerful patron, the head of the Liberal Party, Manuel Pinto de Souza Dantas (1831-1894).

[6] Querino self-identified as *"mestiço,"* or mixed-race, but is consistently described as "Black" in most commentaries on his work, including those by Artur Ramos (2010) and Edison Carneiro (2019, 132). E. Bradford Burns describes him as "a black" (1974, 78). More recently, Wlamyra de Albuquerque called him a "mulatto journalist" (2009, 39).

Demobilized with the help of his powerful political "godfather," Manuel Pinto de Souza Dantas (better known throughout Brazil as Conselheiro Dantas, 1831-1894), Querino returned to Bahia in 1871. The opportunity to sample the cuisine of other parts of Brazil had made him aware of the unique flavors of Bahian dishes, which are strongly influenced by African cooking methods, such as the use of red palm oil. That experience resulted in his posthumously published study of folk foodways, *A arte culinária na Bahia* (The Culinary Arts in Bahia).

Working as a painter and decorator by day and going to school at night, he studied French and Portuguese at the Colégio 25 de Março before becoming a founding student of the Liceu de Artes e Ofícios da Bahia (an arts and crafts lyceum established in 1872). While working his way through school, Querino also helped found one of Brazil's first labor cooperatives for free workers, the Liga Operária Baiana (Bahian Workers' League) in 1877.

When his teacher and mentor, the Spanish artist Miguel Navarro y Cañizares, left the Liceu to found the Escola de Belas Artes (School of Fine Art, now part of the Universidade Federal da Bahia) in 1877, Querino followed. He is also listed among the founding students of that institution (Silva 2005, 233). While there, he obtained a teaching certificate in geometric (architectural) drawing in 1882. He wanted to go on to earn a degree in architecture, but did not graduate because a third-year subject could not be taught due to a lack of lecturers (Vianna 1928, 307). He went on to teach geometric drawing at the Colégio de Órfãos de São Joaquim and the Liceu.

He also worked as a decorator, designer and artist and became a civil servant, holding several posts in the Department of Public Works and later the Department of Agriculture. As a politician, he served two terms on the city council (1890-91 and 1897-99) and espoused the Liberal Party's causes, including republicanism and abolitionism. Although he did not reach the highest ranks of the abolitionist movement, he joined the Sociedade Libertadora Baiana (Bahian Liberation Society) and raised public awareness about the injustices of slavery in articles published in the *Gazeta da Tarde* newspaper. Unlike

many Brazilian abolitionists, he believed that the inequality between Blacks and whites was due to the fact that the enslaved were forbidden access to education.

As an Afro-Brazilian, Querino took the cause of abolitionism personally. He advocated that abolition should be followed by schooling to prepare the enslaved people freed in 1888 for the world of wage-earning work. This may explain his fervent admiration for the African American educator Booker T. Washington (Querino 1955, 22; Gledhill 2020). Querino was also a militant journalist before and after Brazil became a republic in 1889. He founded two newspapers – *A Província* (1887-1888), which supported abolitionism, and *O Trabalho* (1892), which backed the workers' movement.

After retiring from politics and the civil service in 1899, Querino devoted himself to his studies of folklore, Afro-Brazilian history and culture, music, art history and food. He also produced two textbooks on geometric design. His books on art history and folklore were so well received that second editions were published in Querino's lifetime. His son Paulo Querino published his study of Bahian cuisine in 1928, five years after his death. For decades, in addition to a compendium of Querino's ethnological writings edited by the white anthropologist Artur Ramos (Querino 2010), it was his best-known work.

Contradicting the racial pessimism of most of Brazilian intellectuals of his day, Querino embraced the tradition of Black vindicationism – the defense of Black people at a time when racialism predominated in the worlds of science, academia and politics. Querino used Social Darwinism for his own ends: although he believed that Africans were "unevolved," he knew from his own example and those of other eminent Black men whose names he listed for posterity, that when an individual of African descent is respected and duly educated, their social and economic "evolution" is guaranteed. E. Bradford Burns observes that one of Querino's greatest contributions to Brazilian historiography was his insistence that its history take into consideration its African roots and the presence and influence of Africans and their descendants (Burns 1993, 321).

Originally presented at the Fifth Geography Conference held in Salvador, Bahia, in 1916, *A raça africana e os seus costumes na Bahia* (The African Race and its Customs in Bahia) begins with an impassioned defense of Africans and their descendants.[7] In his introduction, Querino observes that he is taking up the line of study "only just begun" by Raimundo Nina Rodrigues, who had died in Paris ten years before at the age of 43 (the work that established Nina's reputation as a founder of Afro-Brazilian studies, *Os africanos no Brasil* [The Africans in Brazil], was in press at the time of his death but would only be published in 1933). Beginning with an epigraph quoting folklorist and historian Alexandre José de Melo Morais Filho – "In terms of ethnographic research, none of the colonizing waves merits our attention more than those imported from Africa and their offspring" (in Querino 1955, 19) – Querino goes on to cite the Benedictine friar Camilo de Monserrate, director of what would become the National Library from 1853 to 1870, who called for a study of the "African race" in Brazil before it became "completely extinct" (Ibid.). In addition to justifying the study of Africans and their descendants in Brazil, Querino gives examples of distinguished Black educators (Ibid., 22), and concludes: "From what we have seen, we must infer that it was only a lack of education that destroyed the African's worth. Despite that, observation has shown that, among us, the descendants of the Black race have occupied positions of great importance in all fields of human knowledge, reaffirming their individual honorability in the observance of the purest virtues" (Ibid., 23).

In Querino's view, Brazil may have resulted from the intermingling of Portuguese, Amerindians and Africans, but the African contribution had been overlooked. He listed and underscored that contribution in *O colono preto como factor da civilização brasileira* (1918),

[7] Illustrated with twenty-three plates, *A raça africana* covers the origins of the enslaved Africans in Bahia and how they arrived in "Portuguese America." It gives considerable attention to Afro-Brazilian religious beliefs, which Querino calls a "culto feticista" (fetishist cult). After describing the divinities, or *ourixas* (orishas), he discusses festivals, divination, initiation rituals and offerings, among many aspects of the religion generally known as Candomblé.

presented at the Sixth Geography Conference in Belo Horizonte, Minas Gerais, in 1919. By emphasizing the role of people of African descent as settlers, the title itself clearly states his intent. *O colono preto* is a vigorous response to the ideology espoused by Gobineau and other followers of scientific racism. Querino highlights not only the knowledge the Africans brought to Brazil as "settlers" and their contributions to the country's development but also compares those "African Spartaci" to enslaved Greeks in ancient Rome, noting that: "Greek slaves were educated, both in public games and in literature, advantages that the enslaved African in the Americas did not possess, because the rigors of captivity, which did not allow the smallest mental preparation, dulled his intelligence" (1938, 148-149).

In the case of the famous maroon settlement Quilombo dos Palmares – Brazil's "Black Troy" – Querino favorably compares the *quilombolas* (maroons) to Greek or Roman slaves. As he was well aware, ancient Greece and Rome were considered the birthplace of European civilisation. Keeping to the principles of Social Darwinism, Querino suggested that, since Africans were also in the "evolutionary stage" of slavery, Africa, in turn, could be considered at least one of the cradles of Brazilian civilisation.

In addition to bringing together biographical data on artists from his home state in *Artistas bahianos* (Bahian Artists, 1911), Querino retrieved the life stories of eminent white, mixed-race and Black artists and artisans, including his own autobiography. In *O colono preto*, he provided a list of illustrious names, including "the privileged Rebouças family" of engineers, novelist Machado de Assis, poet Cruz e Souza, and sculptor Chagas, o Cabra (1918, 36). One of the last works published in Querino's lifetime was a biographical article about the Black intellectual, poet and musician João da Veiga Murici (whom he also named in *O colono preto*).[8]

[8] This biographical article was included in the second edition of *A Bahia de outrora* (1922) and reprinted in 1923 after Querino's death, in the *Revista do Instituto Geográfico e Histórico da Bahia* (Journal of the Geographical and Historical Institute of Bahia) (Nascimento and Gama 2009, 219-224).

The same issue of the IGHB's journal contained another article by Querino entitled "Os homens de cor preta na História" ("Black Men in History"), which provides information about the lives of thirty-eight illustrious men of African descent: doctors, soldiers, priests, revolutionaries, lawyers, musicians and teachers. In this effort to give visibility to Black people, the Bahian intellectual followed the example of the Black press, which, in the nineteenth century, sought to present illustrious men "of color" as positive role models for Black people and combat the stereotypes that surrounded and still surround people of African descent in Brazil.

A man of African descent who garnered an eminent place in Brazilian society, first as a journalist, abolitionist, labor leader and politician and finally as a scholar and author, Querino tried to use his position to defend the African legacy in his country. According to Burns, "His historical studies had a twofold purpose. On the one hand, he wanted to show his fellow Blacks the vital contribution they had made to Brazil, while, on the other, he hoped to remind the white Brazilians of the debt they owed Africa and the Black" (1974, 82).

Manuel Querino died of malaria on February 14, 1923 – Ash Wednesday – survived by his second wife, Laura Pimentel Querino, and two children. The funeral was held at the Quinta dos Lázaros cemetery. It was a modest burial in a cemetery generally reserved for the poor. However, despite falling on the last day of Carnaval, the ceremony was attended by many of Querino's fellow scholars and the "advocate of the poor," Cosme de Farias, among others. His remains were later transferred to the sacristy of the Igreja de Nossa Senhora do Rosário dos Homens Pretos in Pelourinho (now the Historic District of Salvador). In 1933, the Bahian division of the Frente Negra (Black Front) honored him by placing fresh flowers on his grave on 13 May 1933. They were celebrating the signing of the "Golden Law" that abolished slavery in Brazil on that date in 1888 (Bacelar 2008, 148).

The chapters in this anthology have been selected because they address various aspects of Querino's work, albeit not exhaustively – a future edition could be expanded to include works on his activities as

a Carnaval organizer and musicologist, among other possibilities. With the exception of the chapter by E. Bradford Burns, they were previously published in Portuguese, mainly as book chapters and peer-reviewed journal articles, and have been translated into English and edited to avoid unnecessary repetition.

Originally published in the *Journal of Negro History* in 1974, Chapter 1 is a faithful transcription of E. Bradford Burns's bibliographical essay "Manuel Querino's Interpretation of the African Contribution to Brazil." In it, Burns focuses on Querino's pioneering work as an historian who challenged the prevailing "science" of his day to demonstrate the positive contributions made by Africans and their descendants. In Burns's words, "As Querino turned his attention to history, he hoped to rebalance what was by then the traditional emphasis on the European experience in Brazil. No Black had ever given his perspective on Brazilian history before…. He presented his conclusions amid a climate of opinion which was at best indifferent, at worst prejudiced and even hostile" (1974, 82). Burns concludes by offering his translation of the final pages of what he describes as one of Querino's most important essays, *O africano como colonisador.*

Chapter 2, "From Soldiers to Scholars: Manuel Querino's Contribution to Black Vindicationism," is an adaptation of a chapter which I contributed to the anthology *Pensadores negros – Pensadoras negras* (Black Thinkers, Men and Women), edited by Sidney Chalhoub and Ana Flávia Magalhães Pinto (2016). It presents the academic context in which Querino worked, building up his challenge to scientific racism through works like *A raça africana e os seus costumes na Bahia* and *O colono preto como factor da civilização brasileira.*

Chapter 3, "Journalist and Politician" is based on a lecture given by Jorge Calmon at the Universidade Federal da Bahia Centro de Estudos Afro-Orientais (Afro-Oriental Studies Center) in July 1973. The focus is on Querino's activities in journalism and politics, but historians may also find it of interest because – and I hope to be proven wrong – one of Calmon's main sources is now impossible to find: *A Manuel Raymundo Querino: Homenagem dos seus admiradores e amigos no 30°*

dia de seu falecimento (For Manuel Raymundo Querino: Tribute from his Admirers and Friends on the 30th Day Since his Death, Bahia, 1923). Based on the authors Calmon cites, those admirers and friends included the Afro-Brazilian engineer and ethnologist Teodoro Sampaio, historian Brás Hermenegildo do Amaral, the journalist, educator and first occupant of chair no. 128 of the Bahia Academy of Letters Torquato Bahia (Carvalho 2019, 230) and Monseigneur Sólon Pereira, vicar of the district of Vitória in Salvador, Bahia (Leite 1997, 152). Based on the childhood memories of one of his sources, Calmon also gives us an idea of what Querino was like as a person – both his appearance and way of being – and a detailed footnote provides invaluable information about his service on Salvador's city council.

Chapter 4, "Disenchanted with the Republic," is based on a chapter which I contributed to the anthology *Política, instituições e personagens da Bahia (1850-1930),* edited by Jeferson Bacelar and Cláudio Pereira (2013). Carrying on with the subject of Jorge Calmon's essay, it shows how Querino – who had actively worked to make Brazil a republic when it was ruled by an emperor and his ministers – was just as disenchanted with the outcome (now known as the Old Republic) as were other workers, particularly Blacks and people of mixed race. He took on the heavyweights of the oligarchy in the brutal game of politics and lost, but even so, he became an icon for Black activists in the 1930s. It was thanks to this "failure" that Querino changed the backdrop of his struggle from the streets to the libraries and began studying folklore, music, ethnology, and became a Black vindicationist. As we will see in the following chapter, he also wrote about the arts and artists of Bahia.

Chapter 5, "The First Historian of Bahian Art," by Eliane Nunes, shifts the focus to another pioneering aspect of Querino's work. Her essay analyzes Querino's studies of Bahian artists and art history, published in the early twentieth century in the city of Salvador. Following in the footsteps of Giorgio Vasari, he sought to introduce the study of the arts and artists based in Bahia through biographies. Despite the criticism of art historian Carlos Ott, among others, who

tried to discredit him as a trustworthy source, Nunes demonstrates that Querino's work made an essential contribution to the historiography of the arts in Bahia and Brazil. Finally, she challenges the idea that Manuel Querino was an historian of Afro-Brazilian art and assesses the fate of the Black intellectual's work. Thanks to the contributions of Eliane Nunes and Luiz Alberto Ribeiro Freire, whose PhD thesis "A talha neoclássica" (later published as an illustrated book translated into English as *Neoclassical Carvings in Bahia,* 2007) was the first to compare Querino with Vasari, the Afro-Brazilian's pioneering work in that field – in addition to his role in the founding of the Academy of Fine Art (now the UFBA School of Fine Art) – is now widely recognized.

In Chapter 6, "Ground-Breaking Use of Photographs in Africanist Studies," Christianne Vasconcellos showcases another original aspect of Querino's work. In this essay, Vasconcellos demonstrates that his essay *A raça africana e os seus costumes na Bahia* was the first to use photographs when producing historical and ethnographic data on the subject of Africans in Bahia. She notes that the images used to illustrate *A raça africana* – most of which are reproduced in this book – do not appear in the more recent editions of *Costumes africanos no Brasil,* a compendium of Querino's works edited by Artur Ramos and originally published in 1938. (The illustrations in this chapter are reproductions of those included in the 1938 edition.)

In Chapter 7, "'Venerable Elders': Notes on Manuel Querino's Research and the Origins of Africans in Bahia," I take up the subject of Querino's ethnographic research and show how the names of places and cultural groups sometimes designate African "nations," localities and cities that Artur Ramos believed to be erroneous. However, this essay demonstrates that they reflect the realities of the Africans themselves, instead of being designations imposed on them by foreigners.

Chapter 8, "Creator of Bahian Folk Cuisine," Jeferson Bacelar and Carlos Dória provide a "tasting menu" of their book *Manuel Querino – criador da culinária popular baiana* (2020), which focuses on Querino's original research in the field of culinary anthropology. They

analyze his posthumous work *A arte culinária na Bahia* (The Culinary Arts in Bahia), a gastronomic manual published in 1928, five years after the author's death, which for many years has been his best-known and most widely republished work. According to Bacelar and Dória, Querino's pioneering scholarship in this field made the study of Bahia's folk cuisine a staple for understanding Brazilian regionality.

Finally, in Chapter 9, "Reflections on Portraits of Manuel Querino," I show how Querino's own image was used – both by himself and others – in an attempt to reflect or represent his personal qualities. Despite the fact that the few existing portraits of Querino are "icons of memory," today we must look to reproductions in books to see with our own eyes what Querino was like, and how greatly he was esteemed and honored by his confreres and friends.

Sabrina Gledhill

Crediton, Devon, UK

November 2021

Bibliography

Albuquerque, Wlamyra de. "Esperanças de boaventuras: Construções da África e africanismos na Bahia (1887-1910)." *Estudos Afro-asiáticos* 24, no. 2 (2002): 215-245. Accessed 9 February 2021. https://doi.org/10.1590/S0101-546X2002000200001.

———. *O jogo da dissimulação: Abolição e cidadania negra no Brasil.* São Paulo: Companhia das Letras, 2009.

Amado, Jorge. *Navegação de cabotagem.* Rio de Janeiro: Record, 1992.

———. *Tenda dos milagres.* São Paulo: Companhia das Letras, 1969.

———. *Tent of Miracles.* Translated by Barbara Shelby Merello. Madison: University of Wisconsin Press, 1971.

Bacelar, Jeferson Afonso. *A hierarquia das raças: negros e brancos em Salvador.* Rio de Janeiro: Pallas, 2008.

———. "De candomblés a negros ilustres," in *Manuel R. Querino: Seus artigos na Revista do Instituto Geográfico e Histórico da Bahia,* Nascimento, Jaime; Gama, Hugo (eds.), 177-183. Salvador: IGHB, 2009.

Bacelar, Jeferson and Dória, Carlos. *Manuel Querino: criador da culinária popular baiana.* Salvador: P55, 2020.

Burns, E. Bradford. "Bibliographical Essay: Manuel Querino's Interpretation of the African Contribution to Brazil." *The Journal of Negro History* 59, no. 1 (1974): 78-86. Accessed 9 February 2021. doi:10.2307/2717142.

———. *A History of Brazil,* 3rd ed. New York: Columbia University Press, 1993.

Calmon, Jorge. *Manuel Querino, o jornalista e o político.* Salvador: Universidade Federal da Bahia, Centro de Estudos Afro-Orientais, Ensaios/Pesquisas no. 3, May 1980.

Cardoso, Luciene Pereira Carris. "Os congressos brasileiros de geografia entre 1909 e 1944." *História, Ciências, Saúde* – Manguinhos, Rio de Janeiro 18, no.1 (Jan.-Mar. 2011): 85-103.

Carneiro, Edison. *Ladinos e crioulos. Estudos sobre o negro no Brasil.* São Paulo: Editora WMF Martins Fontes Ltda., 2019 (Kindle Edition).

Freire, Luiz Alberto Ribeiro. "A história da arte de Manuel Querino." Paper presented at the 19th Conference of the Associação Nacional de Pesquisadores em Artes Plásticas (Anpap), Cachoeira, Bahia, Brazil, 2010. Accessed 13 February 2021 <http://www.anpap.org.br/anais/2010/pdf/chtca/luiz_alberto_ribe iro_freire.pdf>

————. *Neoclassical Carvings in Bahia*. Translated by H. Sabrina Gledhill. Salvador: Odebrecht, 2007.

Gledhill, Sabrina. *Travessias no Atlântico Negro: Reflexões sobre Booker T. Washington e Manuel R. Querino*. Salvador: Edufba, 2020.

Leal, Maria das Graças de Andrade. *Manuel Querino: Entre letras e lutas. Bahia 1851-1923*. São Paulo: Annablume, 2009.

Merege, Ana Lúcia. Frei Camilo de Monserrate. Biblioteca Nacional - 200 Anos. Accessed 4 February, 2021 <https://bndigital.bn.gov.br/dossies/biblioteca-nacional-200-anos/os-personagens/frei-camilo-de-monserrate/>

Nascimento, Jaime and Gama, Hugo (eds.). *Manuel R. Querino: Seus artigos na Revista do Instituto Geográfico e Histórico da Bahia*. Salvador: Instituto Geográfico e Histórico da Bahia, 2009.

Pereira, Edimilson de Almeida and Gomes, Núbia Pereira de Magalhães. *Ardis da imagem: exclusão étnica e violência nos discursos da cultura brasileira*. Belo Horizonte: Mazza Edições, Editora PUC – Minas, 2001.

Querino, Manuel Raimundo. *A arte culinária na Bahia*. Valladolid: Editora Maxtor, 2014.

————. *A raça africana e os seus costumes*. Salvador: Livraria Progresso Editora, 1955.

————. *Costumes africanos no Brasil*. Salvador: Eduneb, 2010.

————. *O colono preto como factor da civilização brasileira*. Salvador: Imprensa Oficial do Estado, 1918.

Ramos, Artur. "Prefácio à 2ª edição." Querino, Manuel. *Costumes africanos no Brasil*. Salvador: Eduneb, 2010.

Silva, Viviane Rummler da. "Miguel Navarro y Cañizares e a Academia de Belas Artes da Bahia: relações históricas e obras." *Revista Ohun*, 2, no. 2 (Oct. 2005): 219-261.

Tavares, Luiz Henrique Dias. *História da Bahia*. 10th ed. Salvador/São Paulo: Edufba/UNESP (FEU), 2001.

Works by Manuel Querino

- *Desenho linear das classes elementares,* 1903

- *Artistas bahianos,* 1909

- *As artes na Bahia,* 1909

- *Elementos de desenho geométrico,* 1911

- *Artistas bahianos* (2nd edition), 1911

- *As artes na Bahia* (2nd edition), 1913

- *Bailes pastoris,* 1914

- "A raça africana e os seus costumes na Bahia," in *Anais do V Congresso Brasileiro de Geografia,* 1916

- *A Bahia de outrora,* 1916

- *O colono preto como factor da civilização brasileira,* 1918

- *A Bahia de outrora* (2nd edition), 1922

Posthumous publications

- *A arte culinária na Bahia,* 1928

- *Costumes africanos no Brasil,* ed. Artur Ramos, 1938

Acknowledgments

This anthology began with the idea of bringing together English translations of essays I had published about Manuel Querino in Portuguese over the years in scholarly journals or as book chapters. It seemed like the logical step forward, since the movement to appreciate Querino and firmly establish his legacy in the annals of Brazilian history was proving to be successful in Brazil, thanks to the efforts of people like the historian Jaime Nascimento. After exchanging ideas with Jaime, my daughter Isis Gledhill, my son-in-law, Wendel Damasceno, and Professor Luiz Alberto Ribeiro Freire, we concluded that it would be more interesting to include articles by various authors that cover multiple aspects of Querino's life and work. Since we had all the original texts in Portuguese, why not release an edition in that language? And so we did. In the meantime, I translated and adapted the English edition, adding the essay by E. Bradford Burns, which could not be included in the Portuguese edition for copyright reasons. The result is the book that the reader has in their hands, perhaps on paper, or, if purchased in e-book format, on a mobile phone, Kindle or other device.

This publication was made possible by the contributions, participation and interest of Beatriz Mamigonian, Carlos Alberto Dória, Christianne Vasconcellos, Flávio Gomes, Jeferson Bacelar, Jaime Nascimento, João José Reis, Luiz Alberto Ribeiro Freire and Sérgio Guedes.

Paulo Fernando de Moraes Farias very kindly contributed a foreword to this book, for which I am truly grateful.

Food scholar and chef Scott Alves Barton made invaluable contributions to Chapter 8, thanks to his culinary expertise. Scott is a former fellow of the Sacatar artists' residency, based on Itaparica Island in Bahia, so I would also like to thank the founders and directors of the Sacatar Foundation and Instituto Sacatar, Taylor Van Horne and Mitch Loch, for introducing us many years and projects ago.

The University of Chicago Press granted permission to reprint E. Bradford Burns's essay in Chapter 1, and Ana Flávia Magalhães authorized me to republish a chapter that I contributed to the book she co-edited with Sidney Chalhoub, *Pensadores negros - pensadoras negras: Brasil séculos XIX e XX* (2016), adapted in Chapter 2.

I would like to thank the Centre for Afro-Oriental Studies at the Federal University of Bahia (CEAO/UFBa) for granting permission to reproduce the essay by Jorge Calmon that appears in Chapter 3. Eliane Nunes's daughter, Ana Luiza Nunes Almeida, authorized me to include the paper by her late mother found in Chapter 5.

My deepest thanks to the artist Graça Ramos, who gave me her consent to publish her portrait of Manuel Querino.

Holly Caldwell did a wonderful job of proofing the manuscript, proving that "it takes another set of eyes."

Miriã Araújo, who designed the cover of this book (Portuguese and English editions, e-book and paperback), went above and beyond to provide all the versions required.

Finally, I extend my heartfelt thanks to my family in Brazil – especially my daughters, Isis and Barbara – and to my partner, David Pett. Without them, nothing would be possible.

Sabrina Gledhill

1. BIBLIOGRAPHICAL ESSAY: MANUEL QUERINO'S INTERPRETATION OF THE AFRICAN CONTRIBUTION TO BRAZIL

E. Bradford Burns[1]

Manuel Raimundo Querino (1851-1923), a Black, lived during a period of momentous change in Brazil.[2] Challenging well ingrained tradition, modernization and industrialization were beginning to reshape the nation, as the rate of urbanization accelerated. The combination of those forces helped to bring an end to slavery (1888) and to substitute a republic for the Empire (1889). Naturalism replaced Romanticism in literature. The growing complexity and appeal of nationalism prompted the intellectuals to view their country with deeper introspection. Querino actively participated in some of those changes, but his major contribution, in retrospect, appears to have been his efforts to assess

[1] Originally published in *The Journal of Negro History* 59, no. 1 (1974): 78-86. doi:10.2307/2717142. Reprinted with permission from the University of Chicago Press.
[2] There are no biographies of Querino [Editor's Note: as this anthology will demonstrate, this statement is no longer true]. A few eulogistic essays provide some of the data on his life. See "Professor Manoel Querino," *Boletim da Agricultura, Commercio e Indústria,* Nos. 1-6 (Jan.-June, 1923), Salvador, Bahia, 90-95, a brief eulogy which includes the newspaper obituaries of his death; Antônio Vianna, *Manoel Raymundo Querino, Discurso* (Salvador, 1923), a 13 page, highly perceptive speech delivered at the Centro Operário, Antônio Vianna, "Manoel Querino," *Revista do Instituto Geográfico e Histórico da Bahia,* No. 54, Part II (1928), 305-316, an excellent interpretive study and appreciation; and Gonçalo de Athayde Pereira, *Professor Manuel Querino. Sua vida e suas obras* (Salvador: Imprensa Oficial do Estado, 1932), a 31 page biographical sketch praising him principally as an artist. The archives of the Instituto Geográfico e Histórico da Bahia contain a one-page curriculum vitae of Manuel Querino in his own handwriting. See Pasta 1, Maça 1, Documento 10. The novelist Jorge Amado has written a fictionalized account of Querino's life entitled *Tenda dos Milagres* (São Paulo: Livraria Martins Editora, 1969). It has been translated into English as *Tent of Miracles* (New York: Knopf, 1971). The novel is brilliant. In certain aspects, the book follows the basic outline of Querino's life, but Amado liberally elaborated the known facts and altered the time period.

1

the role the Africans played in the formation of Brazil. He reflected in part a greater self-awareness on the part of the Black community as well as an effort of the nationalists to come to grips with Brazil's racial diversity and its implications. He was the first Black to write Brazilian history, a task to which he brought a much needed perspective. No one could hope to understand Brazil, he reasoned in 1916, without knowing the contributions of the "African race" to that nation.[3] His conclusion still struck a note of novelty during the early decades of the twentieth century.

Querino was born on July 28, 1851, in the town of Santo Amaro, Bahia, into what was euphemistically termed "honorable poverty" (Pereira 1932, 3). Indeed, poverty characterized all the Blacks in mid-nineteenth century Brazil. However, the Querinos, unlike three millions of others in the Empire at that time, were fortunate to be free. A severe epidemic of cholera morbus lashed Bahia in 1855, killing nearly 30,000 people, among them Manuel's parents. Officials sent the small orphan to the state capital, Salvador, where a powerful and prestigious guardian, Manuel Correia Garcia, a state deputy and professor in the state teacher training institute, looked after him. Such a guardianship insured the child the privilege of receiving an education, an aspiration few Bahians, white or Black, could nurture. The illiteracy rate during the Imperial period never dropped below 85 percent among the free population. At the time Querino attended classes, Brazil boasted a population of approximately ten million of whom only about 110,000 were in school.

At the age of 17, while Brazil struggled to defeat Paraguay during the War of the Triple Alliance, Querino enlisted in the army. During the years 1868-1871, he served in the provinces of Pernambuco and Piauí and finally in the national capital. Those years constituted his only travels outside of Bahia; according to Querino's own testimony, they

[3] He first expressed that idea in "A raça Africana e os seus costumes na Bahia," *Anais do 5º Congresso Brasileiro de Geografia*, Vol. VII (Salvador, 1916). The essay has since been republished, and I am quoting from a collection of his essays entitled *A raça Africana* (Salvador: Livraria Progresso Editora, 1955), 21.

aroused in the young soldier a curiosity about the different customs and habits in each region he visited (Querino 1951, 23-24).

Returning to Salvador, he took up his studies again and between 1881 and 1884 enrolled in the local School of Fine Art. Only sketchy details remain concerning his advanced education, but enough is known to appreciate the difficulties he had. Work interfered with his studies; sometimes he did not have the money for tuition. Further, the poorly staffed school did not offer the necessary courses for him to finish his degree in architecture, although the training did qualify him to teach design (Querino 1909, 116).[4] In 1885, he began to teach "geometric design" at the Liceu de Artes e Ofícios, a course he also gave at the Colégio dos Órfãos de São Joaquim as well as a subject he tutored. On at least one occasion Querino was praised as an exemplary teacher.[5] In a pattern already well established in Brazil and continuing into the present, meager salaries forced the teacher to supplement his income from other sources. He decorated buildings, working on several churches and theaters, and painted, usually contracting for a painting job and then hiring Black laborers to do the work. From 1888 to 1895 the Provincial Directory of Public Works hired him as a designer.[6] In 1896, he entered the state Secretariat of Agriculture as a "Third Official," a position he held until his retirement in 1916. Without sufficient political connections, he failed to get the promotions he twice sought (Pereira 1932, 18; Artur Ramos in the "Preface" to Querino 1938, 10-11).

Throughout his life, Querino held firmly to well defined ideological views, ideas which in general associated him with the rising urban middle sectors and at the same time put him into conflict with the traditional but still powerful elite. Inclined toward socialism, he took up the struggle of the laboring class of which he was a highly

[4] See the entries of February 19, April 14, 1881; January 3, 9, 31, April 22, December 12, 22, 1883, of Livro Nº 1, Actas da Academia de Bellas Artes, Salvador. Manuscript in the Academia de Belas Artes, Salvador, Bahia.

[5] *Jornal de Notícias* (Salvador), December 4, 1901.

[6] A favorable commentary on an architectural plan drawn by Querino for a public school appeared in the *Jornal de Notícias*, May 29, 1883.

educated member. He entered the incipient labor movement in Bahia in 1875 and helped to organize the Bahian Workers Society League (Sociedade Liga Operária Bahiana) the following year. For several decades the Black teacher was one of the League's leading spokesmen.[7] A forceful writer on labor issues, particularly in two labor newspapers, *A Província* and *O Trabalho*, published in Salvador, he charged political corruption as a major cause for the abuses of the working class, a term he used interchangeably with "oppressed class." To prosper, he advocated, labor had to be free of any connection, direct or indirect, with the government. Only an independent labor could pursue its own best ends. He constantly protested low wages caused by the depressed labor market in Bahia. He received sufficient votes in a municipal election in 1889 to serve a single term on the city's council where he represented labor's interests. Later a working class party nominated him as a candidate for a seat in the federal assembly. He lost the election.

A partisan of "immediate and unconditional freedom" for the slaves, Querino worked hard in the abolitionist movement. He wrote a series of articles favoring manumission in the *Gazeta da Tarde, A Província*, and *O Trabalho* (Ramos 1951, 89) and belonged to the Bahian Liberation Society, the local abolition club founded in 1887.[8]

As a further testimony to his ideological preferences, Querino joined the Republican Club of Bahia. On August 1, 1878, he signed a manifesto denouncing the monarchy and supporting a republic (Querino 1909, 85). Unfortunately, the republic established after 1889

[7] Querino described the development of the labor movement as well as his role in it in his *As Artes na Bahia* (1909), 70-96.

[8] The entire topic of the participation of the blacks in the abolitionist movement begs serious research. In his influential book *A Escravidão, o Clero, e o Abolicionismo* (Salvador: Imprensa Economica, 1887), Luiz Anselmo da Fonseca stated, "The Negroes and men of color of Bahia constitute a real force against civil liberty" (p. 154). He concluded that their participation in the abolitionist movement was minimal. Robert Brent Toplin in his recent study, *The Abolition of Slavery in Brazil* (New York: Atheneum, 1972, 71-22), also concluded that blacks had played an insignificant role in the movement. My own very limited research in Bahia has been less conclusive.

soon disenchanted Querino as it did so many others who perhaps expected too much from it. The Republic showed as little interest in the working class as the monarchy had (Ibid., 8). Further, conditions for the Black seemed to deteriorate. Querino particularly resented the resources the government diverted from internal improvements to entice more Europeans to migrate to Brazil. Those funds, he felt, could be better spent on the educational needs of Brazil's own Black population. Always aware of conditions in Africa, Querino noted ironically that Edward VII treated his subjects in the distant African colonies better than the Brazilian president did his fellow Black citizens (Ibid., 55). The lack of educational opportunities in Brazil figured as a constant theme in his writing. He attributed the lowly status of the Black in Brazilian society to that lack. In short, he concluded, only education could bring about the final, the definitive, emancipation of the Black (Querino 1955, 23).

Although maintaining an active interest in labor and political affairs until his death, Querino increasingly devoted more of his time and energy to historical studies after the turn of the century, in particular to his research and writing on the contributions of the Africans to Brazil's development. It was his education and historical interests which provided Querino with his major access to elite – and predominately white-Brazilian society.[9] He became, for example, one of the founders and charter members of the Bahian Geographical and Historical Institute (Instituto Geográfico e Histórico da Bahia). That connection facilitated the publication of his research. His historical studies had a twofold purpose. On the one hand, he wanted to show his fellow Blacks the vital contribution they had made to Brazil, while,

[9] Little evidence is at hand to know Querino's feelings as a scholar, but studying the black Brazilian's works and reading of his life I could not help recalling the words the U.S. black/historian John Hope Franklin penned in the early 1960's: "The world of the Negro scholar is indescribably lonely; and he must, somehow, pursue truth down that lonely path while, at the same time, making certain that his conclusions are sanctioned by universal standards developed and maintained by those who frequently do not even recognize him." Quoted by Roger M. Williams in his essay "The Emancipation of Black Scholars," *Saturday Review*, December 18, 1971, 54.

on the other, he hoped to remind the white Brazilians of the debt they owed Africa and the Black.

During those first decades of the twentieth century, when Querino was writing, historians still paid scant attention either to the Black or to his contribution to Brazil. When mentioned at all, the Black was discussed as a slave. The historians paid some attention to the abolitionist movement, but then they emphasized the role whites – with the notable exceptions of André Rebouças and José do Patrocínio – played in manumission. Three well-known Brazilian intellectuals, Sílvio Romero, João Capistrano de Abreu, and Afonso Celso, had suggested the essential role taken by the Black in the development of Brazil, but they supplied few details.[10] Much more typical of the mentality of the period were the histories of Rocha Pombo and João Ribeiro, written early in the century but still widely used in the schools. In a text of 493 pages, Rocha Pombo spoke directly of the Black on only seventeen, most of which concerned the slave trade and the abolition movement.[11] João Ribeiro did much the same on sixteen out of 423 pages.[12] For that matter, the Brazilian history text published in 1961 by Hélio Vianna, traditional in every sense, altered not a whit the emphasis.[13] It devoted only twenty-one out of 671 pages to the African background of Brazil and the Blacks' experiences in Brazil. Even though written a half century after Pombo and Ribeiro, the emphasis fell still on the slave trade and abolition. As Querino turned his attention to history, he hoped to rebalance what was by then the traditional emphasis on the European experience in Brazil. No Black

[10] Silvio Romero, *História da Literatura Brasileira,* 2nd ed. (Rio de Janeiro: Garnier, 1902), I, 74-76, 83, 84, 89-91; João Capistrano de Abreu, *Capítulos de História Colonial,* 4th ed. (Rio de Janeiro: Briguiet, 1954), 65-66; Affonso Celso, *Porque Me Ufano do Meu Paiz* (Rio de Janeiro: Laemmert, 1901), 91-94, 184-190.

[11] Rocha Pombo, *História do Brasil,* 10th ed. (São Paulo: Edições Melhoramentos, 1961).

[12] João Ribeiro, *História do Brasil,* 17th ed. (Rio de Janeiro: Livraria Francisco Alves, 1960).

[13] Hélio Vianna, *História do Brasil* (São Paulo: Edições Melhoramentos, 1961).

had ever given his perspective on Brazilian history before.[14] Querino emerged as the first Brazilian – Black or white – to detail, analyze, and do justice to the African contributions to Brazil. He presented his conclusions amid a climate of opinion which was at best indifferent, at worst prejudiced and even hostile.

Querino, then, brought to Brazilian historiography the perspective of a Black man. Living in the Matatu Grande section of Salvador, he was immersed in, an intimate part of, the Black community (Vianna 1928, 311). He knew perfectly well the habits, aspirations, and frustrations of Black Brazilians. Speaking of his source material, Querino revealed that much of his information came directly from respected Black elders who spoke "without reservations or subterfuge because those people saw in me nothing more or less than a friend of their race or one who with understanding and sincerity always respected and knew how to treat fairly those people" (Querino 1955, 23). Evidence exists that besides writing about the Black people he helped to defend them. He tried to bring to the attention of municipal officials the persecution inflicted on the practitioners of the Afro-Bahian religions.[15] The police, labeling the religions as "barbarian and pagan," frequently raided the terreiros where the ceremonies were held destroying property and injuring the participants. Querino's intervention in their behalf before the local government revealed once again the unique position he held bridging different cultures and classes.

Clio certainly owes a heavy debt to Querino. He preserved considerable information on the art, artists, and artisans of Bahia. No one can do research on any of those subjects without consulting his

[14] "Few colored intellectuals in Bahia are at all interested in studying and writing about the Negro," observed Donald Pierson after conducting extensive research there more than a decade after the death of Querino. *Negroes in Brazil. A Study of Race Contact at Bahia* (Carbondale, Ill.: Southern Illinois Press, 1967), 220.

[15] A document in Querino's handwriting, "Notas relativas a fatos policiaes na Bahia," an apparent draft of a protest he prepared for the Chief of Police, can be found in the archives of the Instituto Geografico e Histórico da Bahia, Pasta 11, Mayo 1, Documento 1.

works.[16] Further, Querino is an excellent source for social history. His *As artes na Bahia,* for example, includes an ample sampling of biographies of workers, artisans, and mechanics, those who qualify as "the common man." Such brief biographies are unique sketches providing an invaluable look into the lives of the humble upon whom much of the progress of Brazil rests. He also offers in his essays abundant information on popular customs, culture, and religion. One of the richest sources for the popular culture of Bahia lies in his *A Bahia de outr'ora: Vultos e fatos populares.*[17]

Certainly one of Querino's chief contributions to national historiography was his insistence that the history of Brazil take into account its African background and the presence and influence of the Blacks. Brazil, he emphasized, was the resultant fusion of the Portuguese, Indian, and African (Querino 1951, 24).[18] Yet, the contributions of the Africans had gone unheralded. He sought to redress the balance in his suggestive essay "O colono preto como factor da civilização brasileira," (1918), a title I have translated below as "The African Contribution to Brazil."[19] The essay abounded with insights, many of which later scholarship adopted and expanded – so much so that it is now difficult to appreciate the originality of Querino when he first suggested them. Subsequent scholars have emphasized, for example, that Africa provided the skilled and unskilled labor which developed Brazil. However, the essay suggested other significant

[16] Marieta Alves, "Notas a Margem do Livro 'Artistas Bahianos' de Manoel Querino." *Anais do Primeiro Congresso de História da Bahia* (Salvador: Tip. Beneditina, 1951), V, 535.

[17] This book has gone through three editions, 1916, 1922, and 1946, all of them published in Salvador. [Another edition was published in Bahia in 1955 by Livraria Progresso Editora – Ed.]

[18] The idea was not novel. Karl Friedrich Philipp von Martius was probably the first to emphasize it in 1843. See his essay "How the History of Brazil Should Be Written," in E. Bradford Burns (ed.), *Perspectives on Brazilian History* (New York: Columbia University Press 1967), 21-41. The Positivists always affirmed that Brazilian civilization was a composite of the contributions of three races. See Anníbal Falcão, "Fórmula da Civilzação Brasileira," *Diario de Pernambuco* (Recife), February 27, 1883.

[19] The essay is reprinted in Querino, *A raça Africana* (1955, 123-152), under the title "O africano como colonisador."

contributions of the Blacks on which historians have yet to dwell. For example, Querino assigned the Black a principal role in the defense of Brazil and the maintenance of national unity.[20]

Although still not widely known in Brazil, the essay has received praise from some national scholars. In evaluating the work of Querino, Professor Artur Ramos, a later major contributor to Afro-Brazilian studies, concluded, "He remains one of the most solid sources of honest documentation for the Negro in Brazil" (Ramos, "Preface," in Querino 1938, 6). In those same remarks, Professor Ramos assigned Querino a prominent place in Brazilian historiography. Alas, it is a place too few recognize. Querino died on February 14, 1923, in the same poverty into which he was born. Bahia roused itself to lament his passing. In 1928, the Bahian Geographical and Historical Institute hung a portrait of him in its gallery of distinguished Bahians [See Chapter 9]. From time to time one or another scholar, such as Artur Ramos, pays homage to him. Still he remains largely unknown outside of his native Bahia and totally unknown outside of Brazil despite his significant contributions to Brazilian and Afro-American (defined in its hemispheric sense) historiography. In an effort to bring him to the attention of those who might appreciate his contributions but do not read Portuguese, I offer the following translations of the closing pages of one of his most important essays, "O africano como colonisador."[21]

A griculture was the initial and lasting wealth of the nation. Though encumbered by outmoded, routine, and elementary methods, it still grew and developed from the labor of the slaves. The African exerted all his physical strength in the fields to produce as much as possible, a labor from which the colonists reaped all the benefits. Only after the slave began to weaken from the burden of his field work, from the effect of the climate, and, above all else,

[20] F. J. Oliveira Vianna noted ironically that it was the exploited Black man who defended the white elites and their plantations in Brazil. *Evolución del pueblo brasileño* (Buenos Aires: Imprenta Mercatalí, 1937), 84.

[21] Published in *A raça africana* (Salvador: Livraria Progresso Editora, 1955), 123-152.

from old age was he transferred to duties in the house of the master, a sort of reward for having escaped death while straining and groaning in the fields.

Once transferred to the Big House, the Negro slave with his affectionate nature, his good will, his ability, and his fidelity won the esteem of his master through his sincere devotion and frequent sacrifice. It was in the Big House that the Negro expanded the most noble sentiments of his soul. He collaborated lovingly in bringing up the offspring of his lord and master, teaching them obedience, deference, and respect for age. He inspired good will and even love from all members of the family. The Black mother was a storehouse of tenderness and affection for the master's children. Within the conviviality of the Big House, the Negro performed many intimate services. They were the lady's companions, the valets, the wetnurses, pages, bodyguards, and favorite maids. The African slave was hardworking, thrifty, and provident, qualities which his descendants did not always conserve. He sought to give his offspring a licit occupation and whenever possible he saw to it that his children and grandchildren had mastered a skill. The work of the Negro for centuries sustained the grandeur and prosperity of Brazil. It was the result of his labor that Brazil could afford scientific institutions, literature, art, commerce, industry, and so forth. He thus occupies a position of importance in the development of Brazilian civilization. Whoever takes a look at the history of this country, will verify the value and contribution of the Negro to the defense of national territory, to agriculture, to mining, to the exploitation of the interior, to the movement for independence, to family life and to the development of the nation through the many and varied tasks he performed. Upon his well-muscled back rested the social, cultural, and material development since without the income which he provided and which made everything possible there would have been neither educators nor educated: without that wealth the most brilliant aspirations would have withered; the bravest efforts would have been in vain. With the product of the Negro's labor, the wealthy masters sent their sons to

European universities and later to our own universities, from which, well instructed, came our venerable priests, able statesmen, notable scientists, excellent writers, brave military officers, and all the rest who made of first colonial and then independent Brazil a cultured nation, strong among the civilized peoples. From the conviviality and collaboration of the races in the formation of this country emerged a large mestizo population of all shades and hues, from which have come so many illustrious men of talent who are the true glory of our nation. Without any effort, one can name Francisco Ge Acaiaba de Montezuma, Visconde de Jequitinhona; Caetano Lopes de Moura; Eunápio Deiró; André Rebouças; Antônio Gonçalves Dias; Machado de Assis; João da Cruz e Sousa; José Agostinho; Francisco de Sales Torres Homem; Visconde de Inhomirim; Saldanha Marinho; José Maurício Nunes Garcia; Tobias Barreto; José Lino Coutinho; Francisco Glicério; Natividade Saldanha; José do Patrocínio; José Theófilo de Jesus; Damião Barbosa; Chagas; João da Veiga Murící; and many others. It can be concluded that Brazil possesses two riches: the fertility of the soil and the talent of the mestizo.

The Black is still the principal producer of the nation's wealth, but many are the contributions of that long suffering and persecuted race which has left imperishable proofs of its singular valor. History in all its justice has to respect and praise the valuable services which the Black has given to this nation for more than three centuries. In truth, it was the Black who developed Brazil.

Bibliography

Pereira, Gonçalo de Athayde. *Professor Manuel Querino. Sua vida e suas obras.* Salvador: Imprensa Oficial do Estado, 1932.

Querino, Manuel. *A arte culinária na Bahia.* Salvador: Livraria Progresso Editora, 1951.

———. *Artistas bahianos.* Rio de Janeiro: Imprensa Nacional, 1909.

Querino, Manuel. *A raça africana.* Salvador: Livraria Progresso Editora, 1955.

———. *As Artes na Bahia.* Salvador: Typ. do Lyceu de Artes e Officios, 1909.

———. *Costumes africanos no Brasil.* Rio de Janeiro: Civilização Brasileira, 1938.

———. *O colono preto como factor da civilização brasileira.* Salvador: Imprensa Official do Estado, 1918.

Ramos, Artur. *The Negro in Brazil.* Washington, DC: The Associated Publishers, 1951.

Vianna, Antônio. "Manoel Querino." *Revista do Instituto Geográfico e Histórico da Bahia,* no. 54, Part II (1928): 305-316.

2. FROM SOLDIERS TO SCHOLARS: MANUEL QUERINO'S CONTRIBUTION TO BLACK VINDICATIONISM

Sabrina Gledhill[1]

This essay discusses some aspects of Querino's work as an Afro-Brazilian Black vindicationist and the tactics he used to combat the veiled racism prevalent in Brazil. As we have seen, he was an abolitionist, political activist, civil servant and labor leader, and founded two newspapers, *A Província* (1888-1889), and *O Trabalho* (1892). The former supported abolitionism and the labor movement and the latter continued his defense of free labor after Brazil abolished slavery in 1888 – the last country in the Americas to do so.

After retiring as a civil servant in 1899, Querino began writing and publishing books. The first was a textbook on geometric design (1903), followed by works on art and artists in Bahia, folk dances and other cultural expressions. The first edition of *Artistas bahianos* (Bahian Artists) included photographs of artists and musicians, some of whom were Black or *mestiço* (mixed race). In addition to photographs of works of art, the second edition contained just two portraits – one of the author himself and the other of Ladislau dos Santos Titára, also a man of color, who wrote the lyrics of "Hino ao 2 de Julho."[2] In 1916, Querino published *A raça africana e os seus costumes na Bahia*, a book that not only portrayed Blacks in a positive light but deplored the contempt with which they were usually treated. Thanks to that work, until the 1930s Querino was considered one of the leading authorities on Black

[1] This chapter is a translation and adaptation of "De guerreiros a doutores negros: a contribuição de Manuel Querino," published in *Pensadores negros pensadoras negras: Brasil séculos XIX e XX* (2nd ed.), ed. Sidney Chalhoub and Ana Flávia Magalhães Pinto (Belo Horizonte: Fino Traço Editora, 2020).

[2] A song in praise of the Independence of Bahia that became the state's official anthem in 2010.

history and culture in Brazil (then considered beneath the regard of scholarship in that country), along with the white forensic pathologist Nina Rodrigues. Published in 1918, his essay *O colono preto como factor da civilização brasileira* (The African Contribution to Brazilian Civilization) elevated him into the ranks of another small and prestigious club: the first scholars to perceive and value the positive role of Africans and their descendants in the construction of Brazil.

When he died in 1923, several obituaries published in Bahia newspapers underscored Querino's writings. According to Bernardino de Souza, the secretary for life of the Instituto Geográfico e Histórico da Bahia – of which Querino was a founding member – his portrait was "unveiled along with that of that Brazilian sage Nina Rodrigues in the Gallery of our illustrious men" on 13 May 1928 (Pereira 1932, 34). I bemoan the fate of that portrait in Chapter 9.

Although Querino clearly enjoyed prestige during his lifetime, he was also the target of injustice in life and after his death, as Pereira's biography underscores (Pereira, 1932). Querino's "posthumous trajectory" shows that he was overlooked and disparaged by Renato Mendonça during the Second Afro-Brazilian Congress, held in Bahia in 1937; patronized by Arthur Ramos in the collection of his works that this psychiatrist from Alagoas edited in 1938; accused of plagiarism by the German-Brazilian art historian Carlos Ott in 1947, and, for a time, considered an unreliable source on art history at the Universidade Federal da Bahia School of Fine Art (Freire 2010; see Chapter 5).

A teacher at D. Pedro II College, Mendonça made the following observation about Querino and his work: "Lacking great culture and the capacity for interpretation, Querino limited himself to collecting the material, a fact that is of great value for the demanding ethnographer" (1940, 104). In his foreword to *Costumes africanos no Brasil*, Ramos described Querino as follows: "Although he lacked the methodological rigor and scientific scholarship of Nina Rodrigues, Manuel Querino was an honest researcher, a tireless worker, driven by

the understandable interest that stemmed from his own African roots" (Ramos 1938, 5; see Chapter 7).

Querino was nearly forgotten, only lingering on in the public memory because of his posthumous work on Bahian cuisine. However, the efforts of several scholars, including the author of this chapter, have changed that situation. Today, Querino is receiving more attention and appreciation in Brazil and abroad. For example, in his book and documentary *Black in Latin America,* Henry Louis Gates Jr. compares Querino to three eminent African Americans: Booker T. Washington, Carter G. Woodson and W.E.B. Du Bois (Gates, Jr. 2011, 40-41). The Escola de Belas Artes has dedicated its online dictionary of fine art to Querino.[3]

Scientific racism

As we have seen in Chapter 1, Manuel Querino was one of the first Brazilians to study Afro-Brazilian culture and the first Afro-Brazilian to stress the contributions that Africans had made to his country. So as better to assess Querino's pioneering stance, it is essential to understand the intellectual climate in which he worked. In Brazil, as in other countries, it was dominated by the Positivism of Auguste Comte, the Social Darwinism of Herbert Spencer and particularly Gobinism, the racial pessimism of Gobineau (Ortiz 1985, 14; Gledhill 1986). Better known in Brazil as the Conde de Gobineau, Joseph Arthur Compte de Gobineau (1816-1882) made a considerable impact on Brazilian intellectuals by focusing on miscegenation in Brazil in works written during and after a sojourn in that country. He was also a close friend of Emperor Pedro II, whom the French aristocrat considered to be the only Brazilian who was not besmirched by racial mixture.[4] The author of the *Essai sur l'inégalité des races humaines* (1884), Gobineau spent a little over a year in Brazil (from March 1869 to April 1870), and

[3] http://www.dicionario.belasartes.ufba.br/wp/ Accessed 4 September 2020.
[4] Pedro II disagreed with Gobineau, at least in principle. In a letter to his friend, the emperor declared that racial prejudice did not exist in Brazil: "Here, democracy means the absence of any prejudice as to origins, belief or colour" (Ianni 1970, 268).

saw that country as "living proof" of his theory of Aryan supremacy (Biddiss 1970, 201-204; Skidmore 1974, 30).

Gobineau believed that the Brazilian people had been "irretrievably sullied" by miscegenation and was disgusted by a people that, for him, was entirely mulatto, corrupt, feeble and ugly (Skidmore 1974, 30). The count also declared that the racial mixture was so extensive that "the nuances of color are infinite, causing a degeneration of the most depressing type among the lower as well as the upper classes" (Ibid., 30).

Possibly due to his friendship with Pedro II, he may have managed to overcome his misgivings about miscegenation, as he positively encouraged European emigration to Brazil. In a work written with that aim in mind, Gobineau declares that "the great majority of the Brazilian population is mulatto, the result of mixtures among the indigenous and Black peoples and a small number of Portuguese" (Gobineau 1874, 368). To put the future settlers' minds at ease, he assures them that mulattoes could not produce more than a limited number of generations: "Infertility does not always exist in marriages, but their offspring gradually becomes so weak and feeble that they die before producing children, or have children who cannot survive" (Ibid., 369). Gobineau calculated that mulattoes would vanish from Brazil in less than 200 years due to the increasing degeneracy caused by racial mixture, and predicted that alliances formed with the "superior races" of Europe would result in the revitalization of Brazil: "The race will be restored, public health will improve, the moral temperament will be revitalized, and the happiest changes will be introduced into the social state of that wonderful country" (Ibid.).

Gobineau's followers, such Gustave Le Bon and Georges Vacher de Lapouge, presented their own racialist theories.[5] The Brazilian author Rodrigues de Meréje discusses the theories of

[5] Gobineau did not approve of all of his followers. In a letter to Emperor Pedro II, he observes that the books of Renan, Taine and Maury "were copied from mine, even if they were honest enough to say so. But that does not suit today's times. I will add that to the preface of the upcoming edition of *Inégalité des Races*." Gobineau to Pedro II, Rome, 8 February 1882 (Raeders 1938, 361).

Gobineau and Lapouge in his book *O problema da raça*, in a chapter entitled "Gobinismo." In it, he describes Lapouge's theories as Gobinism taken to the extreme, and combined with Social Darwinist theories of natural selection and evolution. According to Lapouge, there were two human races in Europe, the "Aryan" conquerors *(Homo europaeus)* and the conquered slaves, whom he called "Celts" or "Alpines" *(Homo alpinus)*. Lapouge believed that these two "races" were physically and morally different and that the "Aryans" were always destined to dominate the others, wherever they might be. The "Alpines" were supposed to be submissive and passive, partial toward vice and vulgarity (Meréje 1934, 18-19).

Gobineau and Le Bon agreed that racial mixture resulted in the decadence of humanity, but Lapouge believed that, much worse, they were a danger to the superior race. Since the "Aryans" were said to be more courageous and warlike, the mortality rate among them would be higher because they fought and died in wars. Their religious fervor was more intense, leading them to choose the path of celibacy, thereby reducing their birth rates (Ibid., 20-21). Lapouge believed that the most efficient way of exterminating the inferior peoples was to encourage their vices, particularly lust and drunkenness. Since both Gobineau and Lapouge thought that the Africans were the most decadent of the human races, this seemed to them the perfect solution for "the Negro problem." The two Frenchmen believed that eugenics through the selection of the humans who were considered fittest to reproduce due to their physical and moral qualities would result in a victory for the "Aryan race" (Ibid. 24).

Thanks to the latent sense of shame regarding Brazilian's mixed-race heritage that was produced and maintained by scientific racism, until the 1930s, Brazilian historians paid little attention to the contributions made to Brazilian society by Africans and their descendants. The predominant image of Blacks was that of a passive instrument of labor, the slaveowner's chattel. Their role in the abolitionist movement went virtually unnoticed. To whiten the image of Brazil and its history, Blacks were relegated to a few pages of the

history books regarding slavery and the law that officially abolished that institution in 1888.

Like all Brazilian intellectuals of his time, Manuel Querino read in works by European philosophers and theoreticians that it was not enough to have white skin to belong to the "master race" – one also had to be "Aryan." Even worse, the "Alpine" race that colonized Brazil had intermingled with Blacks and Amerindians, condemning their people to extinction. According to anthropologist Charles Wagley:

> Following the prevalent "scientific thought" of nineteenth and early twentieth century Europe and the United States, it seemed clear to Brazilian intellectuals (and to many not so intellectual) that Brazil was doomed to an inferior status among nations by two immutable conditions. These were the racial inferiority of the Negro and the Indian, and of the mixed offspring of these darker races with the European. Even the darker European Mediterranean from which the Portuguese derived were considered inferior to the lighter Nordic northern European. Furthermore, this nineteenth-century "scientific thought" which carried over into the twentieth century stressed the enervating influence of the tropical climate.... Both racial origin and climate seemed to condemn Brazil to second-rate status (Wagley 1979, 2).

Disheartened, many Brazilian intellectuals became pessimistic about their country's future, believing that racial mixture and the presence of Africans and their descendants in Brazil condemned them to an inferior role in the world. Those intellectuals included Nina Rodrigues and the historian José Capistrano de Abreu. Influenced by the Social Darwinism of Herbert Spencer and Auguste Compte, and the historiographic efforts of Henry Thomas Buckle and Hippolyte Taine, Capistrano de Abreu believed that racial diversity had had a devastating effect on the social body that would be very difficult to overcome. Even so, he came to an optimistic conclusion: the power of patriotism and nationalism would overcome the "dissolving, centrifugal forces" of a mixed-race nation (2000, 80).

In his posthumously published work *Os africanos no Brasil* (The Africans in Brazil), Raimundo Nina Rodrigues clearly stated his nationalistic version of scientific racism and climatic determinism:

> The scientific criterion of the inferiority of the Black race has nothing in common with its revolting exploitation by the slaveholding interests of the Americans. For science, this inferiority is nothing more than a phenomenon of a perfectly natural order, the product of the uneven march of the phylogenetic development of humanity in its various divisions or sections [...]. *The Black race in Brazil, however great its undeniable services to our civilization, however justified the sympathies that surrounded the revolting abuse of slavery, no matter how great the generous exaggerations of its sycophants, will always constitute one of the factors of our inferiority as a people.* In the trilogy of the intertropical climate inhospitable to whites, which plagues this country's vast expanse; the black, who barely civilizes himself; the conventional and unprogressive Portuguese, two circumstances give the second greater prominence: strong hands, compared with whites, lent them by the tropical climate, the vast extent of miscegenation that, *handing the country over to mixed-race people, will end up depriving it, for a long time at least, of the supreme direction of the white race. And this was what guaranteed civilization in the United States* (Rodrigues 2004, 19-21; emphasis added).

Therefore, the ideology of whitening through racial mixture and encouraging European immigration can be seen as a direct result of the acceptance and assimilation of Gobinism, Social Darwinism, climatic determinism and other "isms," mainly racism – as an ideology of the superiority of "white race" and the inferiority of "non-whites," even when, in the words of Nina Rodrigues, "we need not hide the lively sympathy that the black Brazilian inspires in us" (Ibid., 19).

Black vindicationism
Going against the pessimism of Nina Rodrigues and most of the Brazilian intellectuals of his time, Manuel Querino became part of the

illustrious tradition of Black vindicationism – Black and White authors who defended Black people at a time when racism prevailed in the worlds of science, academia and politics. It started out as a tactic used by proponents of abolitionism – for example, in 1848, the Quaker abolitionist Wilson Armistead published *A Tribute for the Negro: Being a Vindication of the Moral, Intellectual, and Religious Capabilities of the Colored Portion of Mankind; With Particular Reference to the African Race*. In addition to highlighting the qualities and capabilities of Black people, the book is illustrated with respectable and dignified portrayals of Africans and Afro-descendants, including portraits of illustrious figures such as Olaudah Equiano, Toussaint L'Ouverture, Cinque (the leader of the rebellion aboard the slave ship *Amistad*), Frederick Douglass and others less known today, such as Jan Tzatzoe, a Christian leader from South Africa, and the pastor and former slave James W. C.Pennington. In contrast to the images of these men, most of them dressed in clothes considered elegant by the European standards of their time (Equiano also holds a book in his hand), there are two pictures depicting scenes from the slave trade in Africa and New Orleans in which the captives are almost naked.

One of the greatest Black vindicationists, who combated Gobineau's theories in the homeland of the "father of scientific racism," was the Black Haitian intellectual Anténor Firmin (1850-1911). The author of *De l'egalité des races humaines* – a direct challenge to Gobineau's *Essai sur l'inegalité des races humaines* – Firmin observes that "All men are endowed with the same qualities and the same defects, regardless of color or anatomical form. The races are equal" (Firmin 2002, 450). His work is a response to scientific racism – using what he called "positivist anthropology" – and even suggests that miscegenation, or *métissage*, would lead to a "positive eugenics" of the human race. Firmin cites the example of Alexandre Dumas and rejects suggestions that being of mixed race (or mulatto) would explain the neuroses of the French author – whose genius is undeniable – comparing him with Byron and with the French poet and novelist Alfred de Musset, whose neuroses were, in Firmin's view, even more

extreme. Until the early 2000s, the Haitian scholar and his work were forgotten outside his homeland, but thanks to the work of the American lecturer Carolyn Fluehr-Lobban, *De l'egalité des races humaines* was translated into English by Asselin Charles and published for the first time in New York in 2002 by the University of Illinois Press.

The first scholar to publish a book on the African contribution to Brazilian civilization that debunks scientific racism was a white sociologist and physician from Sergipe, Manoel Bomfim, the author of *A América Latina, males de origem* (Latin America, Original Evils, 2005), written in 1903. Later, another white Brazilian intellectual would reject the supposed superiority of the Aryan postulated by Gobineau, Vacher de Lapouge and others. He was Alberto Torres, a politician from Rio de Janeiro, who published his views in *O problema nacional brasileiro* (The Brazilian National Problem, 1914, 50 et seq.). However, the overwhelming majority of Brazilians at the time who studied the "Black question," such as Euclides da Cunha, Braz do Amaral, Sílvio Romero and especially Nina Rodrigues, bowed to European racialist thinking and were influenced by the fact that they belonged to an elite of European descent amid a slavocracy that endured until 1888.

Manoel Bomfim's work was overlooked for nearly a century, until Ronaldo Conde Aguiar published a biography of that pioneering intellectual, *O rebelde esquecido* (The Forgotten Rebel) in 2000, and repeated an important question:

> Why, after all, is Manoel Bomfim not mentioned? The question comes from Vamireh Chacon, who attributed the silence that overwhelmed the Sergipe sociologist to "reactionary philistinism, and his brother, pseudo-revolutionary philistinism." Aluizio Alves Filho allowed that Manoel Bomfim's own discourse had led him to be forgotten. "We are not deceived," he observed. "Manoel Bonfim is not just a forgotten essayist; more than that: *he is part of a narrative they seek to silence"* (2000, 59).

Aguiar's final observations regarding Bomfim are also an apt description of Manuel Querino's life and work.

O colono preto

Manuel Querino vindicated and enhanced the image of Blacks in Brazil at a time when the study of Africans and their culture was considered of no value whatsoever. As an author, educator and scholar, he won the respect of his contemporaries in Bahian society and tried to use his status to communicate a message that few of his contemporaries – white or Black – could convey. According to E. Bradford Burns:

> Certainly one of Querino's chief contributions to Brazilian historiography was his insistence that national history take into account its African background and the presence and influence of the Blacks. Brazil, he emphasized, was the result of a fusion of the Portuguese, Indian, and African, but the contributions of the Africans had gone unheralded (1993, 321).

In this, Querino was following the line of thinking of Karl Philipp von Martius (1794-1868), a German botanist and explorer who arrived in Brazil in 1817. Von Martius expressed his ideas in a paper entitled "Como se deve escrever a história do Brasil" (How the History of Brazil Should be Written), which won a competition and was published in the *Revista do Instituto Histórico e Geográfico Brasileiro*, the journal of the Brazilian Historical and Geographic Society, in 1845. Although he stressed and prioritized the Portuguese element in Brazil's singular convergence of the races, Martius warned: "It would certainly be a tremendous mistake, based on all the principles of pragmatic history, if the strengths of the indigenous people and imported Blacks were disregarded; strengths that equally contributed to the physical, moral and civil development of the entire population" (1981, 87).

Querino stressed these contributions in *O colono preto como factor da civilização brasileira* (The African Contribution to Brazilian Civilization), published in 1918, in which he also pointed out the major role that Afro-Brazilians played in the defense of Brazil and the

preservation of its national integrity. In his article "Manuel Querino's Interpretation of the African Contribution to Brazil" (1974), Burns included an English translation of the final pages of *O colono preto*. According to the American historian:

> His historical studies had a twofold purpose. On the one hand, he wanted to show his fellow Blacks the vital contribution they had made to Brazil, while, on the other, he hoped to remind the white Brazilians of the debt they owed Africa and the Black (1974, 82).

Burns also paid special attention to Querino and *O colono preto* in his book *A History of Brazil*:

> It abounded with insights, many of which later scholarship adopted and expanded – so much so that it is now difficult to appreciate the originality of Querino when he first suggested them. Subsequent scholars have emphasized, for example, that Africa provided the skilled and unskilled labor for Brazil. However, the essay suggested other significant contributions of the Blacks on which historians have yet to dwell. For example, Querino assigned the Black a principal role in the defense of Brazil and the maintenance of national unity (1993, 321-322).

Querino emerged as one of the first Brazilians and possibly the first Afro-Brazilian to confront the pseudo-scientific racism of Gobineau and Herbert Spencer that had been disseminated in Brazil by Nina Rodrigues, among others.[6] He also used Social Darwinism to his own ends, an example of what Schwarcz describes as "the originality of Brazilian racial thought that, in its effort to adapt, updated what was agreed and discarded what was in some way problematic for the

[6] As we have seen, the first Black intellectual to contest Gobineau's theories directly in France was the Haitian anthropologist Anténor Firmin. Even when defending "the Blacks," Querino considered himself "mixed-race," but others, like the Black sociologist Edison Carneiro, describe him as "Black" (1964, 107).

construction of a racial argument in the country" (1993, 19). Although he wrote that Africans were "unevolved," he saw in his own example and those of other eminent Black Bahians, whose lives he recorded, that when people of African descent were respected and properly educated, their socioeconomic development was guaranteed.

O colono preto is a forceful response to the ideology of Gobineau and other proponents of scientific racism. In it, Querino underscores not only the knowledge that the Africans brought to Brazil as "colonists" and their contribution to that country's development but also compares the "African Spartacans" to Greek slaves in ancient Rome, noting that:

> Greek slaves were educated, both in public games and in literature, advantages that the enslaved Africans in the Americas did not manage to possess, because the rigor of captivity, which did not allow the least mental preparation, dulled their intelligence (Querino 1938, 148-149).

For Querino, the Quilombo de Palmares, Brazil's most famous maroon settlement, was the "Black Troy," and he praised the *quilombolas* (maroons) as follows:

> The Greek or Roman slaves, when abandoning their masters, did not consider organizing themselves into a regular society in a territory they might have taken over; they were always wandering [alone] or in bands given to pillage.
>
> The devastation the Roman slaves pioneered inspired terror in all who heard of their approach. The founders of Palmares did otherwise; they sought refuge within the virgin forests, and there they laid the foundations of a society, an imitation of those which predominated in Africa, their homeland, a society, moreover, more advanced than the indigenous organizations (Ibid., 149).

This comparison between "Greek or Roman slaves" and enslaved Africans is of paramount importance. Even today, ancient Greece and

Rome are considered the cradle of European civilization. Using the principles of Social Darwinism, Querino suggests that, since Africans were also in the "evolutionary stage" of slavery, Africa, in turn, could be viewed as a cradle of Brazilian civilization.

To bolster that argument, in his introduction to *A raça africana e os seus costumes na Bahia*, Querino quotes Rocha Pombo, suggesting that the Quilombo dos Palmares had introduced the concept of the Republic in Brazil: "Who could have thought that these men, who lacked schooling but were only guided by their observations and by freedom, were the first in Brazil to found a republic, when certainly, in those days such a form of government was unknown and not even spoken of in that country?" (Ibid., 23). In this, Africans and their descendants could be compared to the Ancient Romans.

Soldiers and citizens

As we have seen, Querino stressed the role of Blacks in the defense of Brazil and the preservation of its national integrity. During his time in the army, he could witness the Blacks' contributions first-hand, even those of the Capoeira fighters, Zuavos Baianos and other "Volunteers of the Nation" in the War of the Triple Alliance against Paraguay. This emphasis of the contribution to Brazilian history made by Africans and their descendants is part of the tradition of Black vindicationism and has precedents in the United States. the African American Civil War veteran George Washington Williams underscored the contributions of Blacks in his two-volume work *History of the Negro Race in America from 1619 to 1880. Negroes as Slaves, as Soldiers, and as Citizens,* published in 1892, after publishing *A History of the Negro Troops in the War of Rebellion, 1861-1865 (The North's Civil War)* in 1887.

In an 1894 essay whose title, "The White Problem," inverts the conventional focus on "the Black problem," Richard Theodore Greener, the first African American to attend Harvard University, gives several examples of unsung and legendary African Americans who were soldiers and warriors, including the Blacks who fought in the French and Indian War and (without mentioning his name),

Crispus Attucks, the first "martyr" of the American Revolution, killed in the Boston Massacre in 1770:

> [The Negro] was on the heights of Abraham with Wolfe; in the French and Indian wars with Braddock; the first martyr of the Revolution; is seen in Trumbull's picture retreating with the patriots from Bunker Hill, musket in hand; Washington did not disdain to share a blanket with him on the cold ground at Valley Forge; at the South with Marion and Greene; at the north with Washington and Gates, with Wayne and Allen. On account of the injury to the United States through him, the war of 1812 was begun, and his fertile brain suggested the defense of New Orleans.... No sneer of race, no assumption of superiority, no incrusted prejudice will ever obscure this record, much less obliterate it, and while it stands, it is the Negro's passport to every right and privilege of every other American (Sollors et al. 1933, 44).

Both in the United States and Brazil, war offered opportunities for freedom and citizenship to enslaved Blacks – general abolition in the US and individual manumission in Brazil. The Civil War, begun in 1861 and hard fought until 1865, was the bloodiest conflict ever waged on American soil. It gave rise to traumas and ideologies that persist to this day, particularly in the form of the Confederate flag, which is considered a racist and even separatist symbol, but is still flown with pride by many white Southerners. During the 9 January 2021 insurrection, it was carried inside the US Capitol for the very first time.

For large numbers of free and formerly enslaved Blacks, the battlefield provided an opportunity to demonstrate not only their civic virtue but their courage – debunking racial stereotypes set forth by Gobineau and Lapouge who, as we have seen, claimed that physical courage in battle was exclusive to "Aryans," who were considered more "courageous" and "warlike." Over 180,000 African American men, including two sons of the abolitionist freedman and author Frederick Douglass, enlisted in the 54th Regiment of the State of

Massachusetts, made up of Black soldiers led by a white officer, Colonel Robert Gould Shaw.[7]

The Black writer and leader Martin Robison Delany helped mobilize that regiment and its counterparts in other states, and was the first African American to obtain a recruitment contract to enlist US troops. Delany's idea was to form a *corps d'Afrique* like the Zouaves, the fearsome French troops that fought the Algerians in North Africa and wore a distinctive costume: Arab jackets, waistcoats, waistbands, baggy trousers (sirwal) and fezzes. From the beginning, Delany had a leading role in mind for Blacks in the Civil War.[8] Although his idea never came to fruition, the same concept was carried out in northeastern Brazil, in the form of the Zuavos Baianos who fought on the Paraguayan front in the War of the Triple Alliance (Ibid.).[9]

Waged between 1864 and 1870, that conflict decimated Paraguay's male population.[10] As we have seen, the need to send more troops to the front when volunteers were scarce led to the enforced recruitment of Manuel Querino himself. For enslaved Blacks, the war presented an opportunity to gain their freedom, albeit on an individual basis and taking enormous risks, because – as Querino observed in *A*

[7] The story of this regiment entered popular culture through the film *Glory* (1989), starring Matthew Broderick, Morgan Freeman and Denzel Washington. Frederick Douglass appears in just two scenes in the film, portrayed by Raymond St. Jacques, but the plot omits his sons' participation. The monument to the regiment that appears at the end of the film, when the credits roll, is now in the National Gallery of Art in Washington, DC. Directed by Edward Zwick, the film is considered a pioneer in the positive portrayal of the history of Black people in American cinema.

[8] A regiment of white volunteers called the "Duryée's Zouaves" was formed in New York and became some of the most renowned soldiers of the Civil War (Ethan J. Kytle, "Trading an African Dashiki for Union Blue," *NY Times*. Accessed 30 June 2020 <http://opinionator.blogs.nytimes.com/2013/10/04/trading-an-african-dashiki-for-union-blue/?smid=pl-share>.)

[9] See also Hendrik Kraay, "Os companheiros de Dom Obá: os Zuavos baianos e outras companhias negras na Guerra do Paraguai." In: *Afro-Ásia*, 46 (2012), 121-161; Eduardo Silva, *Dom Obá II d'África, o príncipe do povo*: vida, tempo e pensamento de um homem livre de cor. São Paulo: Companhia das Letras, 1997.

[10] See, for example, Jeffrey L. King. *The Forgotten Conflict: The Paraguayan War of 1864-1870*. Oregon, Wisconsin: CSJ King Publishing, 2011 (Kindle edition).

Bahia de outrora – many never returned, and those who did, came back without a limb (Querino 1922, 165).

Nevertheless, the conflict also gave them a chance to prove their courage under fire. In the section entitled "A Bahia e a campanha do Paraguai" (Bahia and the Paraguay Campaign), Querino quotes a parody of the song "Gigante de Pedra" (Stone Giant). Dedicated to the Zuavos Baianos, it observes: "After large waves of volunteers, the first shipments of contingents of national guards followed. Fortunately, Bahia's act of patriotism was highly productive, as other provinces followed its example" (Ibid., 157).

Biographies of illustrious Black men

According to David Brookshaw, Querino attempted to "parry the blow of the establishment ethnologist Nina Rodrigues, defending Blacks and exalting their qualities" (Brookshaw 1983, 55). For example, Querino wrote biographies of Black men to provide illustrious role models and debunk stereotypes, including his own story as a self-made man, following the example of other leaders and intellectuals in the Black diaspora who started out with nothing but their own intelligence and drive.[11]

The first known biography of Querino appears in the foreword to one of his best-known works, *A Bahia de outrora*. Penned by J. Teixeira Barros[12] and dated May 1916, that biographical essay stresses the author's background: "Manuel Raimundo Querino was born in a humble but hardworking and honorable family on 28 July 1851, in the

[11] Querino also used images of Black people to combat negative stereotypes (Sabrina Gledhill, "Representações e respostas: táticas no combate ao imaginário racialista no Brasil e nos Estados Unidos na virada do Século XIX." *Sankofa*, v. IV (2011), 44-72 <http://sites.google.com/site/revistasankofa/sankofa-07/representacoes-e-respostas>, including his own portraits (see Chapter 9).

[12] José Teixeira Barros (1863-1933) was a journalist and writer. A member of the Geographical and Historical Institute of Bahia (IGHB), along with Querino, he was also a militant abolitionist. In his biographical essay on Querino, the preface to *Bahia de Outrora*, he observes, "We met Manuel Querino in 1887, when the abolitionist campaign was most fervent, and in one of the sessions of the Sociedade Libertadora Baiana, gathered in the newsroom of *Gazeta da Tarde*[...] (Barros 1922, . iii).

neighboring town of Santo Amaro, in this state" (Barros 1922, iv). Teixeira Barros also makes a point of setting forth the factors and aspects of Querino's rise from painter-decorator to educator and writer – his studies, awards, professional, teaching and political activities – and ends with a list of the works published up to that date, noting that another book by Querino, *Costumes africanos*, "a work of a certain magnitude and which will highly recommend the author to public appreciation and the applause of the competent," was being readied for publication (Ibid., vii).

In his book *Artistas bahianos* (1911), a work that art historian Luiz Alberto Ribeiro Freire (2006 and 2010) compares with Vasari's *Lives* (see Chapter 5), Querino took pains to retrieve the life stories of eminent artists and artisans – white, Black and *mestiço* – from the state of Bahia, as well as including his own autobiography. One of his last works was a biographical article about the Black intellectual, poet and musician João da Veiga Murici, published in 1922 in the second edition of *A Bahia de outrora,* and later, in 1923, in the *Revista do Instituto Geográfico e Histórico da Bahia* (no. 48), entitled "Um baiano ilustre – Veiga Muricy" (An Illustrious Bahian – Veiga Muricy).

In an essay published along with two biographical articles by Querino that appeared in the *Revista do Instituto Geográfico e Histórico da Bahia*, Waldir Freitas de Oliveira, questions why Querino chose Veiga Murici as the subject of a biography. He reaches the following conclusion:

> All indications are that Manuel Querino's decision to devote a chapter of his book *A Bahia de outrora* to [Veiga Murici] arose from his condemnation of a social status which maintains inequality that, while privileging the rich, despised the poor without taking into account how much knowledge they possessed.
>
> Looking back on his own life story, Manuel Querino must then have felt a duty to exalt the memory of someone who had struggled in the past as he himself had done, overcoming great difficulties to make a living, with nothing but

his knowledge and his intelligence as weapons in that battle (2009, 210).

Oliveira argues that both men died poor and underscores the fact that Querino was buried in a "simple wall crypt in Quinta dos Lázaros cemetery" (Ibid.). However, he overlooks the fact that Querino's remains were later transferred to a much more prestigious resting place – the sacristy of the Church of Nossa Senhora do Rosário dos Homens Pretos, where they lie to this day.

Thanks to Querino himself, we know that Veiga Murící was also Black. In addition to being an intellectual and musician who took part in the Sabinada rebellion, considered a harbinger of abolitionism and, in a way, the drive to make Brazil a republic,[13] there are other reasons for thinking that the biographer must have identified with his subject. Querino's activism extended to militant journalism. He founded two newspapers that respectively supported abolitionism and the workers' movement, as well as publishing articles condemning the persecution of Afro-Brazilian religious communities in other periodicals. According to Tavares, Murící used the newspaper O *Philopatro* to publish the ideals of the Sabinada, stating that:

> the revolution was immediately against the regent Pedro de Araújo Lima, the centralization and administrative and political submission of Bahia to Rio de Janeiro. But it was no longer opposed to the constitutional monarchy and, much less, to the heir to the throne, the almost boy prince Dom Pedro de Bragança. Abandoning the republican position, the November 7 revolution condemned the aristocracy and supported the abolition of slave labor without presenting any proposal for achieving it (2008, 266).

As Freitas observes, Murící, like Querino, suffered injustice and was passed over for promotion, both in politics and as a civil servant.

[13] As Tavares observes, "The federative ideal [of the Sabinada rebellion] awaited the end of the constitutional monarchy to reappear in association with the Republican movement" (2008, 266).

However, given the fact that Murící was included in the list of illustrious deceased Black man published in *O colono preto,* we can go even further and posit that Querino wanted to demonstrate that, in nineteenth-century Brazil, there were Black intellectuals who did not fit the stereotype of illiteracy and ignorance associated with their 'race.' In part, Querino's efforts were successful. Pedro Calmon based his entry on Murící in his *História da Literatura Bahiana* on Querino's biography, mentioning Murící no less than three times in the chapters on grammarians, philosophers and minor poets. In a footnote citing Querino, Calmon observes: "A teacher, musician and both philosopher and grammarian (1806-1890), [Murící] participated in the Sabinada and published, in addition to the *Curso abreviado da filosofia, 1846, Reflexões gramático-filosóficas* in 1858, [and] *Pontuação arrazoada,* 1864" (Calmon 1949, 140).

However, it is important to note that, in his article on Murící, Querino never mentions the color of his subject's skin. That may be because he considered it a well-known fact. In any event, had it not been for the observation that Querino himself made in *O colono preto,* many today would not know that João da Veiga Murící was an *"homem de cor preta"* (Black man) – all the more so because his name did not appear in Querino's article "Os homens de cor preta na História."

In the unsigned introduction to Querino's article published in the *Revista do Instituto Geográfico e Histórico da Bahia,* possibly penned by Bernardino de Souza, the institute's secretary for life, we are told that Murící was "a man of high intellectual caliber, whose reputation in the small circle of the province and this city [Salvador], associated him with a spirit of deep classical culture, especially with regard to the Portuguese, Latin and Greek languages and their respective literatures" and that his "teacher of Greek and rhetoric" was "the renowned royal professor Francisco Ferreira Paz da Silveira. [Murící] taught French, Latin, Portuguese, Greek and, especially, rational and moral philosophy" (Nascimento and Gama 2009, 219-220).

Querino underscores Murící's work as an educator and his patriotism, observing that teaching gave him "the means for a good

living, which also enabled him to refresh his soul by cultivating poetry and music." Murící improved his own political education as a member of the Literary Institute's Portuguese Classical Library Society, and it was his "patriotic ardor" that led him to take part in the Sabinada. He was a "second-lieutenant in the militia" and proud of his rank, even in the final days of his glorious existence." He was known in intellectual circles for his "profound and solid knowledge" and his "proud character."

Querino goes on to observe that "Such noble attributes were the source of the envy and persecution that [Murící] heroically endured until he was overcome by heartbreak, injustice and the weight of his years." Murící died "after eighty-four years of an exuberant existence of triumphs and full of disappointments and disillusionments. Such is the life of the great men who live by their country and for their country" (Ibid.).

What better way of confronting the "pessimism" of Gobineau, Nina Rodrigues and others regarding the intellectual, moral and rational endowments of Black and mixed-race people, than to use such examples: Black role models who, in Pedro Calmon's words referring to Manuel Querino, "dissipate, with their personal example, prejudices about the inferiority of the race" (Calmon 1949, 154).

"Black Men in History"

Issue no. 48 of the *Revista do Instituto Geográfico e Histórico da Bahia*[14] also contains an article by Querino entitled "Os homens de cor preta na História" (Black Men in History), which provides biographies – in some cases, very brief ones, containing just three lines – of thirty-eight prominent men of African descent: doctors, soldiers, priests, revolutionaries, lawyers, musicians and educators, one of whom was Emigdio Augusto de Mattos, who died when he was in his third year of Civil Engineering at the Escola Politécnica do Rio de Janeiro. According to Querino, "During the last period of the monarchy, most primary school teachers in this city and its outskirts were Black men.

[14] *Revista do Instituto Geográfico e Histórico da Bahia*, no. 48 (1923) pp. 353-363.

Their contemporaries nostalgically recall those friends of their childhood" (Nascimento and Gama 2009, 191).

Querino also lists several Black officers (lieutenants and second-lieutenants), including – as Bacelar observes – Manuel Gonçalves da Silva, "The officer who assumed command of the arms and government of the province after the assassination, in 1824 [during the Revolt of the Periquitos], of Colonel Felisberto Gomes Caldeira," a hero of Bahian Independence (Ibid.). According to Hendrik Kraay:

> Contemporaries hailed Gonçalves as 'the new Henrique Dias' in their accounts of the victorious patriots' march into Salvador and effusively praised individual Black officers. After a harrowing night-time escape from Salvador in May 1823, the anonymous diarist was much relieved to surrender to 'the admirable Captain Neves, a valiant man of much courage.' 'And [of] Black color,' he added as an afterthought (Kraay 2001, 135).

The participation of Blacks on the other side of the Revolt of the Periquitos, which Lieutenant Colonels Gonçalves and Neves helped suppress,[15] is a fact recognized by other scholars and was used as a pretext for excluding Black soldiers from the Bahian garrison. According to Kraay, "the repression assumed racial connotations with the removal of Black and ex-slave soldiers from Salvador" (Ibid., 132), leading to

> ...nothing less than a wholesale racial purge of the patriot army's remains. It was also strikingly effective: A list of 366 deserters from Bahian battalions during twenty-seven months from 1825 to early 1827 records but fifteen Blacks among 275 pardos, eight cabras, four caboclos and sixty-four whites, a far cry from the 90 percent Black rank and file of which the

[15] Kraay notes that the class divide between Neves, who, although possibly a freedman and "married to an African freedwoman," was a "slave-owning artisan," and the "soldiers in the Henriques from the plebeian rank and file in the rebellious Periquitos battalion" may explain why he did not feel any compunction in suppressing an uprising involving "a battalion of freedmen" (2001, 138-139).

president had complained in 1824. These numbers reveal the results of a deliberate effort to restore the distinction between mulattoes and Blacks. Free or freed Blacks might serve in the army, but they would have to endure 'the delights of the cold in Montevideo,' as one commentator dryly remarked on the fate of the Periquitos. They would not serve in Salvador's garrison (Ibid., 133).[16]

Although Querino does not give the dates of birth and death of most of the eminent Black figures he lists, most lived in the nineteenth century. In his efforts to give Blacks more visibility, the Bahian intellectual was following the example of the nineteenth- century Black press, which sought to showcase illustrious people "of color" as positive role models for Black people, while seeking to combat the stereotypes that surrounded them in Brazil in their day and persist in the here and now.[17] According to Jeferson Bacelar:

> Long before some perspectives of the militancy of the contemporary Black movement came into being, he [Querino] *reacted to the invisibility of Blacks in Brazilian history* and tried, through the inclusion of illustrious characters, to build a new pantheon, in addition to the established (white) historical subjects. He differed from the contemporary historiographical perspective that generally considered Blacks as a group – especially in the condition of a slave – and was unaware of their individual presence in the constitution of society.[18]

[16] See also Hendrik Kraay, "'Em outra coisa não falavam os pardos, cabras, e crioulos': o 'recrutamento' de escravos na guerra da Independência na Bahia," *Revista Brasileira de História*, v. 22, no. 43 (2002), 120.

[17] According to Ana Flávia Magalhães Pinto, the Pernambuco weekly *O Homem: Realidade Constitucional ou Dissolução Social* was first published in Recife on January 13, 1876 and the March issue published that same year contained a section entitled "Galeria de Homens de Cor Ilustres" (Gallery of Illustrious Men of Colour), which was "mainly aimed at exalting Black figures in Brazilian history, which is part of the work to strengthen that community" (Pinto 2006, 98).

[18] Jeferson Bacelar, De candomblés a negros ilustres. Nascimento and Gama (eds.), *Manuel R. Querino, seus artigos na Revista do Instituto Geográfico e Histórico da Bahia*. Salvador: Instituto Geográfico e Histórico da Bahia, 2009, 177-183, 181 (emphasis mine).

Querino also stressed other contributions made by Afro-Brazilians in *O colono preto como factor da civilização brasileira* (1918) and several other works. In *O colono preto,* for example, he provides the following list of eminent names:

> Without even trying, we can list the Viscount of Jequitinhonha, Caetano Lopes de Moura, Eunápio Deiró, the privileged Rebouças family, Gonçalves Dias, Machado de Assis, Cruz e Souza, José Agostinho, the Viscount of Inhomirim, Saldanha Marinho, Father José Maurício, Tobias Barreto, Lino Coutinho, Francisco Glicério, Natividade Saldanha, José do Patrocínio, José Teófilo de Jesus, Damião Barbosa, Chagas, Cabra, João da Veiga Murící and many others, *to mention only those who have passed away* (Querino 1918, 36, emphasis mine).

In *A raça africana,* Querino gives the example of Black priests observed by Father Vieira in Cape Verde in the seventeenth century: "Here there are clerics and canons as Black as jet, but so poised, so authoritative, so learned, such great musicians, so discreet and good-tempered that they excite the envy of those we see there in our cathedrals."[19] On that basis, Querino notes that "Based on the above, we must conclude that only a lack of education has destroyed the value of the African people" (Ibid., 23).

As Artur Ramos observed: "We can see how, in his time, Manuel Querino rebelled against the prejudice of the anthropological inferiority of the Blacks, attributing their backwardness to socio-cultural contingencies, and not to racial inferiority" (Querino 1918, 36). In short, Manuel Raimundo Querino was a Black intellectual who rejected, almost entirely, the philosophical and scientific notions that governed the intellectual world of Brazilians in the late nineteenth and early twentieth centuries. In his extensive writings, his vindicationism focused on the contribution of Africans and their descendants to his

[19] "Há aqui clérigos e cônegos tão negros como o azeviche, mas tão compostos, tão autorizados, tão doutos, tão grandes músicos, tão discretos e bem morigerados que fazem invejas aos que lá vemos nas nossas catedrais" (Ibid., 23).

country and could be summed up in his famous phrase: "Brazil has two real claims to greatness: the fertility of its soil and the talent of its mixed-race people" (1938, 160).[20]

Bibliography

Aguiar, Ronaldo Conde. *O rebelde esquecido. Tempo, vida e obra de Manoel Bomfim.* Rio de Janeiro: Topbooks, 2000.

Bacelar, Jeferson. "De candomblés a negros ilustres." Nascimento and Gama (eds.), *Manuel R. Querino, seus artigos na Revista do Instituto Geográfico e Histórico da Bahia,* 177-183. Salvador: Instituto Geográfico e Histórico da Bahia, 2009.

Barros, J. Teixeira. "Manuel Raymundo Querino." Foreword to Manuel Querino, *A Bahia de outr'ora. Vultos e factos populares.* 2nd ed. Bahia: Livraria Econômica, 1922.

Biddiss, Michael D. *Father of Racist Ideology: The Social and Political Thought of Count Gobineau.* New York: Weybright and Talley, 1970.

Brookshaw, David. *Raça & cor na literatura brasileira.* Porto Alegre: Mercado Aberto, 1983.

Burns, E. Bradford, "Manuel Querino's Interpretation of the African Contribution to Brazil." *The Journal of Negro History,* LIX, no. 1 (1974).

———. *A History of Brazil,* 3rd ed. New York: Columbia University Press, 1993.

Calmon, Pedro. *História da literatura bahiana.* 2nd ed. Rio de Janeiro/São Paulo: Livraria José Olympio Editora, 1949.

Capistrano de Abreu, J. *Capítulos de história colonial.* Brasília: Senado Federal, 2000.

Carneiro, Edison. *Ladinos e crioulos. Estudos sobre o negro no Brasil.* Rio de Janeiro: Editora Civilização Brasileira, 1964.

Certeau, Michel de. *A invenção do cotidiano:* artes de fazer. 2nd ed. Petrópolis: Vozes, 2000.

[20] "O Brasil tem duas grandezas reais: a uberdade do solo e o talento do mestiço."

Firmin, Anténor. *The Equality of the Human Races: Positivist Anthropology.* Translated by Asselin Charles. Champaign, Illinois: The University of Illinois Press, 2002.

Freire, Luiz Alberto Ribeiro. "Manuel Querino: o 'Vasari' brasileiro." Lecture given during the "Manuel Querino: Vida e Obra" seminar at the Geographic and Historical Institute of Bahia (IGHB) on 28 August 2008.

————. *A história da arte de Manuel Querino.* Paper presented at the 19th Meeting of the Associação Nacional de Pesquisadores em Artes Plásticas – ANPAP. 20 September 2010, Cachoeira, Bahia, Brazil. Accessed 1 April 2021. <http://www.anpap.org.br/anais/2010/pdf/chtca/luiz_alberto_ribe iro_freire.pdf>

————. *A talha neoclássica na Bahia.* Rio de Janeiro: Versal, 2006.

Gates, Jr., Henry Louis. *Blacks in Latin America.* New York and London: New York University Press, 2011.

————. *Os negros na América Latina.* São Paulo: Companhia das Letras, 2014.

Gledhill, Sabrina. "Afro-Brazilian Studies before 1930: Nineteenth-Century Racial Attitudes and the Work of Five Scholars." Latin American Studies MA Comprehensive Examination Paper, UCLA, 1986.

Gobineau, Joseph Arthur Compte de. "L'émigration au Brésil." *Le Correspondant*, no. 96, 1874.

Ianni, Octávio. "Research on Race Relations in Brazil." Magnus Mörner [ed.]. *Race and Class in Latin America.* New York/London: Columbia University Press, 1970.

King, Jeffrey L. *The Forgotten Conflict: The Paraguayan War of 1864-1870.* Oregon, Wisconsin: CSJ King Publishing, 2011 (Kindle edition).

Kraay, Hendrik. *Race, State, and Armed Forces in Independence-Era Brazil: Bahia, 1790s-1840s.* Stanford: Stanford University Press, 2001.

————. "'Em outra coisa não falavam os pardos, cabras, e crioulos': o 'recrutamento' de escravos na guerra da Independência na Bahia." *Revista Brasileira de História,* v. 22, no. 43 (2002).

————. "Os companheiros de Dom Obá: os Zuavos baianos e outras companhias negras na Guerra do Paraguai." *Afro-Ásia*, 46 (2012): 121-161.

Martius, Karl Friedrich Philipp von. "Como se deve escrever a história do Brasil." *Revista Trimensal de História e Geografia ou Jornal do Instituto Histórico e Geográfico Brasileiro*, no. 24 (1845). From J.B. Spix & C.F.P. Martius, *Viagem pelo Brasil*. Belo Horizonte: Itatiaia, 1981.

Mendonça, Renato. "O negro e a cultura no Brasil: Breve histórico dos estudos afro-brasileiros de linguística, etnografia e sociologia." *O negro no Brasil. Trabalhos apresentados ao 2o Congresso Afro-Brasileiro (Bahia)*. Ed. Edison Carneiro and Aydano do Couto Ferraz. Rio de Janeiro: Civilização Brasileira S.A., 1940.

Meréje, Rodrigues de. *O problema da raça*. São Paulo: Editorial Paulista, n.d. [1934].

Nascimento, Jaime; Gama, Hugo (eds.). *Manuel R. Querino, seus artigos na* Revista do Instituto Geográfico e Histórico da Bahia. Salvador: IGHB, 2009.

Ortiz, Renato. *Cultura brasileira & identidade nacional*. São Paulo: Editora Brasiliense, 1985.

Ott, Carlos. "Noções sobre a procedência d'arte de pintura na Província da Bahia." *Revista do Patrimônio Histórico e Artístico Nacional,* vol. 11, Rio de Janeiro, 1947.

Pereira, Gonçalo de Athayde, *Prof. Manuel Querino. Sua vida e suas obras*. Bahia: Imprensa Oficial do Estado, 1932.

Pinto, Ana Flávia Magalhães. De pele escura e tinta preta: a imprensa negra do século XIX (1833-1899). Dissertation (MA in History), Universidade de Brasília, 2006.

Querino, Manuel. *O colono preto como factor da civilização brazileira*. Bahia: Imprensa Official do Estado, 1918.

————. *Costumes africanos no Brasil*. Foreword and annotations by Artur Ramos. Rio de Janeiro: Civilização Brasileira, 1938.

Raeders, Georges (ed.). *D. Pedro II e o Conde de Gobineau (Correspondência Inédita)*. São Paulo, Rio de Janeiro, Recife, Porto Alegre: Companhia Editora Nacional, 1938.

Rodrigues, Raimundo Nina. *Os africanos no Brasil.* 8th ed. Brasília: Universidade de Brasília, 2004.

Schwarcz, Lília Moritz. *O espetáculo das raças. Cientistas, instituições e questão racial no Brasil 1870-1930.* São Paulo: Companhia das Letras, 1993.

————. *The Spectacle of the Races: Scientists, Institutions, and the Race Questions in Brazil, 1870-1930.* Translated by Leland Guyer. New York: Hill and Wang, 1999.

Silva, Eduardo. *Dom Obá II d'África, o príncipe do povo: vida, tempo e pensamento de um homem livre de cor.* São Paulo: Companhia das Letras, 1997.

Skidmore, Thomas E. *Black into White: Race and Nationality in Brazilian Thought.* New York: Oxford University Press, 1974.

————. *Preto no branco: Raça e nacionalidade no pensamento brasileiro.* Translated by Raul de Sá Barbosa. Rio de Janeiro: Paz e Terra, 1976.

Sollors, Werner, et al. (eds.) *Blacks at Harvard: A Documentary History of the African-American Experience at Harvard and Radcliffe.* New York: NYU Press, 1993.

Tavares, Luís Henrique Dias. *História da Bahia.* 11th ed. Salvador/São Paulo: Edufba/UNESP (FEU), 2008.

Torres, Alberto. *O problema nacional brasileiro: introducção a um programa de organização nacional.* Rio de Janeiro: Impr. Nacional, 1914.

Wagley, Charles. "Anthropology and Brazilian Nationality." Maxine L. Margolis & William E. Carter (eds.), *Brazil: Anthropological Perspectives*, 1-18. New York: Columbia University Press 1979.

3. JOURNALIST AND POLITICIAN

Jorge Calmon[1]

This essay is an attempt to reconstruct the activities carried out during the life of a man who was keenly aware of the realities of his time and did his utmost, as far as his strength and intelligence permitted, for his people and their culture. He was active in fields as varied as politics and the arts, journalism and folklore, the labor movement, ethnology, education and handicrafts.

Clearly, the aim here is not the pure and simple exaltation of Manuel Querino; nor is this work intended to be purely biographical. The intention, certainly, is to produce a critique of his work – in short, an analysis of his relationship with the circumstances of his time and the subjects he studied: an analysis that could place him within the historical-cultural framework of a time marked by the transformations that were taking place in the life of Bahia.

However, there is no harm in recalling, albeit briefly, the character of the man whose activities we are reconstructing. It might even help us gain a better understanding of what motivated his actions.

Manuel Raimundo Querino was born in the town of Santo Amaro on July 28, 1851. His parents were the carpenter José Joaquim dos Santos Querino and Luzia da Rocha Pita, who died when he was just four years old,[2] both victims of the cholera epidemic that

[1] Originally published as "Manuel Querino, o jornalista e o político" by the Centro de Estudos Afro-Orientais – CEAO da Universidade Federal da Bahia in May 1984, Série Ensaios/Pesquisas no. 3.

[2] There are different views on this point. Col. J. Leitão says that Querino's parents died in the epidemic (In *A Manuel Raymundo Querino: Homenagem dos seus admiradores e amigos no 30º dia do seu falecimento*, Bahia, 1923, 1). However, Gonçalo de Athayde Pereira says that only his father died of cholera in 1855 (In *Prof. Manoel Querino. Sua vida e suas obras*. Imprensa Oficial do Estado, 1932). Antônio Viana says that "he lost his parents at an early age" (Conferência no IGHB, *Revista*, n. 54), and was orphaned at the age of 13 (Conferência no 1º Congresso Brasileiro de Folclore, *Anais*, Rio, 1952).

decimated that town, "the most scourged in the province" (Amaral 1923, 196), in 1855. The young orphan found a safe haven in the home of a good woman who had befriended his parents, and who later brought him to Salvador. His protector could not have been a woman of means, as the Judge of Orphans assigned him a guardian, Manuel Correia Garcia, a retired teacher from the Normal School. "A cultured man, educated in Europe, cultivator of letters and interested in teaching" (Viana, Rev. IGHB, n. 54), his foster father took his mission seriously. Patiently, he himself (Cel. J. Leitão, op. cit.) taught the orphaned lad to read and write. Some time later, when his ward was old enough, he had him apprenticed as a painter. Thus prepared to make a living, in 1868, when he was 16 or 17, young Manuel Querino decided to try his luck further afield. He traveled to Piauí (Ibid.) in the company of his guardian's nephew.

The times, however, had a different fate in store for him. Recruited to fight in the Paraguayan War, he was sent to Rio de Janeiro to receive military training before going on to the front. However, he stayed on in Rio, where they found him to be more useful in his battalion's clerical division. In August 1870, having risen to the rank of squadron corporal, he asked to be demobilized, relying on the influence of his "godfather," Manuel Pinto de Souza Dantas, to obtain his discharge from the army. As a result, he managed to return to Bahia. He came back with the firm desire to improve himself through study and cultivate the skills he felt he possessed. Working as a painter by day and attending school at night, he studied the humanities at the newly created Liceu de Artes e Ofícios (Arts and Crafts Lyceum), and, later, Design and architecture at the Academia de Belas Artes (Academy of Fine Art). He also found the time to take the Portuguese language classes taught by Carneiro Ribeiro at Colégio 25 de Março.

On his return to Bahia, now a grown man, Manuel Querino discreetly entered politics, impelled by the duty of solidarity with his "godfather," the head of the Liberal Party in that province. He was also one of the first to enlist in the abolitionist campaign. There, his involvement was less discreet. From being an obscure activist, in time

he became a prominent figure in that movement. Of course, he was overshadowed by the major opinion shapers in the campaign: Ruy Barbosa, Lélis Piedade, Augusto Ferreira França, Frederico Marinho de Araújo, Frederico Lisboa, Augusto Guimarães, Pânfilo Santa Cruz, Eduardo Carigé, Cézar Zama, Jerônimo Sodré, Luís Anselmo da Fonseca and others. Working in the background, he did as much as he could in the fight to win over people's consciences. He expressed himself persuasively and vehemently at the sessions of the Sociedade Libertadora Baiana (Bahian Liberation Society) (Mons. Sólon Pereira, in *A M.R.Q. Homenagem dos admiradores e amigos, etc.,* 2). In a series of articles published in the newspaper *Gazeta da Tarde,* owned by Pânfilo Santa Cruz, he exposed the absurdity of slavery, demonstrating the urgent need for redemptive abolition.

Manuel Querino certainly did not figure among the Blacks and men of color who, freed from the bonds of slavery, fought against the campaign for emancipation in the Bahia of his day, forming what Luís Anselmo called "a veritable force against liberty" (Fonseca 1887, 154).

The feelings he nurtured for his racial brethren accompanied him all his life. For Querino,

> Africans were a major element or the greatest factor behind the nation's economic prosperity; they were the active arm and nothing that they could produce was lost. Their ceaseless labor, not infrequently beneath the blows of the whip, became the source of public and private fortunes. A worthy race, scorned [and] exploited [...] by those who lived in idleness, ostentatious luxury and grandeur at the expense of their labor (Querino 1917, 628-629).

While supporting emancipation, Manuel Querino was also concerned with the nascent working class that represented free labor, which the still-slavocratic economy would only accept with great reluctance. He first encountered this problem in 1874, in the course of the events that led to the creation of the Liga Operária Baiana (Bahian Workers' League). He once again focused on that issue in 1885 with the same

drive as before (Cel J. Leitão, op. cit.), making it one of the watchwords of his militant journalism when he founded the newspaper *A Província* [The Province] in 1887, and another gazette, *O Trabalho* [Labor] in 1892 (Viana, Conferência, *Revista do IGHB,* op. cit).

When the Republic was proclaimed, he naturally joined the organizers of the Workers' Party. Thanks to his part in the successes achieved at the time, he saw himself appointed as an "Intendent" in the first municipal legislature of the new regime. He returned to the city council in 1897 and 1899. After that, driven out by politicians, but mainly disillusioned, he turned his attention to a different subject. However, if politics and journalism had lost Manuel Querino – who did not want to lose himself in them – he placed himself at the service of the people's culture, preserved in his detailed and faithful essays.

So far, we have spoken of the life of Manuel Querino, viewed through its most important milestones.

Now, let us briefly look at the kind of man he was: his appearance, his way of being. His portrait hangs in the Historic Institute of Bahia [IGHB].[3] In fact, it was placed there, in its gallery of honor, five years after his death, in recognition of his contributions to the arts and culture and to that institution [see Chapter 9]. This portrait shows us a man with a poised and confident mien, his face slender and well composed, his firm, pensive gaze expressing intelligence and constant curiosity.

The impression the portrait gives us matches the testimony of those who knew Manuel Querino best.

Reginaldo Guimarães remembers him well. This is how he recalls him:

> When I was five or six, my curious eyes noticed his unique style, watching him enter the Caymis' residence, next door to ours, in Rua Direita da Saúde. I did not know who he was – but his different way of being, imbued with nobility and modesty, made a strong impression. I can almost see him now:

[3] [It is no longer part of the IGHB's collection, see Chapter 9 – Ed.]

medium build, well-shaped head, nearly Black in color, neat and modest clothes, a half-smile full of kindness. And above all, those eyes, small and sad, expressing a mixture of bitterness and acceptance. I could never forget those eyes, the heavy, wrinkled hand that caressed my head. It was somewhere around 1922, just before he died (Guimarães 1973, 15).

Antônio Viana recalls that "from his humble birth he brought a simplicity of manner and contact with common things from which he was able to draw surprising attractions [....] He had an affable way of saying the most serious things [...] he was spontaneous and loquacious, sometimes ironic, sometimes harsh in his judgment of the galvanized powers of all times" (Viana, Conferência, *Revista do IGHB,* op. cit.).

Each sneer from an enemy was powerfully countered by that peaceful-looking creature who surprised with the dexterity with which he retaliated against any kind of attack. With the pen, in the rostrum, in a demonstration of physical resistance. Those who knew him with that tiny gait, like waltzing, loose clothes, sparkling eyes, would find in him the unmistakable example of that race which was used to being on the defensive [...] Querino was a *capoeira* [...] Wary, just like the African ancestors [...]. He was a peace-loving man. Wherever it came from, commotion annoyed him (Viana, Conferência, Anais do 1° Congresso Brasileiro de Folclore, op. cit.).

Gonçalo de Athayde Pereira also described him as "modest, hardworking, ever present, proud-spirited and above all, someone who did his duty" (Pereira 1932).

Braz do Amaral tells us: "Always unpretentious and endowed with a very cheerful nature, without spite or ill will, he was esteemed in all circles" (Amaral, in *A M.R.Q. Homenagem* etc., 3).

Finally, a word from Teodoro Sampaio: "...always poor, as a simple man of the people, he was rich in his pride and independence; jealous of his ideas, he did not advertise them; he always adhered to his values, which he never betrayed. No matter how great the advantages

offered, he did not want them if, to rise, he had to stoop" (Sampaio, in *A M.R.Q. Homenagem* etc., 6).

Endowed with these virtues, it is understandable that, at the age of 23, Manuel Querino took on a leading role in his profession.

The first opportunity to do so was the situation in which the working class found itself between 1874 and 1875, with imminent domination of the labor market by contract bidders. Possessing the capital to carry out large ventures, but mainly enjoying political favor, they began bidding for and monopolizing construction projects and setting wages as a result. To maximize profits, they sought to minimize the cost of labor. Some announced that they would reduce the workers' daily pay to 800 réis.

This threat, which had begun to materialize, rallied the workers. They began meeting daily both in Praça do Palácio and Largo do Teatro to discuss the situation and agree a joint response. The result of this movement was the organization of one of Brazil's first labor cooperatives, the Bahian Workers' League (Liga Operária Baiana), with the objective of taking over the execution of public and private construction works and sharing the work with their members – the construction workers.

In less than forty years, corresponding to the final decades of slavery, free workers in Bahia had nearly replaced slave labor in the so-called mechanical trades (Fonseca 1887, 182). This had created a relatively large working class. Construction workers – including painters, carpenters, masons and other professionals – made up a particularly important part of that contingent.

Representing a just cause – defending the right to work and make a living – the Bahian Workers' League garnered support and sympathy. It won the public tender for the renovation of the Banco da Bahia building with a bid worth thirty million réis. The guarantor for that contract was the owner and editor-in-chief of the *Diário da Bahia*, Augusto Guimarães, Castro Alves's brother-in-law. Later, by order of the President of the Province, Baron de Lucena, the League took over construction of the Normal School and the Provincial Treasury.

Also favored by the President of the Province, Councillor José Luís de Almeida Couto, the League strove to ensure that "in 1877 there was prosperity in the art of construction" (Pereira 1932).

Powerful and trusted, the League founded a weekly newspaper to keep its members abreast of its activities and uphold the interests of the profession. It circulated from January 1, 1877 until February 1878 – therefore, for more than a year (Carvalho 1911, 108-9).

Texeira Barros attributes the League's demise to political interference. After observing that "no one was so committed to elevating the arts in Bahia as Manuel Querino, and no other artist so vehemently advocated the unity of the working class in such a way that it would constitute a force, a will, a powerful element of action, within the collectivity," Teixeira Barros writes that "his greatest ideal was to remove the artist from the tutelage of politics, which overwhelms everything, and make him independent and autonomous. Through newspaper advertisements and word of mouth, in 1875, the Workers' League was born, which would mark the starting point for the fulfillment of Querino's designs; but the professional politicians, availing themselves of the prestige of power and promises of fleeting advantages, had the astuteness to kill the artist's noble ambitions. The new organization, launched under the best auspices, had to close down."

"Not even that," concluded Teixeira Barros, "could make Manuel Querino lose heart. Instead, he became convinced that his attempt had failed because artists lacked the education that was indispensable not [sic] to go through the door of the factory of deputies."

"From 1874 to 1885, he remained aloof from the labor question that arose once again after the introduction of the democratic regime" (Barros 1922, iv).

Here we can see that, for Manuel Querino, the experience of the Workers' League was disappointing. And it could not have been otherwise, considering the circumstances and the human element.

The task he had set himself far surpassed any leader's capacity for action. The educational level of workers at that time certainly did not allow them to visualize objectives that were not presented in a short-term and concrete way, or that did not affect anything more than the most immediate conveniences. The fact is that rights are only obtained when their wielders are aware of them. Now, certain labor rights, further defined and demanded, were not individualized at the time. In a society where so many of the workers' own tasks were still done by slaves; where for that very reason work was a stigma (Pierson 1945, 126); in a society where free and paid workers constituted a relatively small fraction of the population, it would be absurd to raise certain banners, even when they had already taken on shape and color, such as reducing working hours, banning the work of minors, protecting working women, ensuring hygiene in the workplace, resorting to strikes, regulating wages, the right to holidays, etc.

Manuel Querino was a man of talent, but he was not a prophet: he never pretended to be. Only geniuses can divine. He wanted the dispersed working-class community to have the benefits which the prevailing conditions made possible. He wanted to see the unification of the working class, vocational education and professional development, guarantees of work, fair pay and recognition of the respectability of the working classes.

He tried to achieve this again in 1890, following the advent of the Republic.

The political turmoil that had shaken the last years of the monarchy impelled Querino toward militant journalism, and he let himself be carried away, giving in to the impulse to let his message shape events.

He had already worked with several outlets of wide or limited circulation. This time, he did not want to engage with the various groups that practiced political journalism. He preferred to have his own newspaper. Therefore, he founded *A Província*, whose first issue came out on November 20, 1887. It circulated until the following year. As you could see in the header, Manuel Querino was its "editor and

owner." The newsroom was located at Rua do Colégio, 45 (João N. Torres – A. de Carvalho, op. cit, 131).

Querino did not engage in informative or commercial journalism. That is to say, he did not see journalism as a profession, or a mirror of events. He was not a spectator and witness; he was an author and bit player. As was relatively common in those days, when publishing a newspaper was far from being a costly industrial enterprise, he made the press his tribune to spread – more than a record of facts – opinions based on arguments he felt he had to communicate.

During the monarchy, he advocated abolition and the Republic. During the new regime, he went back to sponsoring workers' interests – this time, in the press. He began publishing *O Trabalho*, launched on February 3, 1892. It was a weekly publication. The presses were located at Rua do Colégio, fifty-one. It closed its doors in November of that year (Ibid.).

An active supporter of the Republic since 1878 (Viana, Conferência, *Rev. IGHB,* op. cit.), Manuel Querino must have played a leading role in the episodes that followed the introduction of the new government. In a way, the Republic was also a personal victory. In the nascent regime, he glimpsed an opportunity to obtain better opportunities for people like himself. Therefore, less concerned with institutional formulas than with the practical aspects of the new order, he quickly agreed to the idea of forming a Workers' Party, which was organized in 1890.

The time was right for currents of opinion to improvise societies of that kind. It was an eminently political period. During the institutional breach that opened up between two situations – that which was ending and that which was beginning – while Rio de Janeiro was debating the constitution, the onlookers were replete with public callings. As a result, alongside the emerging guilds, the workers created their own party.

The Workers' Party was led by a board. Chaired by Gonçalo José Pereira Espinheira, that board had nine members, including Manuel

Raimundo Querino. Their meetings were held at the "Luzo-Guarany" musical society in Pelourinho [Salvador's historic district]. They adopted an insignia and the following motto: "With order, firmness and hard work, we will fulfill our aspirations." They also founded a newspaper to disseminate the union's ideas.[4]

Wariness of politicians, who had mischaracterized the Workers' League, must have persisted in Manuel Querino's spirit when he discussed the party's line with his colleagues. Still bearing in mind the experience of fifteen years before, he must have wanted the party to act independently, free from commitments to politicians in order to serve the united working class and achieve their demands, which were now much clearer.

The other leaders of the party do not seem to have agreed with Querino's way of thinking. In the political circumstances of the time, a party made up entirely of workers and acting in a disciplined fashion must have caused serious alarm. Perhaps intimidated by the response, the party's chairman, Gonçalo Espinheira, soon announced that the entity "was not considering politics," adding that each of its members had "full liberty to support the candidates they saw fit." To dissipate any doubts, the bosses, factory owners, were invited to take part in party meetings along with the workers (Ibid.).

Probably compromised by these internal divisions, the Workers' Party could not go much further. The only thing saved from that shipwreck was the movement tending toward professional unity. Having abandoned its political label, it became the Bahia Workers' Center (Centro Operário da Bahia). A supporter of closer relations between workers and professional education, Manuel Querino must have warmly approved that solution. It was the "least worst."

The Workers' Party benefited Querino by making his leadership capacity more evident. In 1890 and 1891,[5] the Governor of the State

[4] Regarding the Workers' Party, Consuelo Novais Soares de Quadros gives a good account of it in *Partidos políticos da Bahia (1890-1912)*, contribution to the III Congresso de História (Third History Conference).

[5] Biographical information about Manuel Querino always mentions his participation in the Salvador City Council, and some accounts differ as to the periods in which he

invited him to hold a seat on the city council. He served there until January 1892, once again becoming a city councillor in 1897 and 1899. After his second term in office, targeted by reprisals from the powers that be, he gave up politics, going back to his civil servant's desk and his studies.

When evaluating Manuel Querino's comportment in journalism and politics, we can see that he was never fully a journalist or politician – that is, he never gave himself entirely to either kind of public activity, nor did he lose himself in them, as so often occurs. We can see that he made use of both the press and politics to spread his ideas about perfectly defended objectives: Abolition, the Republic, workers' rights. For that very reason, his presence in journalism occurred at different times that corresponded to specific phases in which the issues that merited his vigorous commitment came into focus. It was also for that reason that he fought fiercely in the abolitionist movement, in the case of the Bahian Workers' League and

played that role. However, Affonso Ruy, in his two excellent books on the City and its Council (*História política e administrativa da cidade de Salvador,* Bahia, 1949, and *História da câmara municipal do Salvador,* Bahia, 1953), omits the name of Manuel Querino from the list of Council members in the various legislatures, which Ruy assumed to be complete. This omission is explained by the City Council Minutes, which are housed in the Salvador City Archives (Books 10.1 to 10.11). They show that Manuel Querino was an "intendent" from September 6, 1892 to January 28, 1893, and there is no previous record of his term in office due to a lack of accurate minutes. He was appointed between 1890 and 1891 to succeed one of the "Intendents" initially chosen by the Governor, whose names Affonso Ruy provides. Querino returned to the Council on February 16, 1897, as a summoned 1st alternate, replacing Dr. Deocleciano Ramos, who had resigned from his post. In the election held on March 28, 1897, to fill the vacancy left by that resignation, José Alves Ferreira was elected with 1,302 votes, and Manuel Querino obtained 14. However, his role on the council was not interrupted. Presumably the [elected] councilman resigned or encountered an impediment. Following the resignation of seven Council members, also in 1897, Querino again ran for office and, in the polls held on July 11 of that year, he was elected in first place, with 1,582 votes. Due to alleged irregularities, that election was annulled by the City Council (decision taken at the session of August 16, 1897). After Manuel Querino and the other elected officials appealed to the State Senate, that body approved their request and, therefore, the Council's decision was voided (Senate session on August 25, 1897). In view of this resolution, Querino and the other applicants were sworn in and held office until the end of their terms. The last session in which Manuel Querino took part was convened on December 26, 1899.

in the episode of the Workers' Party; but only discreetly as a liberal politician during the monarchy and as a city councillor during the Republic. We can sense this when combing through the minutes of city council meetings. Keeping a distance from topical debates, occasionally appearing with a bill, an amendment or a finding, he is only truly present when the moment requires his voice on behalf of workers, even if it is to lament the lack of interest in these issues from those they most closely affect.

In 1899, when he withdrew from politics altogether, Manuel Querino was a disenchanted man. He himself confided this to Torquato Bahia (Torquato Bahia, in *A M.R.Q., Homenagem,* etc., 4). He believed that he would have made better use of his time by devoting himself to the study of popular culture, which, in fact, he did. Effectively, journalism is ephemeral, because it only exists for a day. Politics is also transitory, as it is generally the companion of circumstance. However, despite his disillusionment about the validity of his efforts, in his sixties Querino retained his youthful ardor about his brothers in race and class. The two essays he produced for the 5th and 6th Brazilian Geography Congresses were inspired by those feelings, the former on the African race and its customs in Bahia, the latter on the Black colonist as a factor in Brazilian civilization (Querino 1918, 35). In the second work, he wrote, "Whoever consults our history will be convinced of the value and contributions of Black people in the defense of our national territory, in agriculture, in mining, as explorers, in the independence movement, arms in hand, as a valuable part of the family and as the hero of labor in all its useful and profitable applications."

The last sentence fits Manuel Raimundo Querino like a glove.

Bibliography

Amaral, Braz do. *História da Bahia, do império à república.* Salvador: Imprensa Oficial do Estado, 1923.

Barros, J. Teixeira. "Manuel R. Querino." Querino, Manuel. *A Bahia de outrora.* Bahia, 1922.

Fonseca, Luís Anselmo da. *A escravidão, o clero e o abolicionismo,* Salvador: n.p., 1887.

Guimarães, Reginaldo. "Breve esboço sobre a vida e a obra de Manuel Querino." *Revista Brasileira de Folclore,* Jan./Apr. 1973.

Pereira, Gonçalo de Athayde. *Prof. Manuel Querino, Sua vida e suas obras.* Salvador: Imprensa Oficial do Estado, 1932.

Pierson, Donald. *Brancos e pretos na Bahia: estudo de contacto racial.* São Paulo: Editora Nacional, 1945.

Quadros, Consuelo Novais Sampaio de [Consuelo Novais Sampaio]. *Partidos políticos da Bahia (1890-1912),* contribuição ao III Congresso de História. Salvador: n.p., 1973. Accessed 25 March 2021. <https://ppgh.ufba.br/sites/ppgh.ufba.br/files/4_os_partidos_politicos_da_bahia_na_primeira_republica.pdf>

Querino, Manuel R. *A Bahia de outr'ora,* Salvador: Livraria Econômica, 1922.

———. *A raça africana e seus costumes na Bahia.* Anais do 5º Congresso Brasileiro de Geografia, vol. 1, Bahia, 1917.

———. *O colono preto como factor da civilização brasileira.* Bahia: Imprensa Oficial do Estado, 1918.

Torres, João N. and Carvalho, Alfredo de. *Anais da imprensa da Bahia.* Salvador: n.p., 1911.

4. DISENCHANTED WITH THE REPUBLIC

Sabrina Gledhill[1]

Amilitant journalist before and after Brazil became a republic in 1889, Manuel Raimundo Querino founded and ran two newspapers that supported the workers' movement – *A Província* (The Province, 1887-1888) and *O Trabalho* (Labor, 1892) – denouncing corruption as the chief cause of the abuses suffered by the working class which, to him, was synonymous with the "oppressed class" (Burns 1974, 80). Identifying with workers and artisans and "inclined toward socialism" (Ibid.), Querino was concerned about protecting workers' rights during slavery, when the free, wage-earning population was in the vast minority. At the time, the job market was controlled by middlemen who monopolized construction projects and set workers' wages. The Liga Operária Baiana (Bahian Workers' League) was established in 1875 to ensure that workers received decent pay. According to Querino's biographer José Teixeira Barros: "no one has worked so hard to elevate the arts in Bahia as Manuel Querino, and no other artist has so forcefully advocated the unity of the working class so that it became a force, a will, a powerful element of action within the community. His greatest aspiration was to remove artists from the tutelage of politics, which overwhelms everything, making them independent and autonomous" (in Querino 1946, 6). Unfortunately, the League was shut down due to political interference (Ibid.) Fifteen years later, in 1890 – two years after abolition – the Partido Operário (Labour Party) was formed under the leadership of Gonçalo José Pereira Espinheira with the motto "With order, firmness and hard work, we will reach the fulfillment of our

[1] This chapter is an adapted translation of "Manuel Querino: operários e negros Diante da desilusão republicana," originally published in Bacelar, Jeferson Afonso and Pereira, Cláudio Luiz (eds). *Política, instituições e personagens da Bahia (1850-1930)*. Salvador: Edufba, 2013, 125-143.

aspirations." Its board of directors had nine members, including Manuel Querino (Calmon 1980).

In the political life of the Second Empire (1840-1889), Querino was loyal to his guardian, Manuel Correia Garcia, and his "godfather," Manuel Pinto de Souza Dantas, espousing the cases of the Liberal Party – republicanism and abolitionism. According to Pereira (1932, 5):

> He achieved something useful from the closer relations he sought with his patron Counc. Manuel Pinto de Sousa Dantas and became a liberal politician, with free ideas, so he was one of those who signed the republican manifesto of 1870, along with Virgílio Damásio, Lellis Piedade, Spinola de Athayde and others from the fortnightly publication of the Sociedade Libertadora Sete de Setembro, edited by Frederico Marinho and Augusto Guimarães, both lawyers and journalists in [Salvador] (1871-1874).

Although he did not achieve the eminence of the leaders of the abolitionist campaign, including Rui Barbosa and José do Patrocínio, Querino joined the Sociedade Libertadora Baiana abolitionist society and wrote articles published in the *Gazeta da Tarde* to raise awareness about the iniquities of slavery. In addition to being part of the Liberal Party's platform, for Querino, as an Afro-Brazilian,[2] abolitionism was a very personal cause:

> It was by studying the character of Black that he awoke to the defense, to the fight for his unfortunate brothers. Aspects of slavery, seigneurial attitudes, its proceedings incompatible with human dignity, all this jumble of facts and reasons that justify the abolitionist journey, greatly influenced his spirit, since his first steps in his youth. *It did not seem fair to condemn those who loved freedom.* A people with such feelings were worthy of better

[2] Querino self-identified as "mulatto" or *mestiço* ("mixed race"), but has been described as "Black" by scholars who commented on and edited his works, such as Artur Ramos and Edison Carneiro (2019, 132). E. Bradford Burns referred to him as "a black" (1974, 78). However, he has also been characterised as a "mulatto journalist" (Albuquerque 2009, 39).

treatment. How many times have I heard him make broad considerations, in a private lecture, on the moral greatness of the Black, the African, who, as a slave, molested and without rights, fanatically confronted the fulfillment of duty (Viana 1928, 311, emphasis mine).

Querino worked alongside the abolitionists Frederico Marinho de Araújo and Eduardo Carigé, among others. Unlike many of his fellow activists, as a militant abolitionist, he believed that inequality between whites and Blacks were due solely to the lack of opportunity afforded to the latter. In "A raça africana," he cites examples of Black clergymen observed by the eminent Jesuit Father Vieira (1608-1697) on Cape Verde Island [*sic*] in the seventeenth century: "There are clerics and canons here as Black as jet, but so poised, so authoritative, so learned, such great musicians, so discreet and good-tempered that they are the envy of those we see there in our cathedrals" (Vieira in Querino 1938, 23). And he closes the argument with these words: "From the above we must conclude that *only a lack of education destroyed the African's value*" (Ibid., emphasis mine). Therefore, he advocated the abolition followed by the preparation of formerly enslaved individuals for the world of wage labor because, based on his own experience, he was convinced that human beings could not develop without education. (In this sense, he can be compared to Booker T. Washington, of whom he was a fervent admirer.)[3] Unfortunately, to his tremendous regret, no such attempt was made.

In the United States, the enslaved people emancipated in 1865 after the Civil War faced numerous obstacles to the achievement of full civil rights, including lynchings, disenfranchisement and the segregation system called "Jim Crow," but several educational institutions, mainly normal and industrial schools, like the Tuskegee Institute, were created for freedmen by paternalistic but philanthropic

[3] In his introduction to "A raça africana," Querino asks: "Who is unaware, perhaps, of the prestige of the great American citizen Booker [T.] Washington, the eminent educator, the accomplished speaker, the wise man, the most genuine representative of the black race in the American Union?" (Querino 1938, 22).

whites such as Colonel Samuel C. Armstrong, founder of the Hampton Institute, whose most eminent student was Booker T. Washington himself, enslaved as a child and the future founder and director of the Tuskegee Institute.

In his book on the history of the arts in Bahia, *As artes na Bahia,* Querino praises the cultural initiatives carried out during the Imperial period and goes even further – as far back the opening of the ports when the Portuguese Crown transferred the seat of its empire to Brazil in 1808 (1913, 26). He observes that the Liceu de Artes e Ofícios (Arts and Crafts Lyceum) and the Escola de Belas Artes (School of Fine Art) were established in the Province of Bahia during that time, since "In the time of the Empire, it is an honor to confess, the presidents of the province did not disdain to protect and enliven artistic culture." He stressed that the Lyceum and the School of Fine Art "were also considered as instruments of education for the people, whose worthy intentions were respected" (1913, 27). Referring specifically to vocational education, he reports that the navy and war arsenals produced "distinguished workers whose skills proved ample during the war with Paraguay, when the general government removed them to Rio de Janeiro to work in shipbuilding, without mentioning the works performed here" (Ibid.).

The advent of the "republican regime" reversed this situation, according to Querino. Artists and artisans were left without commissions, teachers, without pay – "a professor of sculpture and another of painting at the School of Fine Art left for Europe, abandoning teaching, with regret, due to lack of payment. When a well-intentioned governor [f]avours the arts, another withdraws the favor" (1913, 28).

However, his harshest criticism fell on the closing of the arsenals. Due to that measure,

> [...] the young apprentices, future workers, were left to the practice of vice; far from being an economic measure, it became a sordid speculating convenience for a few *laborious* and *diligent* people, to whom all the work of the army and navy were handed

over, so that the Rio de Janeiro firm "Lage & Companhia" could exploit, with the greed of the time, that which should be distributed to many and at a reasonable price. It is through this process that perversity flaunts and scoffs at the unfortunate heroes of labor, delivering true artistic vocations up to abandonment (1913, 29).

Giving up politics

According to Lília Moritz Schwarcz, in a foreword to a collection of short stories by Lima Barreto – another Afro-Brazilian journalist who experienced the dream and disillusionment of the First Republic, a period the historian describes as "particularly incandescent" (Barreto 2010, 18):

> [...] if it is a fact that the new regime introduced promises, previously non-existent, of promotion and social inclusion, the reality soon proved to be the opposite. After all, while slavery had just been abolished, free labor had not yet taken on a more defined form or wage framework [...]. Thus, a kind of interregnum was created, characterized by the lack of clear rules, but also by an excess of personal arrangements [...]. Therefore, the promises of inclusion of the Black and enslaved population were not fulfilled, and employment and services contracts were not publicly regulated. On the contrary, clientelist relations were strengthened, the bonds of cronyism were expanded (Ibid., 18-19).

More than ever, the working class needed to unite and defend itself. Querino ran for Federal Deputy for the Labour Party in 1890 and was elected class delegate at the Brazilian Workers' Congress in Rio de Janeiro. However, that "party organization composed only of workers, acting in a disciplined fashion" once again aroused the fears of the elite, especially the bosses and industrialists. Intimidated, Gonçalo Espinheira announced that the movement was apolitical and the party was renamed the Centro Operário da Bahia (Calmon 1995, 29; see Chapter 3).

His journalistic campaign and the leadership he demonstrated at the head of the Workers' Party earned him the appointment as a member or "Intendent" of the city council, the first municipal legislature of the city of Salvador, in 1890 or 1891 (Viana 1928, 308; Calmon 1980, 1995). According to Calmon (1980): "he was appointed, between 1890 and 1891, to succeed one of the 'Intendents' initially chosen by the Governor of the State [...]." Pereira notes that:

> [...] the workers did justice to his efforts by electing him to the city council, where he was not undeserving of the confidence of his friends and the voters who elected him. While there, he opposed the laws of exceptions, unjust reforms, displeasing the lords and masters while winning the sympathies of those who would be harmed by such reforms, which only served to benefit the friends and protégés of the dominant situation. On that same occasion, he formed a bloc with others and, through appointment, brought back several officials dismissed by an unjust reform; and it cost him re-election, retiring happily to obscurity [...] (1932, 11).

He returned to the city council in 1897 as first alternate and replaced a councilman who had resigned from his post (Calmon 1980). He lost the election to fill the vacancy left by that resignation, but remained on the council until December 26, 1899. In the same year, he left politics due to reprisals from the "powers that be" (Ibid.).

Querino was also a civil servant, holding several posts in the Public Works Directorate and the Department of Agriculture, where he was "recognized as one of the most outstanding officials due to his technical skills and ethics" (Teixeira Barros in Querino 1946, 9). According to Artur Ramos, in his foreword to *Costumes africanos no Brasil*, "Manuel Querino aptly symbolized that type of average civil servant, hardworking and fulfilling his duties but without the perks of this incredible thing that in Brazil was baptized with the name of *pistolão* (political patron). Simply put, Manuel Querino was a civil servant without a pistolão" (in Querino 1938, 11). (As we have seen, he did

have an influential patron at one time, Manuel Pinto de Souza Dantas, who died in 1894.)

After leaving politics and retiring from his post at the Department of Agriculture in 1916, Manuel Querino decamped to his home in Matatu Grande and the safe haven of the Geographic and Historical Institute of Bahia (Instituto Geográfico e Histórico da Bahia; IGHB), of which he was a founding member, to dedicate himself to the scholarly work already begun and for which he is best remembered: a number of studies that are of fundamental importance for the history of the arts in Brazil, Brazilian historiography in general and the formation of Black identity in that country. He was one of the only intellectuals of his time, and probably the first Afro-Brazilian scholar, to recognize and publicize the African contribution to Brazilian society, played a key role in recording and documenting the contributions of Africans and their descendants to the development of Brazil and preserved a considerable amount of information about the arts, artists and artisans of Bahia. He also provided an abundance of information on the customs, culture and religious beliefs of Africans and their descendants.

Nevertheless, he also continued his political activism. Even when he was writing his book on the arts in Bahia, he was scathing in his critique of the government he had worked so hard to establish:

> It is no wonder [...] that Bahia, for the most part, is devoid of the artistic element, due to the contempt of its rulers, who, fortified by the much discussed and never practiced *economy of public funds,* abandoned the cultivation of the arts a time when they have been dismantled at a vertiginous pace in these few years of republican existence, where we are always groping in the darkness, forgetting that "one cannot be inside civilization and outside the arts."
>
> In the republican regime, divorcing public power from the people the regrettable shock of contempt has been reflected in the arts. It is as if we were witnessing a contemptuous spectacle in which the disordered command of personal conveniences

dislodges the brilliant patriotism of other ages (Querino 1913, 24).

Querino observed that the only country that "never lacked distinguished sculptors" was France (Ibid.). He may have seen *"liberté, égalité, fraternité"* as the most fertile soil for the arts.

Conclusion

Referring to two great Afro-Brazilian writers, the poet João da Cruz e Souza and the novelist and journalist Afonso Henriques de Lima Barreto, Bosi notes that, "the grandchildren of slaves and children of freedmen with patronage, they received a refined education of a European nature, which gave them hopes of professional fulfillment and acceptance by the liberal circles of the newly created Republic. But the barriers were already beginning to rise: with the loss of their protectors, both fell into straitened circumstances, without prospects" (Bosi 2002, 186-187). Cruz e Souza is said to have sublimated his resentment in poetry such as "Dor negra" (Black Pain) and "Emparedado" (Walled In) and Barreto exposed his "naked and raw" feelings in fiction, starting with the novel *Recordações do escrivão Isaías Caminha* (The Memoirs of Isaías Caminha, Clerk), whose protagonist is a boy who only discovers that he is "Black" when he leaves the countryside and seeks his fortune in the big city. Comparatively speaking – after all, Querino received a refined education, of a European nature, thanks to his own efforts as a founding student of the School of Fine Art, and he also lost his "pistolão," as Ramos noted (in Querino 1938, 11) – it can be said that the former journalist and Bahian councilman dedicated himself to the research and defense of Blacks and the arts for the same reason. As Frederico Edelweiss observes: "How many times must he have heard that trite and commonplace expression: 'that Black is too big for his boots.' His demands on behalf of his racial brethren would bring him sympathizers and detractors; more detractors" (in Querino 1946, 1-2).

Querino is much better known for the direction he took in the last decades of his life – his works, some of which were pioneering studies, in the areas of Black culture and the African contribution to Brazilian society, art history, and Bahia's folklore and cuisine – than for his activism as a republican, abolitionist, and labor and political leader. However, that aspect of his career has not been overlooked. The institutions that took part in the centennial celebrations of Querino's birth included not only "the cultural entities of Bahia" – the IGHB, the Academy of Letters and the Folklore Commission – but also others "of a different nature, notably proletarian" – the Sociedade Protetora dos Desvalidos and the Centro Operário da Bahia *(A Tarde,* 28.07.51). During the celebrations, in a lecture given at the IGHB on July 28, 1951, confrere Antônio Viana

> presented [...] unprecedented aspects of Manuel Querino's life and work, always focusing on him as a renowned friend and defender of his people, an honest servant of the arts, history and letters. The speaker reported several episodes of the honouree's life to demonstrate the interest and pertinence with which he had sought to raise the level of workers to complete independence (Ibid., 29.07.51).

According to Lopez and Mota (2008: 52), the "'pure' republicans [...] advocated a regime change that, like France, would result in greater public participation in the nation's political life." As a "pure republican" and activist, Manuel Querino was bitterly disappointed with the outcome of this movement at two levels. At the "macro" level, the First Republic strengthened the power of national oligarchies, maintained the Empire's "model of political and socio-cultural exclusion" in a Republic "without democratic citizenship" (Ibid.), despised the arts (Querino 1913, 24) and nothing did to include the enslaved people freed in 1888 in the free labor market. On the contrary, it carried on with the "whitening" project begun during the Empire, encouraging the immigration of European workers (Skidmore 2003, 112). At the "micro" level, Querino faced and suffered the wrath

of the Bahian oligarchy, which forced him to leave political life and public service. According to Pereira, "He failed to please the politicians, and therefore paid dearly for his boldness and independence" (1932, 13).

Bibliography

A Tarde, "Centenário de Manoel Quirino — As homenagens da Bahia." 28 July 1951. N.p.

A Tarde, "Encerradas as comemorações do centenário de Manuel Querino." 29 July 1951. N.p.

Albuquerque, Wlamyra Ribeiro de. *O jogo da dissimulação. Abolição e cidadania negra no Brasil.* São Paulo: Companhia das Letras, 2009.

Alves, Marieta. *Intelectuais e escritores baianos — breves biografias.* Salvador: Prefeitura Municipal/Fundação Museu da Cidade — FUMCISA, 1977.

Barreto, Lima. *Contos completos de Lima Barreto.* Organização e introdução de Lília Moritz Schwarcz. São Paulo: Companhia das Letras, 2010.

Bosi, Alfredo. *Literatura e resistência.* São Paulo: Companhia das Letras, 2002.

Braga, Julio Santana. *Sociedade Protetora dos Desvalidos, Uma irmandade de cor.* Salvador: Ianamá, 1987.

Burns, E. Bradford. "Manuel Querino's Interpretation of the African Contribution to Brazil." *The Journal of Negro History,* LIX, no. 1 (Jan. 1974): 78-86.

Butler, Kim D. *Freedoms Given, Freedoms Won: Afro-Brazilians in Post-Abolition São Paulo and Bahia.* New Brunswick/London: Rutgers University Press, 2000.

Calmon, Jorge. Manuel Querino, o jornalista e o político. *Ensaios/Pesquisas,* no. 3. Salvador: Universidade Federal da Bahia/Centro de Estudos Afro-Orientais, May 1980.

————. *O vereador Manuel Querino.* Salvador: Câmara Municipal de Salvador, 1995.

Carneiro, Edison. *Ladinos e crioulos, estudos sobre o negro no Brasil.* Rio de Janeiro: Civilização Brasileira, 1964.

Freire, Luiz Alberto Ribeiro. *A talha neoclássica na Bahia.* Rio de Janeiro: Versal, 2006.

Gledhill, Sabrina. "Manuel Raimundo Querino." In *Manuel Querino, Seus artigos na Revista do Instituto Geográfico e Histórico da Bahia,* Nascimento, Jaime and Gama, Hugo (eds.), 225-238. Salvador: IGHB, 2009.

Leal, Maria das Graças de Andrade. Manuel Querino entre letras e lutas — Bahia: 1851-1923. Thesis (PhD in History) — Pontifícia Universidade Católica de São Paulo, São Paulo, 2004.

————. *Manuel Querino entre letras e lutas — Bahia: 1851-1923.* São Paulo: Annablume, 2010.

Lopez, Adriana e Mota, Carlos Guilherme. *História do Brasil, Uma Interpretação.* 2nd ed. São Paulo: Editora Senac, 2008.

Mattoso, Kátia M. de Queirós. *Bahia: a cidade de Salvador e seu mercado no século XIX.* Salvador: HUCITEC Ltda., 1978.

Nascimento, Jaime and Gama, Hugo (eds.). *Manuel Querino, Seus artigos na Revista do Instituto Geográfico e Histórico da Bahia.* Salvador: IGHB, 2009.

Nunes, Antonietta d'Aguiar. "As leis orçamentárias provinciais baianas (1835-1889) como instrumento de política educacional." *Gestão em Ação* 8, no. 3 (Sept.-Dec., 2005): 329-340.

Pereira, Gonçalo Athayde de. 1932. *Prof. Manuel Querino, Sua vida e suas obras.* Bahia: Imprensa Oficial do Estado, 1932.

Querino, Manuel. *As artes na Bahia.* 2nd ed. Bahia: Officinas do "Diário da Bahia," 1913.

————. *A Bahia de Outr'ora, Vultos e factos populares.* 2nd ed. expanded. Bahia: Livraria Econômica, 1922.

————. Os homens de côr preta na História. *Revista do Instituto Geográfico e Histórico da Bahia,* Salvador, n. 48, pp.353-363, 1923.

————. *Costumes africanos no Brasil.* Preface and notes by Artur Ramos. Rio de Janeiro: Civilização Brasileira, 1938.

————. *A Bahia de outrora.* 3rd ed. Salvador: Progresso, 1946.

————. *Costumes africanos no Brasil.* 2nd edition, expanded and commented. Preface, notes and editing by Raul Lody, introduction by Thales de Azevedo. Recife: Editora Massangana, 1988.

Silva, Viviane Rummler da. "Miguel Navarro y Cañizares e a Academia de Belas Artes da Bahia: relações históricas e obras." *Revista Ohun* 2, no. 2 (Oct. 2005).

Skidmore, Thomas E. *Preto no Branco. Raça e nacionalidade no pensamento brasileiro.* São Paulo: Editora Paz e Terra, 1976.

————. *Uma história do Brasil.* 4th ed. São Paulo: Editora Paz e Terra, 2003.

Tavares, Luís Henrique Dias. *História da Bahia.* 10th ed. Salvador/São Paulo: Edufba/UNESP (FEU), 2001.

Viana, Antônio. Manoel Querino (lecture). *Revista do Instituto Geográfico e Histórico da Bahia,* Salvador 54 (1928): 305-316.

Wantuil, Zeus. Teles de Menezes: pré-história do espiritismo no Brasil. *Grandes Espíritas do Brasil.* Accessed 21 April 2021 <www.universoespirita.org.br/TOSHIBA%20JA%20COLOCADOS/TELES%20%20DE%20%20MENEZES.htm>

5. FIRST HISTORIAN OF BAHIAN ART

Eliane Nunes[1]

This essay analyzes Manuel Raimundo Querino's theoretical production, specifically his focus on the arts, a subject to which this unique agent of Bahian intellectuality devoted his attention. When revisiting his writings, the aim is not to fall into the trap of simplistic interpretation. Instead, I want to emphasize the complexity and even the contradictions in a thinker of the greatest importance for the historiography of Brazilian art, particularly because he was the first to study that subject in Bahia. It is thanks to his work that the biographies of many local artists have reached us today. Today, Querino is valued on account of his association with Blackness, as he was one of the first to inventory the material culture of the community of African descent in Salvador and carry out studies that emphasized the positive contribution of Blacks to Brazil's socioeconomic development. However, his work as art historian has not yet received due attention, eclipsed by accusations of inaccuracies and misuse of sources.

My aim here is not to carry out a biographical study of Querino – for that I refer the reader to the doctoral thesis by the historian Maria das Graças de Andrade Leal (2004), among other previous writings.[2] However, some aspects of his life are mentioned to contextualize the socio-cultural conditions in which he composed his work. Manuel Raymundo Querino was born in 1851 in the town of Santo Amaro da Purificação, Bahia. He was the son of carpenter José Joaquim dos Santos Querino and Luiza da Rocha Pita. We do not know exactly how and when his parents died, but the most accepted

[1] This chapter is an adapted translation of "Manuel Raymundo Querino: O primeiro historiador da arte baiana." *Revista Ohun* 3, no. 3 (Sept. 2007): 237-261. Accessed 26 March 2021. <http://www.revistaohun.ufba.br/pdf/eliane_nunes.pdf>

[2] See also Barros, J. Teixeira. "Manuel R. Querino." Querino, Manuel. *A Bahia de outrora*; Aguiar, Pinto de. "Manuel Querino e sua obra." Querino, Manuel. *A raça africana e seus costumes*; Calmon, Jorge. *Manuel Querino: o jornalista e o político*; Calmon, Jorge. *O Vereador Manuel Querino;* Sodré, Jaime. *Manuel Querino, um herói da raça e classe.*

version is that they both succumbed to a cholera epidemic when Querino was a child.

After a military career that took him away from Bahia for a while, Querino returned and entered, in 1872, the Arts and Crafts Lyceum (Liceu de Artes e Ofícios) under the tutelage of the Spanish teacher and artist Miguel Navarro y Cañizares (?-1913),[3] enrolling in the drawing course. He followed his mentor when Cañizares founded the School of Fine Art in 1877, and graduated in geometric drawing in 1889.[4]

It is impossible to evaluate Querino as an artist, because according to art historian José Roberto Teixeira Leite (1988), all his art works have been lost. His main paintings were decorations of walls in homes and public buildings, tram posters and theater curtains, as well as easel paintings. At Cañizares's invitation, he helped paint the curtain for the São João Theater in Salvador in 1880. As a decorator, he produced some reliefs, such as those on the walls of the Santa Casa de Misericórdia and the Church of Nossa Senhora da Graça, in which he assisted the painter Manuel Lopes Rodrigues (1861-97). Presumably, his work was well regarded, as he received several prizes, including bronze, silver and gold medals and honorable mentions, both from the Arts and Crafts Lyceum and the School of Fine Art.[5]

After several attempts to take part in public life,[6] in 1889 Querino retired from politics and devoted his time to publishing books and articles on subjects related to – among others – Black culture in Salvador and the arts. In the words of Frederico Edelweiss, in his

[3] [Editor's Note: According to the MA dissertation by Viviane Rummler da Silva, 2008, Navarro y Cañizares was born in Valencia, Spain, in 1834. Accessed 6 April 2021 <https://silo.tips/download/universidade-federal-da-bahia-escola-de-belas-artes-mestrado-em-artes-visuais-vi>]

[4] He also studied architecture, but did not take the final exams due to a lack of lecturers.

[5] He was awarded bronze, silver and gold medals from the Lyceum and the School of Fine Art, with honourable mention (1880) and two silver medals (1882 and 1883).

[6] He was one of the founders of the Sociedade Liga Operária Baiana (Bahian Workers' League Society, 1876) and the Partido Operário da Bahia (Bahia Workers' Party, 1890), in addition to having been a City Councillor on two occasions (1891-1892 and 1897-1899) [See Chapters 3 and 4 – Ed.].

preface to the third edition of *A Bahia de outrora - vultos e fatos populares,*[7] during that period, between the late nineteenth and early twentieth centuries, "Manuel Querino became spiritual" (Querino 1954, 6). In other words, he left public political activism for solitary intellectual labors. The weapons had changed, but the objectives remained the same, including valuing work and workers. However, writing did not make money and, in addition to making a living for himself, Querino had a family to support: he taught geometric drawing at the Bahia Arts and Crafts Lyceum, the same subject he taught at the São Joaquim College of Orphans and as a private tutor, in addition to being a civil servant at the Public Works Department for twenty years, from 1893 to 1916.

After a long and productive life, Manuel Querino died at the age of seventy-one. The author of several books and articles, his work is essential to understanding studies of Black people in Brazil, particularly due to the change in perspective on how that subject was treated – especially when compared to the physician Raimundo Nina Rodrigues (1862-1906), who wrote some of the first works on that subject in Querino's Salvador, and whose ideas were followed by most Brazilian intellectuals.[8] Contemporaries, their perspectives were diametrically opposed, because while Nina Rodrigues based his work on the assumption of the biological inferiority of Blacks, Querino showed how much they had contributed to the formation of the country, establishing two new paradigms for his research, namely treating Blacks as colonizers and promoters of civilization, "[...] reversing the traditional association of 'Black' with 'barbarism' and as the subject of the civilizing work of Portuguese whites," concepts that were absolutely revolutionary for their time (Guimarães 2004, 12-13).

Querino was Black and suffered the discrimination typical of that condition in a country that was still a slavocracy and,

[7] The first edition of this book was published in 1916. Further editions followed in 1922, 1946 and 1954.

[8] The theoretical conflict between the two was the subject of Jorge Amado's novel, *Tent of Miracles,* published in 1969, whose main character, Pedro Arcanjo, was inspired by the life of Manuel Querino.

consequently, racist. Despite being born free, he was thirty-seven years old when abolition was proclaimed. In addition to being Black and poor, and despite the patronage of members of the Bahian elite, his social ascension was limited. He never obtained recognition to the point of being promoted in his main occupation, that of a civil servant, even though he was extremely devoted to his work, according to his biographers.

However, what matters here are the explicit ideas in the author's publications about art and artists, as well as their impact on the historiography of Brazilian art. We can assess Manuel Querino's importance as an art historian through the words of José Roberto Teixeira Leite, who dedicated his book *Pintores negros do oitocentos* (Black Painters of the 1800s) to him. According to Teixeira Leite, his "[...] activities as an art historian and scholar of Bahian traditions far surpassed his little-remembered work as a painter" (Leite 1988, 23).

Bahian art historian Luiz Freire (2000) established a felicitous comparison between Manuel Querino and the Italian Giorgio Vasari (1511-1574).[9] Let us go further, underscoring their similarities and differences as a way of introducing the approach of Querino's writings on art.

The chapter on Vasari in Germain Bazin's *Histoire de l'histoire de l'art: de Vasari à nos jours* (History of Art History: From Vasari to the Present Day; Portuguese edition, 1989) receives the suggestive title of "The Founding Father." In fact, no other term could more aptly describe the man who is considered the creator of art history. Vasari's desire, expressed in his autobiography, was to exalt the great artists, and in this one can find the first resemblance to our Manuel Querino. Like Vasari, as Freire has already stated, by memorializing artists, he was exalting his own profession, as he was also an artist and, like Vasari, he includes his own biography in his work. But if it took Vasari twenty years and a second edition of his book, published in 1568, to include his own biography among those of the artists considered to be

[9] He published the first edition of *The Lives of the Most Excellent Painters, Sculptors, and Architects* in 1570 (sic) [1550].

excellent, Manuel Querino's was included in the first edition of *Artistas bahianos* (1909, 116-117), which points to a distinction between the two: the criteria they used to select the artists mentioned in their studies. Vasari establishes a value judgment based on "aesthetic" categories, while Querino, imbued with a more encyclopedic spirit, seeks to inventory the largest number of professionals who worked in the city of Salvador, engaged in activities related to "artistic" production, whether or not they were considered competent. Another distinction in this selection is that Vasari only deals with what he considers "minor arts" "...indirectly, speaking of medals, carvings and cameos in architecture, and painting, gilding, marquetry and stained glass in the painting section" (Bazin 1989, 30). For Vasari, the mechanical arts were considered minor, and, therefore, servile, not deserving to appear alongside what he considered the major arts: architecture, sculpture and painting. Querino follows the distinction between the major (liberal) and minor (mechanical) arts, but does not shy away from broadly addressing the latter's representatives, especially in *As artes na Bahia,* first published in 1909.

Both for Querino and Vasari, Art, with a capital "A," respected the conventions established in the Renaissance, such as the use of perspective, the balance between idealism and realism and the suitability of the size of the work to the subject, among others.

Querino, despite his recognized commitment to valuing the social and cultural condition of the humble, paradoxically had academic training and criteria, disregarding the artistic production that lacked a certain training. He unconditionally demanded a degree of craftsmanship and an identification of the artist with the *taught and established* style. It is in this sense that he equates skilled craftsmen with creative artists (Valladares 1967, 87-88).

This concept explains why Querino did not include so-called folk art. He valued artists from humble backgrounds, but only those who produced works in accordance with the elitist canons of Western scholarship.

When writing their works, both men used sources such as manuscripts and oral tradition, but Querino resorted more to the latter. This was presumably due to difficulties in accessing the original documents that would indicate the authorship of many works, the vast majority of which were in the hands of the Catholic Church, especially the confraternities, which have always been reluctant to make them available to scholarship, possibly worsened by the fact of Querino being Black, poor and without a university degree.

From a methodological point of view, the similarity between Vasari and Querino is overwhelming: both men built up an art history based on succinct but detailed biographies of artists. The idea of art history as a history of the artists' lives was the inaugural method of this discipline, supported by the bourgeois concept of "Creative Man" that has run through the discourses on art since the Renaissance, the historical period in which this conception began. The legacy of the biographical method continued influencing the history of art until the nineteenth century, although in the collections meant for the general public, the success of this approach is still clear. This methodological practice was widely criticized, especially for emphasizing the producer and not the artistic product; for paying little attention to the context in which the artist developed, resulting in the idea of creative genius detached from the social body, which finds its finest example in the construction of the legendary Leonardo da Vinci, and to which Vasari made a decisive contribution.

Querino stands for the periodization of Bahian art, just as Vasari stands for that of the Renaissance: the two concepts have solid roots in historiography and have reached our time. Querino draws a line in Bahian art marking the periods before and after the introduction of academic education in Salvador, the break with its Iberian roots and the absorption of primarily French neoclassical values. Querino developed the concept of the Bahia School of Painting in its heyday with the triumvirate of painters José Joaquim da Rocha (1737-1807), José Teóphilo de Jesus (? -1847) and Franco Velasco (1780-1833). Presented for the first time in a manuscript that he used as source

material and which will be discussed later, the idea of a local school is one of the most consistent historiographic means of dealing with painting practiced in Bahia between the late eighteenth and nineteenth centuries, whose creator and master was José Joaquim da Rocha.

Another similarity between the two historians lies in their evolutionary and progressive idea of art. For Vasari, European art evolved from medieval obscurity to its Renaissance prime, only to experience a period of decline (later called Mannerism) during his time. Querino also considered himself to belong to a time when the arts were in decline. In sculpture, whose beginnings he found in the colonial period under exclusively Portuguese influence, he highlights a period of relative splendor in the eighteenth century, which he attributes, without considering other influences, to the natural development of the Brazilian artistic tendency, whose main exponent was Chagas, *o Cabra* (active in the eighteenth century). At the end of that period and marking the beginning of the decline of sculpture in Bahia, inspired by the same manuscript, Querino mentions Domingos Pereira Baião, who died in 1871 (Querino 1913, 13-24). He finds several causes to explain this decline, beginning with that fact that that art form had "[...] lost the value of liberal art, reduced to the role of a profitable craft" (Querino 1913, 23). In addition to this change in conception, Querino blames the advent of the Republic for the decline of the arts in Brazil, due to the lack of official incentives. When it comes to painting, he also finds a golden age in the past, between the end of the eighteenth century and the first decades of the 1800s: that of the Bahia School of Painting, which ends with the death of the painter Antônio Joaquim Franco Velasco (1780-1833) and is reborn in all its glory with the founding of the School of Fine Art (1877) (Querino 1909, 79-94).

Of course, there are major differences between Italy and Bahia, but despite that and the different periods in which the two authors were active, a comparison is possible because there are many similarities. This demonstrates how much Querino was respecting the tradition of art history, despite later criticisms that treat him as being ignorant on that subject. After all, a new type of art history, formalism,

different from the biographical one proposed by Vasari, was just being born in Germany through Heinrich Wölfflin, who published *Renaissance and Baroque* in 1888, and the classic *Principles of Art History* as early as 1915, laying the foundations for this new method.

Both Vasari and Querino suffered harsh criticism due to the inaccuracies pointed out in their works, but at the same time, they are pioneering figures in the history of art in their respective locales of activity.

Manuel Querino's work has been extensively reviewed, particularly by art historians Marieta Alves and Carlos Ott. Let us return to this process in general terms in order, with sufficient historical distance, to assess its fairness. In 1946, Ott found a manuscript in the National Library of Rio de Janeiro entitled "Noções sobre a procedência da arte da pintura na Província da Bahia" (Notions About the Origins of the Art of Painting in the Province of Bahia),[10] partly published in the *Revista do Patrimônio Artístico e Histórico* in 1947, and reproduced in full by Luiz Freire in 2000. Reading the manuscript, it is undeniable that Manuel Querino drew on it to write some of the biographies he included in his books *Artistas bahianos* and *As artes na Bahia*, even copying parts. However, it is also undeniable that he added a great deal to the original information. The manuscript only mentions twenty-three painters and fifteen sculptors, a much smaller number than the biographies inventoried by Querino.

However, when commenting on Querino's act of using the manuscript without citing it, Ott does so with prejudice, detracting from the accomplishments of the author of the first publication on the arts in Bahia as if that writer were his contemporary:

> We can excuse this blunder, considering that in the first years of his life he was just a craftsman (a painter of walls; later a teacher of drawing), and who, enthusiastic about the study of art in Bahia, tried to collect everything he could in this regard. He had the merit of safeguarding for posterity numerous

[10] Carlos Ott attributes the manuscript to the Bahian painter José Rodrigues Nunes (1800-1881), who wrote it – also according to Ott – between 1866 and 1876.

pieces of information that would otherwise be irretrievably lost, since others who were better equipped for such studies did not consider doing so. At the same time, he published errors, repeating mistakes made by his anonymous informant with regard to works produced before 1820, while contradicting his informant for no apparently serious reason (Ott 1947, 200).

The biographical information about Querino indicates that he was brought up in a literate family that, unusually as Guimarães (2004) observes, encouraged him to study the arts, in addition to taking the art history classes at the School of Fine Art. Therefore, he was not unfamiliar with the subject, which is evident in his writings on the subject. He was also not an uneducated man and moreover, he had a thirst for knowledge and endeavored to obtain it, studying French at night, as it was the language of the best publications available in Salvador. This profile does not match the ignorant wall painter that Carlos Ott described. In any event, according to Freire,

> [...] his merit is undisputed, and the proclaimed absence of scientific training only contributes to his greatness, because even without that training, which is debatable, Querino managed to produce a major work [...] (Freire 2005, 3).

Clarival do Prado Valladares wrote a forceful defense of Querino's use of the anonymous manuscript:

> Before Carlos Ott's accusation continues to damage the memory of Querino, it would be fair to ask whether the use of an anonymous, limited and incomplete text by another author from the late 1800s and early 1900s to supplement a work that extends far beyond that document, was actually a serious offense (Valladares 1967, 141).

In "Notas à margem do livro 'Artistas bahianos' de Manuel Querino" (Margin Notes to the Book *Artistas bahianos* by Manuel Querino, 1951) the art historian Marieta Alves continued the operation of critiquing

the author's work, correcting several errors found in the biographies he researched.[11] In *Dicionário de artistas e artífices da Bahia* (Dictionary of the Artists and Artisans of Bahia, 1976, 11), she clearly states that she will not use his work as a source because she cannot determine its veracity, due to the absence of documentation.

In a paper presented at the Fourth Bahian History Conference, Maria Helena Flexor describes Querino as being more of a chronicler than an historian, lamenting the fact that later authors continued to use him as a source, despite the fact that the errors and inaccuracies present in his work had been made public: "[...] as if time, and other more recent works, did not play a role in the history of Bahian art. His information is repeated without the scrutiny of analysis or criticism, without seeking documentary evidence" (Flexor 2000, 335). Among those who made this theoretical mistake, Flexor mentions Friar Pedro Sinzig (1933), Afrânio Peixoto (1947), Sílio Boccanera Júnior (1921 and 1928), Friar Mathias Teves (1926). Sílvio Romero and Marieta Alves herself, who used Querino as a source in writings prior to the research carried out in the local archives that proved its inaccuracies. "As recently as 1997-98 there are articles citing Manuel Querino as a primary source of information" (Ibid., 336). However, Flexor does not reveal the names of her contemporaries, which makes her criticism unproductive for historians. Observing the dates of the publications she criticizes for using Querino's data, we can see that they are prior to 1947, the year when Carlos Ott published his accusations. As Flexor herself explains, Marieta Alves used this source before her archival research unearthed its flaws. Therefore, we can conclude that the abovementioned authors were unaware of the mistakes made by Manuel Querino, which makes Flexor's criticism inconsistent.

[11] "Retificações sobre autoria das obras de José Joaquim da Rocha, Teófilo de Jesus, João Francisco Lopes Rodrigues, Manuel Inácio da Costa, entre outros" (Valladares 1960, 2).

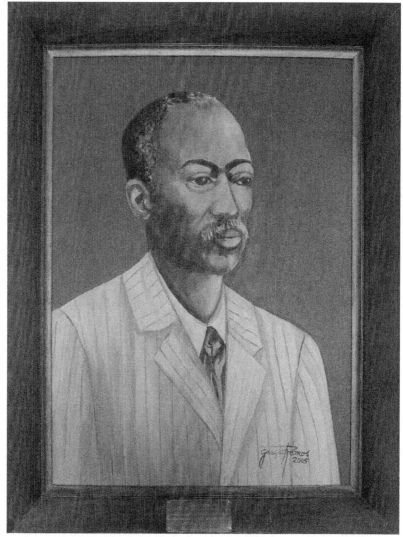

Portrait of Manuel Querino by Graça Ramos (2005)

Having made these observations, let us analyze the works of
Manuel Querino that refer specifically to the arts with a view to
understanding his objectives and methods. A detailed reading of his
work is also necessary to determine whether Manuel Querino can truly
be considered a historian of Afro-Brazilian art.

Recognized as a folklorist and the first Afro-Brazilian historian, his main works were published nationally in Brazil by Artur Ramos in 1938 under the title *Costumes africanos no Brasil* (African Customs in Brazil). As a scholar of art history, Querino began to write about the subject in 1906, through the *Revista do Instituto Histórico e Geográfico da Bahia*,[12] but Manuel Querino's longer works on the arts were both published in 1909: they are the books *Artistas bahianos: indicações biográficas* and *As artes na Bahia: escorço de uma contribuição histórica*. Let us go on to analyze them and their subsequent editions individually.

In *Artistas bahianos: indicações biográficas,* the author outlines the biographies of 194 artists from the eighteenth and nineteenth centuries, including sculptors, painters, *estofadores* (painters specialized in patterning drapery, particularly for religious statues), carpenters, carvers, masons and musicians, also citing nine architects,[13] whose biographies he does not provide, listing their works instead. In 207 numbered pages, he takes up the subject of his article "Os artistas bahianos: indicações biográficas," published in the *Revista do Instituto Geográfico e Histórico da Bahia* (1906), expanding it considerably, as he only featured fifteen artists' biographies in that study. In his book, he starts with sculpture, referring to eighteen names. He divides painting into two periods, before and after the foundation of the Liceu de Artes e Ofícios. In the first, there are forty-three biographies and in the second, thirty. Between the two periods, he includes two sub-items, one on estofadores, including fourteen names, and another on the decorative painting of buildings, which comprises four artists. He mentions twenty carvers, also referring to a marble worker, a surveyor, five *carapinas* (carpenters) and three masons. In the music category he lists sixty-one biographies.

[12] They include "Os artistas baianos" (1906), "Contribuição para a História das Artes na Bahia" (1908), "Teatros da Bahia" (1909), "Contribuição para a História das Artes na Bahia - Os quadros da Catedral" (1911) and "A litografia e a gravura" (1914), among others that do not refer specifically to art and therefore are not mentioned here.

[13] Several professionals who built civil construction works are listed as architects.

A second edition of *Artistas bahianos* was published in 1911, in which Manuel Querino makes several additions. He subdivides the Sculptors section, adding a subtitle – Minor Sculptors – and two of the "major ones" are demoted: Raymundo Nonato Vieira Lima and Jovino de Mattos Guimarães. Among the minor sculptors, he includes the biographies of nine artists. There is only one addition to the painters – the biography of Ângelo da Silva Romão. The same is true for the section on image painters and estofadores, in which he adds a biography for Antônio Valeriano dos Santos. References to music increase considerably, including the biographies of nine artists that were not found in the first edition. In the sections on architects and carvers, respectively, Querino adds three and four more artists. Throughout the book, it is clear that the author has supplemented the biographies with new data obtained in the interval between the two editions.

Some exclusions in the second edition of *Artistas bahianos* are noteworthy: Querino no longer includes carpenters, cabinetmakers and bricklayers, and the question is: did he no longer consider those professions to be artistic activities? The subdivision that he creates in the second edition between sculptors and minor sculptors is an indication that his criteria had changed, adapting a little more to the official conception of art history, with its consequent hierarchies. In the 1911 edition, he favored what were then called the liberal arts: architecture, sculpture, painting and music.

There is also *As artes na Bahia: escorço de uma contribuição histórica* (The Arts in Bahia: Sketch of an Historical Contribution), which was first published in 1909, followed by a second edition in 1913, which has a more essayistic character and is primarily a critical study on the situation of the arts at that time:

> In *As artes na Bahia* [...] he gathered several articles published in the newspaper *Diário de Notícias* in 1908 and 1909 under the title "Contribution to the History of Art in Bahia." In it, architecture, Sculpture, the Teaching Monopoly, Artistic and

Industrial Exhibitions, Decline of the Arts, Geometric Drawing, Art Classification, Theaters of Bahia, biographical sketches of several artists and some articles on political workers, the labor movement in the Republic and the Workers' Congress make up the thematic collection on the world of work and the social, political and cultural situation of the working classes – artists and workers. All of them criticized the situation of the arts and professions in the Republic and, consequently, the shortage of artists and workers in general. It is a text laden with political content. In this edition, article XXVI is entitled "Operários" (Workers), which includes other subtopics under the title "Political Workers"; "Workers' Movement in the Republic" and "The Workers' Congress." In the 2nd edition published in 1913, there are fifty-two additional articles (the first contained 34). The same article was entitled "Tempos Coloniaes" (Colonial Times), with the same subtopics bearing identical titles to those in the previous edition (Leal 2004, 37, note 53).

He begins with a theoretical approach to art history, from which we can ascertain his mastery of the subject and, above all, his conception of art. Manuel Querino obtained his knowledge on the subject in an art school, shaped by the movement called academicism, which was introduced in Brazil after the foundation of the Imperial Academy of Fine Art in 1816,[14] and in Bahia, after the establishment of the School of Fine Art. With an ideology derived from French neoclassicism, this conception repudiated the baroque, blaming that period for the decline of the arts, as clearly expressed in this observation on architecture: "The decline of the arts dates from the mid-sixteenth century[...]. The Renaissance, or rather the rebirth of the human spirit, in its multiple modalities, began to decline in Italy from 1589 to 1680, with the architect Lorenzo Bernini, the creator of the baroque style" (Querino 1913, 2).

[14] It effectively began its activities in 1826.

Querino is just as critical of Portuguese art from the baroque and rococo periods. "None of those beautiful lines on which the eye is happy to rest, but an abundance of cutouts, cornices, contours and bizarre frames" (1913, 4). He blames this heritage for what he considers the bad taste of Salvador's colonial architecture, as expressed here:

> They date from colonial times, and are still largely in existence today, the irregular, low buildings, in an ugly and strong style; churches erected in narrow, winding streets, simple products of neglect, which are still preserved and reproduced, perhaps as a historical reminder of barbarism, or as a symbol of habitual negligence (1913, 5).

This view of art shaped by neoclassicism, which ideologically guided the academies and, naturally, their teachings, demonstrates how much the historian was in line with the aesthetic ideas of his time, as the baroque was only incorporated into the history of art as a positive factor in Europe in the early twentieth century and in Brazil, only with the advent of modernism in the 1920s. Thus, José Valladares made an anachronistic critique of Manuel Querino's bad taste in 1957, in his article "O mau gosto nas ruas da cidade" ("Bad Taste in the City Streets"), which is included in the book *Artes maiores e menores,* by the same author.

Clearly expressed in detail in Querino's book, we find not only a loathing of the baroque and rococo periods but praise of Greek art. He also protests against the destruction of the architectural and artistic heritage of Salvador, a contradiction already pointed out by his chief biographer, Maria das Graças Leal. Another characteristic of academicism manifested in Querino's work is the excess of formalism when developing his narrative on the history of art, as if to demonstrate technical knowledge without regard for contextualizing the periods he analyzes.

Keeping to the method begun in the previously analyzed book, he carries out biographical studies, but in this work, he also devotes his attention to the lives of foreign artists, presenting the biographies of twenty-seven Europeans, ten from other Brazilian states and twenty-four from Bahia who engaged in artistic activities in that state, especially in the state capital, Salvador. He does not mention birthplaces of ten artists. All told, Querino sketches the biographies of seventy-one artists,[15] including musicians, painters, decorators, engineers and members of similar professions.

Precisely regarding one of these foreigners, and presumably for that very reason, Manuel Querino feels free to make a scathing criticism of his artistic competence. This is by no means common in his biographies, which are full of praise and laudatory references. When discussing Oreste Sercelli, the Florentine painter and decorator:

> [...] as a specialist in decoupage, he is a good artist in the genre. He capably paints a fruit, a leaf, a shrub, like those he has seen in Europe[...]. When, however, he approaches figure drawing, it is a complete disaster; deformed features, mere cripples that detract from the richness of the palette and the spontaneity of shades [...] it is intolerable that a representative of the classical school, such as the Italian one, should give solid proof of ignorance of the elementary rudiments of figure drawing, as the works in the School of Medicine attest (1913, 121-122).

His critique of the artist does not stop here, as he compares him unfavorably with two of his contemporaries from Bahia: Firmino Procópio and Cyrillo Marques, former students of the School of Fine Art of Bahia, who decorated the Normal School. They "[...] did not receive lessons from great teachers, nor did they travel" (1913, 122). Querino also found it unforgivable that, when decorating the

[15] The author mentions other artists in some passages of the book. For example, when commenting on sculpture in Bahia, he refers to Chagas, Felix Pereira, Bento Sabino dos Reis, Manuel Inácio do Costa and Domingos Pereira Baião. For organisational purposes, I have only included the biographies with the subject's name in the subtitle.

Fantoches Club for Carnival in 1910, Sercelli excluded architecture from an allegory of the liberal arts. "An inexcusable circumstance in a European artist who attended a higher art school and *claims to have been a professor there"* (emphasis added, 1913, 123). Clearly, Querino doubts that the artist was a lecturer in Florence, which is also implied in the statement he makes at the beginning of the biography: "[...] *said to have been awarded a prize at a competition in Milan"* (emphasis added, 1913, 121). By not accepting these statements, he casts doubt on their veracity and, implicitly, criticizes the preference for foreign artists over their Brazilian counterparts.

In this book, Querino emphasizes the biographies of shipbuilders, carpenters, machine builders, mechanical fitters, iron boilermakers, machinists, smelters, joiners, cabinet makers, masons, and gunsmiths,

> [...] who, in the context of the Republic, saw themselves on the margins of the productive world and creative and professional improvement. He managed to produce a record of the tradition of artistic culture in Bahia, bringing together the names and works of unknown and famous artists in a single document, pointing out the democratic character of art, as well as perpetuating and preserving the stories of workers who would [otherwise] inevitably fall into oblivion (Leal 2004, 293-294).

Unlike the previously analyzed book, *Artistas bahianos,* this work devotes more space to artisans, which makes Querino's research a unique source, since the archives of Salvador's Navy Arsenal, where most of them trained, have been lost.

In an article published in the *Revista do Instituto Geográfico e Histórico da Bahia* in 1909, "Contribuição para a história das artes na Bahia" (Contribution to the History of the Arts in Bahia), Querino addressed the controversy about the nationality and birthplace of the painter José Joaquim da Rocha (1737-1807), siding with those who believed he was born in Bahia, and disagreeing in this respect with the

famous manuscript that was used to compose several of his biographies, as its author refers to José Joaquim da Rocha as an "illustrious Mineiro (native of Minas Gerais)."

"Teatros da Bahia" (Bahia's Theaters), an article that lists the theatrical establishments present in Salvador until 1909, reinforces Querino's theory that the city was experiencing a period of artistic decline. Writing about playhouses that had closed their doors:

> It was at the time when theaters were considered schools of morals and social regeneration, and before the perversion of the taste for football and other kinds of physical exercise; the real sport in Bahia was the theater, and the proof of this fwas the large number of playhouses (Querino 1910, 118).

In 1911, he published an article entitled "Contribuição para a história das artes na Bahia. Os quadros da Catedral" (Contribution to the History of the Arts in Bahia: The Cathedral's Paintings), which he attributes to the Flemish school of painting. The work of an unknown artist, Querino supposes that they were the work of the Bahian monk Friar Eusébio da Soledade. As in the previous article, he does not miss the opportunity to express his disappointment with his time: "And as a lesson to the present, religion and art represent the tradition of a thriving civilization that has passed away" (1911, 63). Querino's disillusionment with his time, artistically, socially and politically, is a constant theme that accompanies all of his work.

A review of Manuel Raimundo Querino's writings clearly demonstrates that, despite his devotion to the cause of Black people in Brazil and the struggle he waged against racial discrimination, he was not always concerned with reporting the color of the artists he biographed, because, out of the more than three hundred names he included, he listed fewer than ten as being Black. Let us analyze his work and see when and under what circumstances he did so.

In *As artes na Bahia* and *Artistas bahianos,* Manuel Querino only refers to the African ancestry of one artist: the musician Manuel Esmeraldino do Patrocínio, who was "colored, but esteemed"

(Querino 1909, 131). This information is found in a quotation by one Dr. Milton, the author of *Ephemerides cachoeiranas* (Daily Life of Cachoeira).[16] As for the rest, our author says nothing about the color of many of the artists, which has been made public in subsequent writings. One case is emblematic of Querino's reluctance to embark on that undertaking: his biography of the artist Chagas, known as "O Cabra."[17] The aforementioned manuscript, which he utilized, reads as follows: "Perhaps a century ago, an admirable genius existed in the person of a Bahian, *a dark-colored man*, 'O Cabra,' named Chagas" (emphasis added, Freire 2000, Appendix II, 7). However, Querino omits this information in the two books published in 1909, and only in 1918 does he describe Chagas as Black.

In his essay published that year, "O colono preto como factor da civilização brasileira" (The Black Colonist as a Factor in Brazilian Civilization), Querino names two artists among the *mestiço* (mixed-race) individuals "[...] the illustrious Pleiad of talented men who, in general, represented the most select in affirmations of knowledge, true glories of the nation" (1918, 156). They are José Teófilo de Jesus and Chagas, "O Cabra." This is a brief list for someone like Querino, who was familiar with the large number of Black and mestiço artists in Salvador, but, as he observes, he only mentions the dead. His article "Os homens de cor preta na História" (Black Men in History), was published in 1923 in the *Revista do IGHB*. In ten pages, Querino lists a number of important men who were Black, referring to their activities and achievements in society. This article follows a more emphatic line of activism in favor of the Black cause that began in 1918, with the abovementioned essay. The six artists include Emigdio Augusto de Mattos, an apprentice bricklayer who nearly became an engineer (he died in the third year of his engineering course), as well as Malaquias Perminio Leite, a schoolmaster and draftsman, Manuel Fernandes do

[16] As on several other occasions in the books written by Querino, the citations are incomplete, sometimes omitting the name of the author, the book, and other references.

[17] [Editor's Note: Cabra literally means goat, but is also a Brazilian racial classification, meaning dark, but lighter than Preto (Black).]

Ó, a captain and architect, in addition to the musicians João Baptista Henriques de Paiva, João Bispo da Egreja and Joaquim de Sant'Anna Gomes.

However, several other artists, who were much more famous than those mentioned as Blacks, worked in Salvador and with whom Querino himself must have had the opportunity to rub shoulders or learn about their African ancestry, are not identified. Furthermore, when writing his own biography, Querino does not self-identify as Black. Among the most famous subjects of his biographies, we can name Bento Sabino dos Reis, Domingos Pereira Baião, Veríssimo de Souza Freitas, José Theophilo de Jesus, Antônio Joaquim Franco Velasco, João Chrysostomo de Queiroz, Victorino Eduardo de Oliveira, Cyrillo Marques de Oliveira, Captain Cypriano Francisco de Souza, Victoriano dos Anjos, Antônio Rafael Pinto Bandeira and Antônio Firmino Monteiro. However, Querino says nothing about their ancestry.

Having mentioned Manuel Querino's reticence in describing as Black many of the artists whose lives he recounts, and by engaging in dialogue with the historiography of Afro-Brazilian art, my intention is to do away with a misunderstanding that has permeated his story. It is said that Querino is an essential historian because he wrote the biographies of Black artists from the eighteenth and nineteenth centuries, not allowing their ethnicity to fall into oblivion. However, a reading of this author's work makes it impossible to corroborate this statement, as we have shown when analyzing his writings on art.

In Emanuel Araújo's[18] "Introduction and Proposal," the essay with which he introduces the catalog *A mão Afro-brasileira (The Afro-Brazilian Hand),* published in 1988, and which remains the most important reference work on Black participation in Brazilian art, he observes:

[18] This renowned artist is also a curator, editor, museum director and writer, among other activities. Over the past twenty years, he has carried out numerous projects, including curating exhibitions, publishing catalogues and books, and opening a museum that houses his own collection of art of African origin from both sides of the Atlantic.

However, past scholars who were concerned about the ethnicity of the artists are rare. The Bahian Manuel Querino – a Black writer, researcher and journalist – was, in a way, the pioneer of these studies, obviously limited to Bahia. Many critics contest the value of Querino's work due to the imprecision of data and attributions that have not been historically proven, but the truth is that he preserved names, important references that would certainly have fallen by the wayside had it not been for his initiative (Araújo 1988, 9).

In his eagerness to give a positive assessment of Manuel Querino's work, Araújo, whose industry and constant efforts over the course of at least thirty years have contributed to our knowledge of the African ancestry of Brazilian artists and to the development of studies on Afro-Brazilian art, seems to exaggerate the few mentions in which Querino cites the color of the artists' skin, as we have seen.

Another author, Carlos Eugenio Marcondes de Moura, whose essay "O negro na formação cultural do Brasil: tentativa de nominata e iconografia" (Blacks in the Cultural Formation of Brazil: An Attempt at Name Listing and Iconography) is also included in the catalog *A mão afro-brasileira*, repeats this mistake:

From these broad overviews of the history of collectivities, we go back to conceptualizing the attempt at name listing, which is so personalized. The essays by Manuel Querino, Gilberto Freyre, Arthur Ramos, Abdias do Nascimento and Oswaldo Camargo on the presence of Blacks in the visual arts, in literature and on the social rise of the mulatto in the Second Reign [the reign of Emperor Pedro II, 1840-1889], listed in the bibliography, served as a starting point for the organization of this survey. These reference works were an invaluable source of information (Moura 1988, 371).

In her article "De Querino a Araújo: testemunho e resgate do artista negro na historiografia da arte brasileira" (From Querino to Araújo:

Witnessing and Reinstating the Black Artist in the Historiography of Brazilian Art), the Bahian art historian Luciana Brito observes:

> [...] the appearance of Black artists in the historiography of Brazilian art is largely due to the studies and efforts of Manuel Raimundo Querino, who introduced in Bahia the first publications containing historical and biographical data on Black artists and their works (Brito 2006, 30).

Brito goes on to list the works in which, in her view, that information is provided: *Artistas bahianos: indicações biográficas* and *As artes na Bahia, escorço de uma contribuição histórica.* She also mentions *A raça africana e seus costumes na Bahia, O colono preto como factor de civilização brasileira,* "Candomblé de caboclo," "Homens de cor preta na História," *A Bahia de outrora: vultos e fatos populares, A arte culinária na Bahia* and *O africano como colonizador* (Brito 2006, 30-31), which, as we have seen, add little to our knowledge of Black Brazilian artists.

Brito also emphatically insists:

> However, *by identifying and recording biographical data about Black artists and their works,* he provided future generations with significant and indispensable research material on a subject so little discussed in the historiography of Bahian art [...] (emphasis added, Brito 2006, 31)

This article consolidates the myth of Manuel Querino as an historian of Afro-Brazilian art, because the author very clearly draws a line from him to Emanuel Araújo. Treating Manuel Querino as an historian of Afro-Brazilian art, and equating him with Emanuel Araújo, who is responsible for a body of work that recognizes the art produced by Blacks in Brazil, is an historiographic distortion that does not help us understand Querino's work. Instead, it mythologizes it, as he was actually an art historian who was Afro-Brazilian and not, as has been claimed, a scholar of Afro-Brazilian art history.

We can say that, in the discourse that can be read between the lines, by featuring names that would have fallen into oblivion had it

not been for his work, Querino dealt with Black artists, but were it not for later works, including that of Marieta Alves, who does identify them as Black, brown or mulatto, we would still have their names, but we would not know that they were non-white. Consequently, we would have whitened them, as that is this color of artists in the popular imagination and, according to the paradigm established by Joel Rufino dos Santos in the foreword to *A Mão afro-brasileira*, it is a matter of "[...] *identifying as Blacks those who were Black"* (1988, 10).

This begs the question of why Querino omitted that information. The answer can be found in the underlying clues found in his works. The first is the time line for his writings, and the changes in focus regarding Black people that we can perceive in them.

When he published *Artistas baianos* and *As artes na Bahia* in 1909, the author wanted the artists to be recognized for the merits of their work, while denying them their color. In these biographies, he makes a point of revealing the artists' social backgrounds, emphasizing their poverty, productivity, and, frequently, the bitterness and hardships faced by those who did not receive the recognition they deserved. The focus is not on race, but class:

> [...] he came to the defense of talent, regardless of the social pressure that was imposed by society in its class divisions. In this sense, he rediscovered existing talents in the popular milieu, identified by their artistic and human qualities, producing biographies that sought to demonstrate that the effort to develop talent was much more significant than class. While valuing artists for their work, he reported how much they were rejected and discredited in society, consequently dying in obscurity and the direst poverty (Leal 2004, 297).

In the first decade of the twentieth century, Querino began focusing directly on the "Black question" in the articles already analyzed: *O colono preto como factor da civilização brasileira* and *Os homens de cor preta na História* in which, however, the focus is not on artists, although he mentions some – fewer than ten, as we have noted. His scruples about

identifying his colleagues as Black can be explained by the negative view of their ethnicity in Bahia at the beginning of the century. Thus, implicit in his discourse is that Black people were competent, capable and productive, "despite being Black."

Another reason for this omission can be found in the strategy Querino devised to defend his brothers in race. Among the ideas in circulation in his time, he is indebted to those of Booker T. Washington (1856-1915) (Querino 1955, 23), an African American activist and theorist whose autobiography *[sic]* was published in installments in a Salvador newspaper in 1902 (Guimarães, 2004, 16).[19] Washington was the founding teacher of the Tuskegee Institute, a technical school created in 1881 in the state of Alabama and devoted exclusively to educating Black people.[20] There, he applied his ideas that the improvement of living conditions and the achievement of civil rights for African Americans were linked to their training for industrial activities, ownership of property and the consequent social respectability (Lopes, 2004, 682). It aimed to integrate Black people into white ways of life and, above all, white values, a project which Manuel Querino supported in many ways.

His writings exude the belief in the regenerating power of art (fine arts or crafts) through the appreciation of personal talent. He exemplifies this conviction in the lives showcased in his work: we see many men of the people, some of whom were Black, who studied at the Naval Arsenal, at the Liceu de Artes e Ofícios and the School of Fine Art. They were distinguished for their dedication and commitment as good professionals, and some achieved what Querino saw as the supreme glory: public recognition.

[19] [Editor's Note: This was actually a review of Washington's autobiography *Up from Slavery*, written by the French journalist Th. Bentzon (for a full transcription, in Portuguese, see Gledhill, Sabrina. *Travessias no Atlântico Negro: reflexões sobre Booker T. Washington e Manuel R. Querino*. Salvador: Edufba, 2020, Anexo II).]

[20] [Editor's Note: The original focus of the Tuskegee Institute was on training teachers and providing job skills to the newly emancipated African Americans after the abolition of slavery in the US. It is now an historically Black university.]

For example, Malaquias Perminio Leite was one of the artists Querino mentioned in his article "Os homens de cor preta na História" (1923), although he included Leite in *As artes na Bahia,* without identifying him as Black:

> As a significant example of how much hard work and perseverance can achieve, when served by a disciplined intelligence, the artist I am discussing, lauded for his efforts, has always enjoyed the highest consideration of his superiors, who esteemed him as a superior man and a good servant of the motherland.[...] There we find a hero not only of labor but of intelligent and productive labor, a beautiful example of how much the energetic action of perseverance can attain (Querino 1913, 240-41).

Thus, we can see that on several occasions, when he writes about the life of an artist who is later identified as Black, Querino generally makes a point of emphasizing his professional competence, the respect and recognition he obtained and even the discrimination he suffered with regard to awards. This was the case with Cyrilo Marques de Oliveira, who was passed over in a competition that gave the winner an opportunity to study in Europe, "[...] despite having done better than his rival, Archimedes José da Silva, who was preferred" (Querino 1909, 110). However, he does not give the reason for that discrimination.

Manuel Querino's omission regarding the African ancestry of most of the artists he dealt with does not discredit the author. Instead, it evinces possible awareness in its historical context when dealing with art history, a discipline marked by elitism and a concept of art based on the parameters of European scholarship. If it was already difficult to elicit admiration for Brazilian artists, who often came from a working-class background, generally without the privilege of a European education, that task would be even harder if the artist were identified as Black.

In conclusion, Manuel Querino was an art historian of the greatest importance to Bahia and Brazil. The first to engage in such

studies in Bahia, he used the long-established biographical tradition as his method of spotlighting artists and giving them their due. Two forces played a part in his aesthetic training: academicism and a strong sense of dignifying the arts and especially artists, not only those belonging to the so-called major arts, but especially those we now classify as manual workers, artisans and specialized craftsmen, or in the sense used by Querino, "mechanical artists." Requiring him to be an historian of Afro-Brazilian art in his approach to high art at the beginning of the twentieth century goes beyond what was possible in his time and place.

Bibliography

Alves, Marieta. "Notas à margem do livro *Artistas bahianos* de Manuel Querino." *Anais do I Congresso de História da Bahia* V (1951) 535-543.

———. *Dicionário de artistas e artífices na Bahia.* Salvador: Universidade Federal da Bahia; Conselho Estadual de Cultura, 1976.

Amado, Jorge. *Navegação de cabotagem.* Rio de Janeiro: Record, 1992.

———. *Tenda dos milagres.* 40th ed. Rio de Janeiro: Record, 2000.

Araújo, Emanuel. (ed.) *A mão afro-brasileira.* São Paulo: Tenenge, 1988.

Barros, J. Teixeira. "Manuel R. Querino." Querino, Manuel. *A Bahia de Outrora.* Bahia: Livraria Econômica, 1922.

Bazin, Germain. *História da História da Arte. De Vasari a nossos dias.* São Paulo: Martins Fontes, 1989.

Boccanera Júnior, Sílvio. *Bahia histórica: reminiscências do passado registro do presente.* Bahia: Typ. Bahiana, 1921.

———. *Bahia epigraphica e iconográfica.* Bahia: s.n., 1928.

Brito, Luciana. "De Querino a Araújo: testemunho e resgate do artista negro na historiografia da arte brasileira." *Cultura Visual. Revista do Mestrado em Artes Visuais da Escola de Belas Artes* 8 (Second Semester 2006): 29-35.

Calmon, Jorge. *Manuel Querino: o jornalista e o político.* Salvador: CEAO, 1980.

———. *O Vereador Manuel Querino.* Salvador: Câmara Municipal de Salvador, 1995.

Flexor, M. H. M. O. "Historiografia das artes plásticas da Bahia." *Anais do IV Congresso de História da Bahia* (2000): 333-46.

Freire, Luiz Alberto Ribeiro. A talha neoclássica na Bahia. PhD thesis. Departamento de Ciências e técnica do patrimônio. Universidade do Porto. Portugal, 2000.

———. "Descuido corrigido." *A Tarde.* Salvador, 17 December 2005.

———. *A talha neoclássica na Bahia.* Rio de Janeiro: Versal, 2006.

Guimarães, Antônio Sérgio Alfredo. "Manuel Querino e a formação do 'pensamento negro' no Brasil, entre 1890 e 1920." Comunicação apresentada no 28°. Encontro Nacional da ANPOCS. Caxambu, October 2004. [Accessed 27 March 2021

<https://www.scribd.com/document/138237337/Manuel-Querino-e-a-formacao-do-pensamento-negro-no-Brasil-de-A-S-A-Guimaraes>]

Leal, Maria das Graças de Andrade. "Manuel Querino entre letras e lutas - Bahia: 1851-1923." PhD thesis (History). Pontifícia Universidade Católica de São Paulo, 2004.

Leite, José Roberto Teixeira. *Pintores negros do Oitocentos*. São Paulo: Emanuel Araújo Editor. 1988.

Lopes, Nei. *Enciclopédia brasileira da diáspora africana*. São Paulo: Selo Negro, 2004.

Ott, Carlos. "Noções sobre a procedência da arte da pintura na Província da Bahia. Manuscrito transcrito pelo autor." Rio de Janeiro: *Revista do Patrimônio Histórico e Artístico Nacional* 11 (1947): 197-218.

Pacheco, Renato. "Três folcloristas centenários." *Jangada Brasil* 36 (August 2001).

Peixoto, Afrânio. *Livro de Horas*. Rio de Janeiro: Agir, 1947.

Querino, Manuel. "Contribuição para a história das artes na Bahia." *Revista do Instituto Geográfico e Histórico da Bahia* 34, vol. XV (1909): 79-82.

————. "Teatros da Bahia." *Revista do Instituto Geográfico e Histórico da Bahia* 35, vol. XVI (1910): 117-133.

————. "Contribuição para a história das artes na Bahia. Os quadros da Catedral." *Revista do Instituto Geográfico e Histórico da Bahia*. Salvador: Litho-Typ. e enc. Reis e C. 36, vol. XVII (1911): 59-67.

————. *Artistas bahianos*. Rio de Janeiro: Imprensa Nacional, 1909.

————. *Artistas bahianos*. 2nd ed, revised. Salvador: Officinas da Empreza "A Bahia," 1911.

————. "Os artistas bahianos. Indicações biográficas." *Revista do Instituto Geográfico e Histórico da Bahia*. Salvador: Litho-Typ. e enc. Reis e C. 31, vol. XII (1906): 94-115.

————. *As artes na Bahia: escorço de uma contribuição histórica*. Ed.. Salvador: Officinas do Diário da Bahia, 1913.

————. "O colono preto como factor da civilização brasileira." *Afro-Ásia* 13 (1980) [1918]: 143-158.

————. "Os homens de cor preta na história." *Revista do Instituto Geográfico e Histórico da Bahia*. Salvador: Imprensa Oficial do Estado, no. 48 (1923): 353-363.

————. *Costumes africanos no Brasil*. Rio de Janeiro: Civilização Brasileira, 1938

————. *A Bahia de outrora*. Salvador: Livraria Progresso, 3rd ed., 1954.

————. *A Raça africana e seus costumes na Bahia*. Salvador: Livraria Progresso, 1955.

Sinzig, Frei Pedro. *Maravilhas da religião e da arte na egreja e no convento de São Francisco da Bahia*. Rio de Janeiro: Imprensa Nacional, 1933

Sodré, Jaime. *Manuel Querino, um herói da raça e classe*. Salvador: s.n., 2001.

Teves, Mathias Frei. *A egreja de S. Francisco da Bahia*. Bahia: Imprensa Oficial do Estado, 1926.

Valladares, José. "O mau gosto nas ruas da cidade." *Artes Maiores e Menores*. Bahia: Publicação da Universidade da Bahia (1957): 111-114.

Valladares, Clarival do Prado. *Riscadores de milagres. Um estudo sobre arte genuína*. Rio de Janeiro: Superintendência de difusão cultural da Secretaria de Educação do Estado da Bahia, 1967.

Wölfflin, Heinrich. *Renascença e Barroco*. São Paulo: Perspectiva, 1989.

————. *Conceitos Fundamentais da História da Arte. O problema da evolução dos estilos na arte mais recente*. 2nd ed. São Paulo: Martins Fontes, 1989.

6. GROUND-BREAKING USE OF PHOTOGRAPHS IN AFRICANIST STUDIES

Christianne Silva Vasconcellos[1]

In 1916, Manuel Raimundo Querino presented a paper entitled "A raça africana e seus costumes na Bahia" (The African Race and their Customs in Bahia) at the Fifth Brazilian Geography Conference, held in the city of Salvador, Bahia, from September 7 to 15. That essay was an ethnographic study of the African peoples in Bahia, based on an analysis of the religion and work and social strategies of Salvador's African population. His sources were photographs and oral histories from those Africans and their descendants who lived in Salvador in the first decade of the twentieth century. His arguments were, in part, based on the statements of "venerable elders," with whom Querino suggests that he maintained relations of solidarity and friendship.[2]

In this chapter, I stress that Querino's essay made pioneering use of photographs in historiographic production on the subject of Africans in Bahia. In another study, I used his essay as a source for identifying the uses and meanings of photography in turn-of-the-

[1] This chapter is an adaptation of "O Uso de Fotografias de Africanos no Estudo Etnográfico de Manuel Querino." *Sankofa*. Revista de História da África e de Estudos da Diáspora Africana, no. 4 (Dec. 2009).

[2] At no point does the author claim to belong to the religion he describes. He highlighted the reserve maintained by Africans regarding religious rituals and the relationship of trust that he established with his informants: "news that we have gathered from venerable elders and that they have given us without reservations or subterfuge, because in us these people did not see more than a friend of their race, or who with sincere sympathy, has always respected and done justice to the people whom captivity demeaned, insulted and persecuted, without ever managing to change their innate, affective qualities" (Querino 1917, 7). Throughout the essay, Querino mentions the Gantois terreiro and Candomblé practitioner Manuel de Xangô. For an ethnography of Candomblés in Bahia, see Pares 2007, Reis 2008, Castillo 2009 and Castillo and Parés 2007.

century Bahia until 1916.[3] Some portraits were not produced specifically for Querino's work, but for commercial purposes, undergoing a change of meaning as illustrations for his essay. The photographs portraying the material culture of Candomblé also deviate from commercial standards, albeit in a different way. Therefore, they may have been produced specifically for this ethnographic analysis without keeping to the norms of ethnographic photography.

From that perspective, I will analyze the terminology Querino used to identify the photographs, and the terms developed by social evolutionism during the same period. However, unlike contemporary authors such as Nina Rodrigues and Sílvio Romero, who used evolutionism to situate Africans and their descendants at a lower stage of development, Querino pointed out the contributions of those populations to the construction of Brazilian society. I will also seek to identify the key aspects of the ethnographic approach developed by Querino, and how this procedure presented a positive view of Africans in Bahia.

"A raça africana e seus costumes na Bahia" contains twenty-three photographs, including fifteen portraits of Black men and women, five images of votive objects, three photographs of sculptures and two prints. The documentary value of the collection is clear, as some portraits are only known to us thanks to the publication of Querino's essay. This is particularly true of the statues of orishas, the Mermaid's Waterfall – Candomblé do Gantois Peji, the high altar of the Peji, the shrine of Humoulu (Omolu) and musical instruments of African origin, which form a unique record of the material culture of Candomblé. The plates illustrating Querino's essay are shown below in the same order as they appear in the text. All of them are entitled "Estampa" (Plate or Print), numbered with roman numerals and identified according to the ethnographic terminology of the time.

[3] That essay is part of chapter 3 of my master's dissertation: Vasconcellos, Christianne, "O circuito social das fotografias da Gente Negra. Salvador 1860-1916." Salvador, UFBA, 2006.

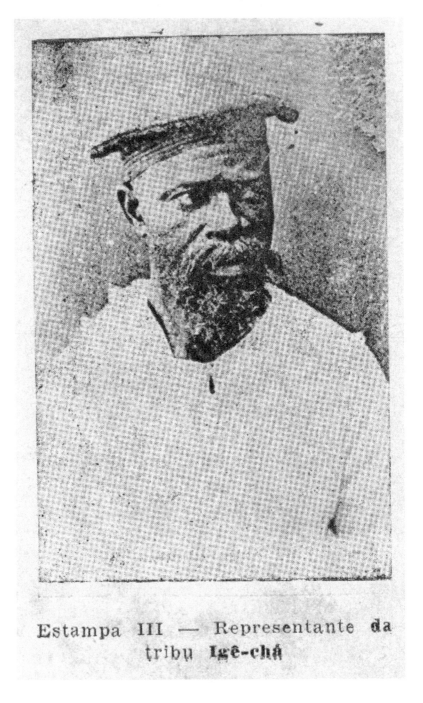

Estampa III — Representante da tribu Igê-chá

Plate III. Representative of the Ijesha Tribe

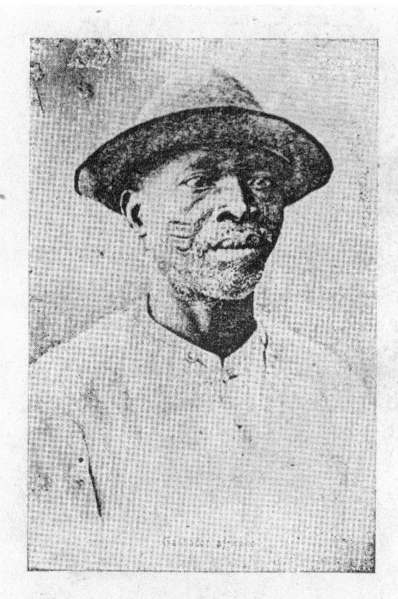

Estampa IV — Representante da
tribu **Iorubá**

Plate IV. Representative of the Yoruba Tribe

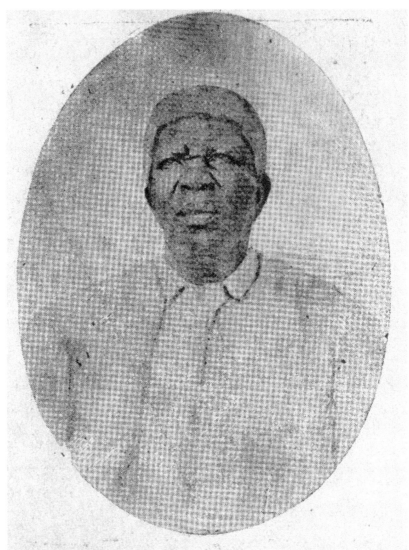

Estampa V — Representante da tribu Igê-chá. Descendente de familia real

Plate V. Representative of the Ijesha tribe. Descendant of a royal family

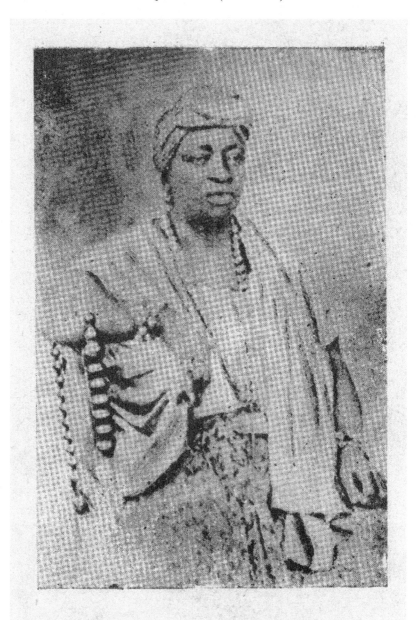

Estampa VI — Typo Ben'n

Plate VI. Benin Type

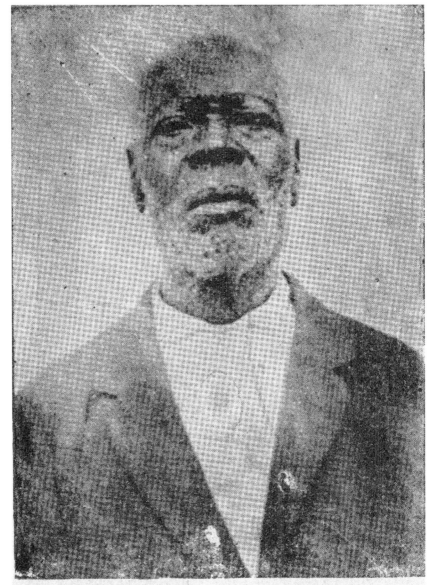

Estampa VII — Typo Igê-chá

Plate VII. Ijesha Type

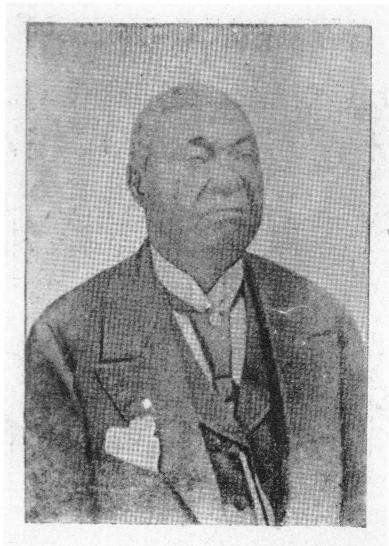

Estampa VIII — Typo **Iorubá**

Plate VIII. Yoruba Type

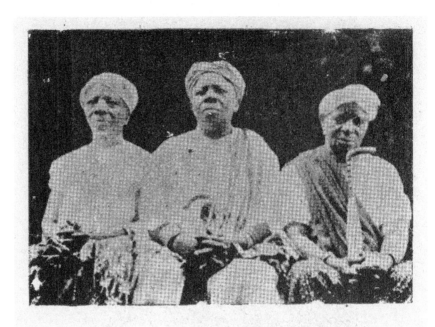

Estampa IX — Oondó Igê-chá Igê-chá

Plate IX. Ondo, Ijesha, Ijesha

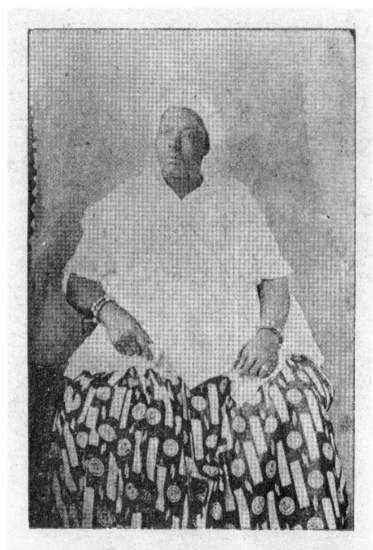

Estampa X — Typo Gêge

Plate X. Jeje Type

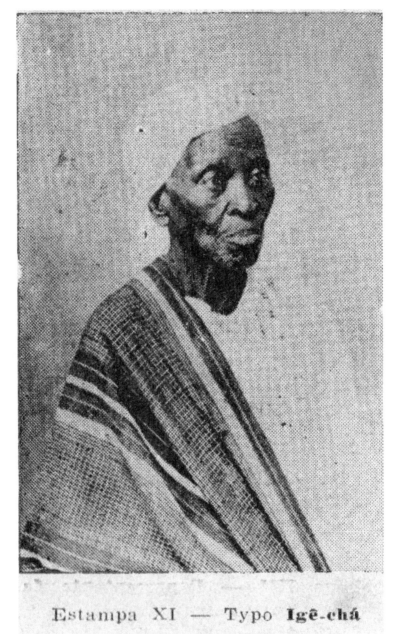

Estampa XI — Typo Igẽ-chá

Plate XI. Ijesha Type

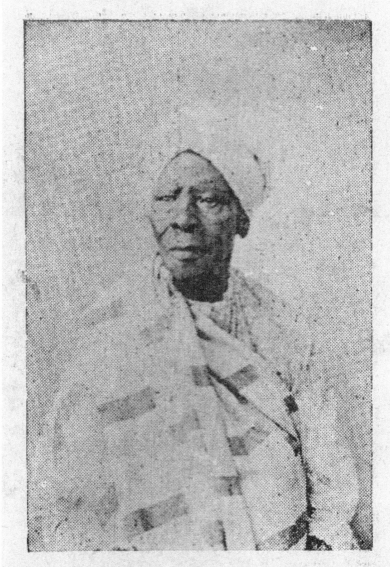

Estampa XII — Representante da
tribu Igê-chá

Plate XII. Representative of the Ijesha tribe

In the captions that accompany each photo, Querino specified the presence of people from the Yoruba, Ondo, Egba and Ijesha cultural groups, all Yoruba-speaking, who were called Nagô in Bahia. The author's identification is corroborated by data from the transatlantic slave trade, which show that these individuals came from the interior of the Bight of Benin region, particularly from what is now Nigeria and the eastern part of the Republic of Benin. The conflicts that took place in that region of Africa in the early nineteenth century led to local migrations and wars whose captives were enslaved and sold, particularly to Brazil and Cuba (Verger 2002).

In the late nineteenth century, the term "Yoruba," originally used by the Hausas to designate the neighboring Oyo people, was extended in southern West Africa to all speakers of the same language, which was also called Yoruba. According to Matory, at the turn of the century, "Black cultural agents" developed a single culture based on the standardization of the Yoruba language and the affirmation of the value of Yoruba culture. Those agents were members of an African elite educated in the United Kingdom, including African American ministers recently converted to Christianity, initially living in Freetown, Sierra Leone, and later in Lagos, Nigeria. This group was joined by Afro-Brazilians who returned to that city. The idea of the superiority of the Yoruba people was spread by those agents, who argued in West Africa, Britain and Brazil, that the sophistication and civilizing aspects of their culture were a means resisting the pressures of colonialism (Matory 1999). However, in Querino's essay, populations appear with specific ethnicities. For example, when the author specifies a "Yoruba type," he is probably referring solely to the people of Oyo. This suggests that the Yoruba unity being built up in Africa still lacked a parallel among the West-African population in Bahia.

However, Querino does not include term Nagô among the "types." This could mean that he wanted to avoid generalizations, as Nagô was an umbrella term used to refer to West Africans in general. This is an important point, as it demonstrates the ethnographic richness presented by Querino, who individualized the cultural

contributions of peoples who were mixing and redefining themselves in Africa.

The cultural group that most frequently appears in the captions of the photos Querino used is the Ijesha people. This coincides with the fact that that cultural group was one of the chief victims of the last decade of the transatlantic trade to Bahia (Peel 2003, 28-30; Verger 2002, 233-256). Therefore, members of that group survived until the end of slavery in larger numbers than other groups. Another important theory is that the majority of the Candomblé community Querino studied was Ijesha. He identified one of those Ijeshas (Plate V) as a "descendant of a royal family," which the British consul James Wetherell corroborated in 1843 when he wrote about the presence of "Negro princes" in Salvador who were greeted reverently by their fellow countrymen in their native language. The terms "type" and "representative" with which Querino identifies the photos were also used in contemporary anthropological studies, such as those by Louis Agassiz and Nina Rodrigues. These studies classified peoples within the framework of social evolutionism, whose taxonomic project, originally applied to nature, was quickly used to explain the evolutionary stages of different human societies. Nevertheless, Querino stood out from other evolutionist authors when he demonstrated that the ethnic diversity of the Africans was an asset to Brazilian society.

To understand the unique nature of Querino's arguments, we must first understand the process of establishing social evolutionism in Europe, and then how that trend was interpreted by scholars in Brazil. In his analysis of that project, Johannes Fabian observes, "The paradigm of evolutionism rested on a conception of time that was not only secularized and naturalized but also thoroughly spatialized" (1983, 14-15). As Anne McClintock notes,

> The axis of time was projected onto the axis of space, and history became global. With Social Darwinism, the taxonomic project, first applied to nature, was now applied to cultural history. Time became a geography of social power, a map from which to read a global allegory of the 'natural' social difference" (1995, 37).

These analyses show that a new concept of time, born from Darwin's theory of evolution, was used to understand the differences between human societies, classifying them within a hierarchical scale. In this sense, it was assumed that each social formation, despite existing simultaneously, exhibited a different stage of the human evolutionary chain destined to attain civilization. In fact, a unilinear development model of human history was built in which everyone had to reach the highest stage: that already attained by the Europeans, the only one considered "civilized." Only urbanized and literate societies deserved this qualification due to their technological development, their capacity to organize bureaucratic states, linguistic superiority and Christian monotheism.

In this concept of time spatialized by the Europeans, Africans were classified as being at the earliest stages of development. Their political organization was called tribal, with charismatic leaders or theocracies, their religions called fetishist beliefs, sects and idol worship, and their languages considered unwritten dialects. In Querino's day, the world had become a showcase of social evolution, and all groups were classified and situated at the evolutionary stages through which all human societies would have to progress.

These were the theoretical paradigms used by Louis Agassiz and, soon afterwards, by the professors of the Bahia School of Medicine, such as Nina Rodrigues, a contemporary of Manuel Querino. Agassiz, a professor at Harvard University, spent some time in Brazil between 1865 and 1866, where he defended and spread the ideas of scientific racism among Brazilians. Agassiz visited the Amazon and Northeast, where he conducted studies of Brazilian and African miscegenation. A follower of the polygenist theory, he believed that there were different races in the human species, as well as different stages of development at which those races were located.

Following the conventions developed by Social Darwinism, Agassiz commissioned and directed photographic series of enslaved Africans, *mestiços* and indigenous people in Brazil, which were used in

his investigations into racial typologies. The photographs were taken by Walter Hunnewell, a member of Agassiz's commission, and Augusto Stahl and Germano Wahnschaffe, German photographers based in a studio in Rio de Janeiro since 1863 (Kossoy 2002). The composition of this type of photography consisted of a portrait without background details, taken in a narrow space, where the subject was placed naked, alone, posing at different angles: profile, front and back. A ruler was included in the frame to measure the physical proportions of people categorized as "races." The focus and lighting favored the detailed portrayal of the subject's physical features. The eyes were photographed when lowered or focused outside frame and the subject could be seen from the front, side and back in the same group. Finally, the images were arranged to suggest a "species catalog" (Alinder 2003).[4] This sort of photograph was intended to find physical differences and images were used as records for classifying non-European human types.

The photographs Querino utilized were not produced for the purpose of recording human types and, therefore, their composition is different. Taken a few years before the publication of his essay, most of the images date from the turn of the twentieth century. Part of the collection (Plates III, IV and XVIII) consisted of public photographs, produced in series called "urban types" of Bahia. They were sold as postcards or *cartes-cabinet* at the photographer's studio, as well as in bookstores, gift shops and stores selling household goods. Advertised in newspapers as photographs of "types," they bore captions that highlighted the occupation, color or ethnicity of the person portrayed, such as "porter," *ganhador* (a person who hired out their services, usually as a street vendor or porter), Creole or African. Such captions demonstrate that terms used during slavery, particularly those which implied that Black people had a different social status, remained in use during the post-abolition period.

The words *typo* ("type") and *representante* ("representative") in Querino's captions are terms used in scientific epistemology, which

[4] The collection is now housed in the Peabody Museum at Harvard University.

brought him closer to the ideas of evolutionism. Despite using the racialist concepts of his time, however, he identifies the hard work and technological and artistic skills specific to each African cultural group as civilizing contributions to the social development of Bahia. He states that, although they were enslaved and therefore deprived of material advantages, which hindered their development, these peoples had made a major contribution to Brazilian civilization. Thus, he was directly confronting the predominant ideas of his time, which viewed the work of Africans and their descendants as inferior to that of European immigrants.

Querino associated the physical and behavioral characteristics of women with their adaptation to different kinds of work. The Jejes [Gbe-speaking peoples] were considered "the most loving in terms of the function of motherhood" and, therefore, "sculptural correctness; they did not have their faces cut with lines and used to paint their lower eyelids blue, out of coquettishness or for embellishment" (1938, 98). His emphasis on these characteristics goes against the discourse of the doctors at the Bahia School of Medicine, who believed that African wet nurses not only passed on diseases but were completely amoral. An example of this medical discourse is found in a thesis defended in 1855. Its author argues that wet nurses should have qualities that not only include physical attributes, but, above all, moral ones. It also stated that it was nearly impossible to find all the attributes necessary for an ideal wet nurse or nanny in the same person, especially in Brazil,

> where the women given to this task are usually African, stupid, immoral, uneducated, lacking in beauty, without religion, devoid of affectionate feelings, badly made, irascible, unclean, hateful, slovenly, with rough skin, often bringing with them those diseases which can be transmitted through nursing. Among us I believe that one should always prefer a free [not enslaved] wet nurse (Vianna 1855, 24).

Although he used physical typologies associated with moral attributes and types of labor, Manuel Querino opposed racialist ideologies,

stressing the value of this population's active participation in Bahian society.

Why did anthropology, beginning in the nineteenth century, use phenotypes to identify a person's cultural belonging? According to the Comaroffs, in the 1800s, there was a historical break in scientific epistemology, marking the difference between the sixteenth-century chronicler and the nineteenth-century naturalist. In the course of this transformation, the use of images was fundamental, because, if in previous centuries the differences among peoples and nations were narrated through events and circumstances, with the emergence of photography, considered an exact replica of reality, they tried to record the entire visible world in order to go on to organize, order and classify it (Comaroff 1991, 86-125).

Furthermore, in an appropriation of the Darwinian paradigms of "natural selection," "evolution" and "heredity," a biological interpretation of the human body that extended to culture was developed in which not only physical but cultural differences were seen as the result of organic and natural laws. Based on this "new biology," the concept of evolution was established as the paradigm of the time, and all peoples and races began to be ranked according to their physical, mental and moral characteristics (Edwards 1996, 14). In this hierarchy, images of African bodies supposedly reflected their stage of cultural development. Specifically, they were classified at the most primitive level of the evolutionary scale. When treating Africa and its inhabitants as savages, the writings of naturalist travelers strove to present "accurate" descriptions of both bodies and customs (Comaroff 1991, 108). The Africans represented the transition between animality and humanity, and the explanation for their inferior ranking lay in the color of their skin and the shapes of their bodies. The introduction of photography made it possible to portray these "bodies" objectively. As Edwards observes,

> [photography] becomes a metaphor for power, having the ability to decontextualize and appropriate time and space and those which exist within it. [...] Photography assisted the

process of treating abstractions as material objects to the extent that the mind's creations became concrete, observed realities, recorded in the camera's mechanical eye. Through photography, for example, the "type," the abstract essence of human variation, was perceived as an observable reality. The unavoidable detail created by the photographer becomes a symbol for the whole and induces the viewer to admit the specific as a generality, becoming an emblem of broader truths, at the risk of stereotyping and misrepresenting (1996, 16-17).

Indeed, photographs have become indispensable tools for describing peoples and cultures from the perspective of racialist elaborations of anthropology. As Querino added the term "type" or "representative" to cultural groups, this demonstrates his access to these racialist discourses in which physical heritages established a direct relationship between the body and cultural expressions. The methodology used by this trend, as the Comaroffs explain, was to associate an individual's phenotype with the culture to which he or she belonged. A second step for the same methodology consisted of locating the place this phenotype occupied within the hierarchy established by cultural evolutionism. Once phenotype was associated with behavior, scientists no longer needed to refer to the behavior, as they placed the individual within the Darwinian hierarchy with their phenotype alone (Comaroff 1991, 98-99). The invention of the "Hottentot woman," the best-known stereotype of African women, was created during the nineteenth-century European scientific expeditions in South Africa. Under the pretext of seeking "samples of the inferior races," these expeditions subjected women who were kidnapped as children on the African continent to imprisonment, mistreatment and death. Furthermore, these studies produced drawings, casts and photographs of the bodies of kidnapped African women with the aim of locating morphological primitivism and seeking equivalents in their cultures (Dubow 1995; Samain 3002; Comaroff 1991, 117-19).

The physical characteristics of the "Hottentot Venus" were stereotyped and served as a model for the creation of a paradigm. Querino's unfortunate comparison of the "protruding buttocks" of

Jeje women with the body of the "Hottentot Venus" demonstrates his ignorance of the implications of this stereotype for African women. However, the photograph of the Jeje woman (Plate X) published by Querino bears no resemblance to portrayals of the "Hottentot." The "Jeje" woman is shown wearing an elegant blouse under a white *pano da costa* (wrapper), a long skirt with geometric motifs, textiles and Creole jewelry, an aesthetic characteristic of African women in Bahia, who made up an exclusive consumer market for those products.

Querino also classified men according to their adaptation to specific types of work, personality traits, customs and intellectual capacity. He mentions ten cultural groups: Mina, Yoruba, Egba, Ketu, Angola, Ijesha, Congo, Nagô, Jeje and Efon [see chapter 7 – Ed.]. Only three are represented in the photographs: the Jeje, Yoruba and the Ijesha. Querino observes:

> …the ones which adapted best were: the Angolas, which gave rise to the type of the trickster, funny, introducer of capoeira; the Ijeshas, the Congos and notably the Nagôs, the most intelligent of all, the best natured, the bravest and the most hardworking. The Jejes have assimilated local customs a little, but not entirely. They were very fond of playing music and dancing, and lacked the strength for farm work (Querino 1917, 14, note 1).

There are some complications here, and we do not know how Querino resolved them. Unlike the captions, in which the term Yoruba denoted a specific cultural group, in the extract above, he uses the generalizing term Nagô which, as we have seen, generally included the Ketu, Ijesha, Egba, Efon and all other Yoruba-speakers. Furthermore, we do not know how he arrived at this description. Another aspect noted has to do with the Bantu (plural of *mtu*, person). Querino recognizes people from Congo and Angola in his ethnography, but does not represent them photographically. This absence can be explained by the reduced numbers of these cultural groups prior to the elimination of the Bahian slave trade [in 1850].

According to João Reis, as of 1819-1820, the names of the "nations," as cultural groups were called, were better identified in the records, which allows us to verify that "the most numerous groups embarked in the ports of Benin (Nagôs, Hausas, Jejes and Tapas) represented almost 54 percent of the African-born slaves in the City of Bahia," while the Bantu population declined from 31.4 percent in 1819-1820 to 27.2 percent in 1835 (Reis 2003, 308). For the later period, based on 1, 760 inventories among the years 1811-1888, Maria Inês Oliveira reports that 57.4 percent of those inventoried were born in Africa. Of these, 78.4 percent came from the part of the West Coast formerly known as Dahomey, now Nigeria and the Republic of Benin. Individuals embarked at the ports in that region came from nations designated in Brazil as Nagôs (who also self-identified as Ijeshas and Ijebus from Oyo and Ketu), Jejes, Hausas, Minas, Tapas and Bornos (Oliveira 1997, 37-74; Oliveira 1995-96, 174-193). The data found in the inventories which Oliveira consulted corroborate the data published by Verger, who broke down the transatlantic slave trade to Bahia according to its ports of origin: Guinea, in the second half of the sixteenth century; Angola and Congo, in the seventeenth century; the Mina Coast, eighteenth century and the Bight of Benin from 1770 until the period of illegal trafficking (Verger 2002). However, this does not mean that the Bantu population and culture were not present in Bahia. The fact that Querino refers to them in his ethnography makes that abundantly clear.

Another use of photography as ethnographic support was the series in which Querino covered the subject of Candomblé.

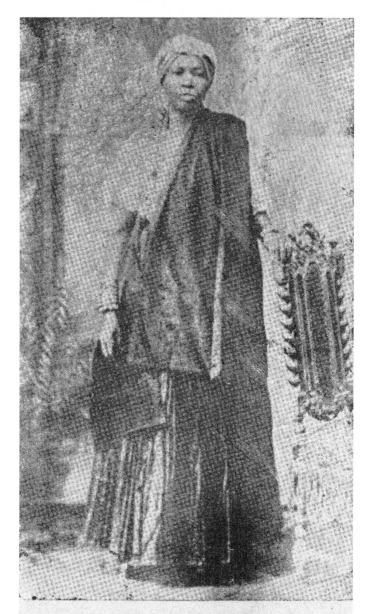

Estampa XII-a — A antiga mãe de
terreiro do Gantois. Typo Egbá

**Plate XII-a. Former high priestess of the Terreiro do
Gantois. Egba Type**

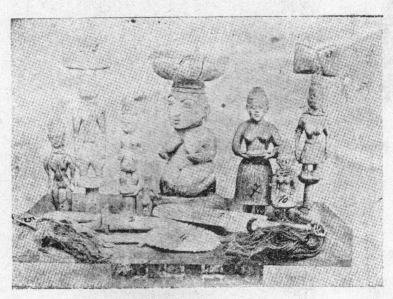

Estampa XIII — Os **Ourixás**

1 — **Ossilú**, Espada de **Ochun**
2 — Idem Idem
3 — **Ochê** ou **Ichê** de **Changô**
4 — Leque de **Ochun**
5 — **Iruquéré**, cauda de boi **(Ochossi)**
6 — **Ourixá** de **Yêmanjá**. A gamella que se vê na cabeça chama-se **Opon**; serve para conduzir os attributos de Santa Barbara ou de **Ochun**
7 — **Ourixá** de **Ochun**
8 — **Ichê** de **Ibualama**
9 — ,, ,, **Ochóssi**
10 — ,, ,, **Ochun**

Plate XIII. The Orishas

Estampa XIV — A Cascata da Sereia. 2.ª parte —
Pegi, Santuario, Candomblé do Gantois

**Plate XIV. Mermaid's Waterfall. Part 2. Peji, Shrine,
Candomblé do Gantois**

Estampa XV — Altar mór do Pegi

Plate XV. High altar of the Peji

Estampa XVI — Santuario de **Humoulú**

Plate XVI. Shrine of Humoulu (Omolu)

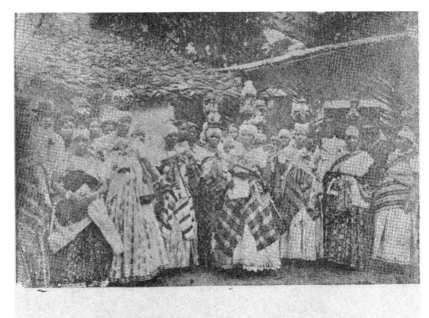

Estampa XVII — A dansa das quartinhas. Festa de **Oohôssi**

Plate XVII. Dance of the jars. Feast of Oshosi

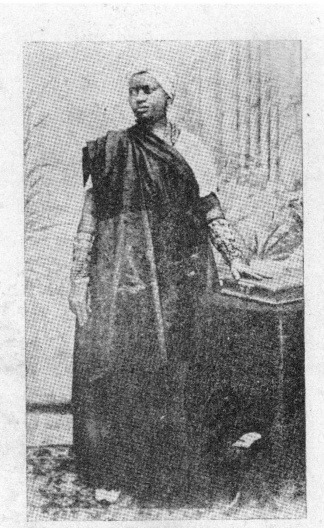

Estampa XXIII — Creoula em grande gala.
A mãe do terreiro do Gantois. Pulcheria
Maria da Conceição

Plate XXIII. Creole woman in gala dress. The high priestess of the Terreiro do Gantois. Pulchéria Maria da Conceição

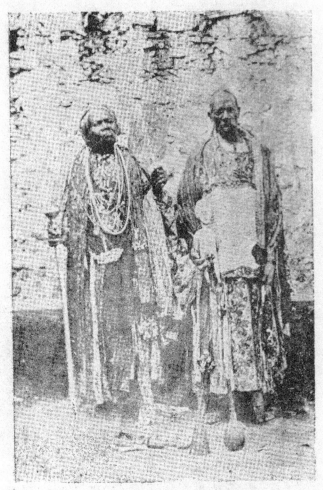

Estampa XIX — Candomblezeiros em grande gala

Plate XIX. Candomblé practitioners in gala dress

In particular, Querino's use of portraits of the *mães de santo* (high priestesses) of the Terreiro do Gantois religious community stands in vivid contrast with the stereotypical representation of photographs of "human types." Pulchéria Maria da Conceição (Plate XXIII) is individualized with her name and rank in the religion she professed. Pulchéria was the second high priestess of the Terreiro do Gantois, the

daughter of its founder, Maria Júlia da Conceição Nazaré (Plate XII-a), who is described as an "Egba type" and identified as "the former high priestess of the Terreiro do Gantois." This information suggests that, for Querino, the term "typo" was associated with the concept of pure African races, while Pulchéria, a "Creole woman in gala dress," was born in Bahia and could not be characterized as a representative of a specific African cultural group.

Another photograph in the Candomblé series shows the "Dance of the Jars, Feast of Oshosi" (Plate XVII). This image accompanies the section of the essay in which Querino explains the initiation ceremony for an *ogan*, a religious post held by men. "Before the altar of St. George (Oshosi), surrounded by a large throng, the protagonist is presented by the high priestess of the *terreiro*, who utters a few words in an African language and places a pano da costa over his shoulders." After six months, the ogan is confirmed during festivities that go on for several days. The "dance of the jars" ceremony was introduced by the Ialorixá Pulquéria (1840-1918) in honor of her orisha, Oshosi (Nóbrega and Echeverria 2006).

I have found a copy of the photograph that Querino used in the archives of the Henriqueta Catarino Women's Institute. It was printed on photographic paper without the photographer's name or a caption. There is a note on the photo saying "reproduction rights reserved." On the back, there is a dedication from Alberto M. M. Catharino to the Women's Institute dated August 13, 1934, eighteen years after Querino's work was first published.[5]

These details indicate that this is a private photograph and suggest that the people photographed or their leader, in this case, the high priestess of Gantois, had banned the sale of images of her terreiro's private activities as postcards. The prohibition on reproducing this photograph did not extend to Querino's essay, which not only included the image but described the ceremony. In this context, Querino's study may have been a joint strategy between the

[5] Photo archives of the Instituto Feminino Henriqueta Catarino, small envelopes, photo no. 99.

researcher and the terreiro for the author to disseminate the cultural refinement of this religious expression as a means of combating the police persecution that the Candomblé terreiros suffered in the first decades of the twentieth century.[6]

The series of photographs that focused on Candomblé and its feasts were, for the most part, produced by Photographia Diamantina. Sofia Olszewski, who had access to the originals, gives the address of the establishment located at Rua Dr. Seabra, 211, information that often appeared on the back of the cards (Olszewski Filha 1989, 108-109, 111). Located in the parish of Nossa Senhora do Passo, a popular shopping district in Salvador, Photographia Diamantina was far removed from the commercial circuit of the city's other studios, which were located in the parishes of Sé and São Pedro. The Diamantina studio does not appear in the almanacs and periodicals of the time, where photographic establishments advertised their services; nor is it found in the tax or trade license records. The only record of this business's existence is on the photograph, which is associated with the religion Candomblé, its sacred objects and leaders (Vasconcellos 2006).

The last series in Querino's collection deals with a segment of the world of work in nineteenth-century Bahian society: porters known as *ganhadores* who were organized in *cantos*,[7] whom Querino analyzes in the section entitled "Industry." According to him, "Africans, after being freed, not having a trade and not wanting to give themselves up to the farm work they had left behind, became ganhadores," the most profitable activity in the urban service sector. To represent them, Querino used the famous postcard "Group of African Porters – Bahia – Brazil" published by J. Mello in the late nineteenth century. In his caption, Querino identified the image as "Ganhadores in the canto."

[6] Regarding the persecution of the Candomblé communities in Bahia, see Pares 2006; Castillo 2009.

[7] [The Portuguese term *ganhador* refers to enslaved and free people who hired out their services as porters, sedan chair carriers, street vendors or other activities. Ed.]

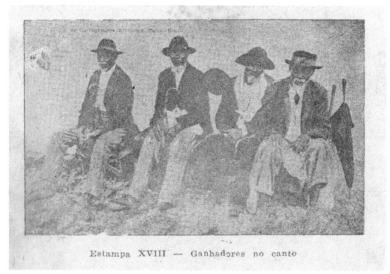

Estampa XVIII — Ganhadores no canto

Plate XVIII. *Ganhadores* in the *canto*

According to Querino, a canto (literally "corner") was a gathering place for African workers specialized in transporting goods and people. Organized along ethnic lines, the cantos were found throughout the city. While waiting for a load to carry, the workers engaged in a range of activities such as: "making rosaries of palm seeds with colored tassels, leather bracelets trimmed with cowries and others with oiled Morocco; they made wire chains for parrots, mats and hats made with straw from the uricury palm, as well as piassava brooms; they cleaned hats made with Chile and any other kind of straw, and repaired sunhats." The cantos were also places where panos da costa were processed after arriving from Africa. Frizzy and hard, the wrappers were polished and softened with a technique that involved using a cylindrical wooden log. Used panos da costa were renovated with dye. The workers produced sculptures in the cantos as well: "they also showed tendencies toward the liberal arts, sculpting the fetishist symbols of their sect, as perfectly as possible" (Querino 1917, 46).

Querino's ethnographic description demonstrates his knowledge and proximity to the context studied — that is, the daily life of the cantos, which were productive units of social relations and

entertainment. Querino describes a traditional African game called "Ai-û, which consisted of a board with twelve concave parts, where they placed and removed the ai-û-s, small lead-colored fruits, originating in Africa and of strong consistency" (Ibid.).[8] He also describes a ceremony, which he probably witnessed, installing the captain of the canto in his post. Querino's study, alongside the little that Nina Rodrigues has written, is now a source for research on the subject (Reis 2000, 199-242; Rodrigues 1977; Mattos 2000.)

The photographs Querino identified as "representative of the Ige-cha tribe" (Plate III) and "representative of the Yoruba tribe" (Plate IV), as well as the "ganhadores in the canto" (Plate XVIII), can be found in Salvador's municipal archives in the form of postcards with the caption "African ganhador."

The photographs and captions of these portraits were produced by the German photographer Rodolph Lindemann, probably between 1890 and 1900, at his studio in Largo do Theatro, in Salvador. They were identified as "Ganhador Africano" and were part of a larger series that linked the person portrayed to a trade: street vendor, wet nurse, fruit seller, female ganhadora, washerwoman and African ganhador. The postcards found in the Municipal Public Archives are artificially colored (Vasconcellos 2006, 30-52).

In particular, the same photograph is used for "Representative of the Yoruba Tribe" in Querino's work and Lindemann's "African Ganhador." The image was also used as a vignette in the composition of a postcard that contains a dedication identifying the person portrayed as a "Ganhador/Portefaix."

This is an example of different meanings ascribed to the same image. In Lindemann's caption, "African ganhador" is a reference to a specific type of work and racial category under the general heading of "street types." In Querino, the image takes on the status of an

[8] [According to the MA dissertation by Rinaldo Pevidor Pereira, ai-û or *ayo* was the Yoruba version of an African game called *mancala*. "O jogo africano mancala e o Ensino de matemática em face da lei no 10.639/03." Universidade Federal do Ceará, Programa de Pós-Graduação em Educação Brasileira. 2011, 66. – Ed.]

ethnographic document and, as such, was used to explain differences between people from a specific African cultural group. In the dedication, the individual was identified as a representative worker from Bahia, "*portefaix* ganhador (porter)."

Estampa XX — Ganhador africano

Plate XX. African ganhador

Estampa XXI — Ganhadeira africana

Plate XXI. African ganhadeira

Estampa XXII — Ganhadeira africana

Plate XXII. African ganhadeira

Also on the subject of male ganhadores and female ganhadoras, Querino added to his collection photographs of sculptures he identified as "African ganhador" and "African ganhadora." In his book

Artistas bahianos, published in 1909, similar sculptures are attributed to Erotides América de Araújo Lopes, with the caption "Street Types (Vendors) made from hog plum tree bark" (1909).

The ethnographic technique which Querino used to study African culture in Bahia was exploited in his essay to demonstrate the rich panoply of religions, work, technology, art and entertainment produced by Africans in Bahia. As an approach to research, Querino's ethnography made unprecedented contributions to the field of studies about Africa and the African diaspora in the Americas. In his essay, the detailed description of the data indicates the author's concern with presenting Africans as social agents who made a dynamic and modifying contribution to the social structures of slavocracies.

As for the quality of the prints in the collection, the incipient technique of photoengraving can be observed. Used at that time, it blurred the images in the offprint and the Annals of the Congress, both published in 1917. These same illustrations were reproduced in the anthology of Querino's work edited by Arthur Ramos and published in 1938. However, the photographs were omitted in the 1955 publication by Livraria Progresso, and in the expanded and commented edition published by the Joaquim Nabuco Foundation in 1988. Except for four photographs – and this is important in terms of the value of the source materials – the original publications are the only evidence of the existence of those photographs, as well as the use Querino made of them.

In the late 1980s, Sofia Olszewiski observed that, "in the photographs of Black people in the Instituto Histórico collection there are annotations on the back containing the names of the possible nations to which the subjects portrayed belonged. The author of these notes is unknown" (Olszewiski Filha 2003, 70). The images to which she is referring were published in her book *A foto e o negro na cidade de Salvador, 1840-1914* and are also present in Querino's essay, with the same annotations which Olszewiski mentioned. Therefore, Querino certainly made those annotations and collected the photographs. He had been an active member of the Geographical and Historical

Institute of Bahia since 1894, and while there he had the opportunity to develop his scholarly production. Furthermore, it was the IGHBa that organized the 5th Brazilian Geography Congress, for which he intended his illustrated essay. Unfortunately, none of these photographs can be found in the institute's collection today. They have disappeared into the maw of neglect that devours the public archives in Brazil.

Manuel Querino, ca. 1911

Manuel Raimundo Querino was born in Santo Amaro, Bahia, on 28 July 1851. At the age of four, he was orphaned by the cholera epidemic that scourged the Recôncavo region of Bahia at that time.[9] Querino was *mestiço* (mixed race), but we do not know whether his parents were mestiço, or whether one of them was Black, brown or African, and the other white, whether they were slaves, freed persons or free.

In the capital of Bahia, Querino learned the trade of painter-decorator and, at the age of 17, was recruited for the Paraguayan War, in which he served as a clerk until the end of the conflict. Back in Salvador, in 1871, he worked as a painter and studied at the newly created Liceu de Artes e Ofícios da Bahia, where he learned Portuguese, French, drawing and painting. He later became a teacher of Industrial and Geometric Design at that institution. He taught the same subject at the Colégio dos Órfãos de São Joaquim and was a civil servant, working at the Department of Agriculture. He participated in the foundation of the Partido Operário da Bahia, in 1890, and was elected city councillor, a post he held between 1897 and 1899. At the end of this role in politics, he dedicated himself exclusively to teaching and intellectual production, becoming a member of the Geographical and Historical Institute of Bahia (IGHBa) (Sodré 2001, 89-93. See also Leal 2004, 37).

Querino witnessed the struggle to integrate the recently emancipated Black population into the new republican regime. As a poor, orphaned mestiço, he himself suffered from the racial discrimination that prevailed in his time. In his writings, he took on the role of critic of slavery and the Republic, defending Brazil's working class and the African legacy in Bahian culture. He was the author of the following works: *Desenho linear das classes elementares* (1903), *As artes na Bahia* (1909, 1913), *Artistas bahianos* (1909, 1911), *Elementos do desenho geométrico* (1911), *Bailes pastoris* (1914), *A Bahia de outrora, vultos e fatos*

[9] Regarding Querino's life and work, see the biographies by Leal (2004) and Gledhill (2009).

.

populares (1916, 1922, 1946, 1954), *A raça africana e seus costumes na Bahia* (1916, 1917, 1955), *O colono preto como factor de civilização brasileira* (1918) and *A arte culinária na Bahia* (1928, 1951). He died in Salvador in 1923 without being recognized for his intellectual work.

As Antônio Sérgio Alfredo Guimarães argues, during that period, Black intellectuals were considered folklorists rather than scientists. They were primarily valued for their access to oral sources and not for their theoretical formulations:

> Black laymen and self-taught anthropologists recognized as folklorists or journalists who made African "culture" or "customs" the subject of their work....were never recognized as "men of science" or scientists...their legitimacy was based almost exclusively on the privileged access they had to the sources and people about which they wrote (artisans, organizers and participants in folk festivals, Africans, high priests and priestesses of Candomblé). The social recognition of these Black intellectuals is largely due to the work of other, more prestigious intellectuals, almost always white, who between 1930 and 1950 changed the focus of their concerns from European and Portuguese culture to African or mestiço popular culture, mainly Afro-Brazilian religions and cuisine (Guimarães 2004).

Manuel Querino was one of those intellectuals who were neglected by Brazilian academia, despite the pioneering nature of his propositions in the field of Bahian art history (Nunes 2007; see Chapter 5) and his theories on Afro-Brazilian history and culture. In Bahia, in the early years of the Republic, few people of African descent entered academia, the liberal professions, the civil service and the military, their low numbers reflecting the obstacles which this group, even the mestiços, had to surmount to enter the circles of European tradition. Among Querino's contemporary mestiços who succeeded in entering that space, we can mention Francisco Álvares dos Santos (professor at the School of Medicine), Luiz Gama, André Rebouças, Luiz Anselmo da Fonseca, Virgílio Climaco Damásio, César Zama, Abílio César Borges

(Baron of Macaúbas), Teodoro Sampaio, Antônio Carneiro da Rocha, João Florêncio Gomes, Ramos de Queiroz and Braz do Amaral (Leal 2004, 96).

At the 5th Congress, chaired by the Black engineer Theodoro Sampaio, Manuel Querino's essay was the only historical and ethnographic study among the 111 presentations, 104 cartographic exhibitions and 1, 057 registered attendees (Anaes 1916; Leal 2004, 317, note 150). At the Geography Congresses, studies of the toponymy and historical memory of the municipalities, cartography, hydrography, climatology, hinterlands, droughts and natural resources were given preference. Each work highlighted the scientific methodology applied in the institution to which its author was linked. However, in addition to scholars, the studies were presented municipal, state and federal government officials. This indicates that the environment of these congresses was not exclusively academic (Evangelista).

In the same year the congress was held, Querino was "abruptly" removed from the post he had held since 1893 in the Department of Public Works (Leal 2004, 270). Due to the proximity of the two events and the limited participation allowed to academics of African descent, it is possible that his removal from office was related to Querino's theoretical stances. That same year, Manuel Querino published *A Bahia de Outrora – vultos e fatos populares,* a collection of articles published in local newspapers and the journal of the IGHBa. Two years later, he published *O colono preto.* Manuel Querino used writing to undermine the racist universe that tried to silence him in various ways. Paradoxically, the historiography that had long overlooked or belittled him now uses his life and work as a historical source.

Bibliography

Alinder, Jasmine. La retórica de la desigualdad: Las fotografías de los escravos del Brasil em el siglo XIX. *História y memória: sociedad, cultura y vida cotidiana en Cuba 1878-1917*. Havana: Centro de Investigación y Desarrollo de la Cultura Cubana Juá Marinello. 2003.

Annaes do V Congresso de Geografia. Salvador: Imprensa Oficial, 1916.

Andrews, George Reid. *Negros e brancos em São Paulo (1888-1988)*. Bauru: Editora do Sagrado Coração, 1998.

Castillo, Lisa Earl; Parés, Luis Nicolau. "Marcelina da Silva e seu mundo: novos dados para uma historiografia do candomblé ketu." *Afro-Asia* 36 (2007).

Castillo, Lisa Earl. *Entre a oralidade e a escrita: etnografia nos candomblés da Bahia*. Salvador: Edufba, 2009.

Comaroff, Jean e John. *Of Revelation and Revolution: Christianity, Colonialism and Consciousness in South Africa*. Chicago: The University of Chicago Press, 1991, vol. 1.

Dubow, Saul. *Illicit union: Scientific Racism in South Africa*. Johannesburg: Witwatersrand University Press, 1995.

Edwards, Elizabeth. "Antropologia e Fotografia." *Cadernos de Antropologia e Imagem* II. Rio de Janeiro, 1996.

Evangelista, Hélio de Araújo. Congressos Brasileiros de Geografia. Accessed 8 April 2021. <http://www.feth.ggf.br/congresso.htm>

Fabian, Johannes. *Time and the Other: How Anthropology Makes its Object*. New York: Columbia University Press, 1983.

Gledhill, Sabrina. "Manuel Raimundo Querino." In *Manuel Raimundo Querino. Seus artigos na Revista do Instituto Geográfico e Histórico da Bahia*, Nascimento, Jaime; Gama, Hugo (eds.), 225-238. Salvador: Instituto Geográfico e Histórico da Bahia (IGHB), 2009.

Guimarães, Antônio Sérgio Alfredo. Manuel Querino e a formação do pensamento negro no Brasil entre 1890 e 1916. 2004. Accessed 8 April 2021 <https://www.scribd.com/document/138237337/Manuel-Querino-e-a-formacao-do-pensamento-negro-no-Brasil-de-A-S-A-Guimaraes>

Kossoy, Boris. *Dicionário histórico-fotográfico brasileiro: fotógrafos e ofícios da fotografia no Brasil (1833-1910)*. São Paulo: Instituto Moreira Salles, 2002.

Leal, Maria da Graças. "Manuel Querino: entre letras e lutas." Bahia 1851-1923. PhD thesis PUC, São Paulo, 2004.

Matory, J. Lorand. "The English Professors of Brazil: On the Diasporic Roots of the Yoruba Nation." *Comparative Studies in Society and History* 41, no. 1 (1999).

Mattos, Wilson Roberto de. Negros contra a ordem. Resistências e práticas negras de territorialização cultural no espaço da exclusão social – Salvador – BA (1850-1888). PhD thesis, PUC-SP, 2000.

McClintock, Anne. *Imperial Leather: Race, Gender and Sexuality in the Colonial Context.* New York: Routledge, 1995.

Negro, Antônio Luigi; Gomes, Flávio. "Alem das Senzalas e fábricas. Uma história social do trabalho." Accessed 19 April 2021. <http://www.scielo.br/pdf/ts/v18n1/30015.pdf >

Nóbrega Cida e Echeverria Regina. *Mãe Menininha do Gantois, Uma biografia.* Salvador: Corrupio; Rio de Janeiro: Ediouro, 2006.

Nunes, Eliane. Manuel Raymundo Querino: o primeiro historiador da arte baiana. *Revista Ohun* 3, no. 3 (Sept. 2007): 237-261.

Oliveira, Maria Inês Cortes. "Quem eram os 'negros da Guiné'? A origem dos africanos na Bahia." *Afro-Asia* 19-20 (1997): 37-74.

–––––––––. "Viver e morrer no meio dos seus: nações e comunidades africanas na Bahia do século XIX." *Revista USP* 28 (1995-96): 174-193.

Olszewski Filha, Sofia. *A fotografia e o negro na cidade do Salvador.* 1840-1914. Salvador, EGBA.

Parés, Nicolau. *A formação do Candomblé - História e ritual da nação jeje na Bahia.* Campinas: Ed. Unicamp, 2007.

Peel, J.D.Y. *Religious Encounter and the Making of the Yoruba.* Bloomington: Indiana University Press, 2003.

Querino, Manuel. *Artistas bahianos.* Rio de Janeiro, Imprensa Nacional, 1909.

–––––––––. *A raça africana e os seus costumes:* memória apresentada ao 5º Congresso de Geographia. Bahia: Imprensa Official do Estado. 1917.

Reis, João. "De *olho no canto:* Trabalho de rua na Bahia na véspera da Abolição." *Afro-Asia* 24 (2000): 199-242.

–––––––––. "Domingos Pereira Sodré: um sacerdote africano na Bahia oitocentista." *Afro-Asia* 34 (2006): 237-313.

————. *Domingos Sodré: um sacerdote africano. Escravidão, liberdade e Candomblé na Bahia do século XIX.* São Paulo: Cia das Letras, 2008.

————. *Rebelião escrava no Brasil. A história do levante dos Malês em 1835.* São Paulo: Cia das Letras, 2003.

Samain Étienne. "Quando a fotografia (já) fazia os antropólogos sonharem: O jornal La Lumière (1851-1860)." *Revista de Antropologia*, São Paulo, USP. Ano 44, n 2, 2001.

Sodré, Jaime. *Um herói de raça e classe.* Salvador: n.p., 2001.

Vasconcellos, Christiane Silva. "O circuito social da Fotografia da Gente Negra. Salvador, 1860-1916." MA Dissertation, UFBA, 2006.

Verger, Pierre. *Fluxo e refluxo do tráfico de escravos entre o golfo do Benin e a Bahia de Todos os Santos dos séculos XVII ao XIX.* Salvador: Corrupio, 2002.

Vianna, Joaquim Telesphoro Ferreira L. Breves considerações sobre o aleitamento materno. Dissertation presented to the Bahia School of Medicine (Faculdade de Medicina da Bahia), 1855. Arquivo da Faculdade de Medicina da UFBA, Salvador – Bahia.

Wetherell, James. *Brasil, Apontamentos sobre a Bahia.* Salvador: Edição Banco da Bahia S/A.

7. 'VENERABLE ELDERS': NOTES ON MANUEL QUERINO'S RESEARCH AND THE ORIGINS OF AFRICANS IN BAHIA

Sabrina Gledhill[1]

M anuel Querino was one of the first Brazilian scholars to study the ethnic origins of enslaved Africans in Bahia. He was also the first Afro-Brazilian to devote himself to the study of Brazilian history with the aim of giving a detailed analysis and vindication of African contributions to his country. Long before he focused on the African presence and the positive influence that "Black settlers" exerted on Brazilian society (Querino 1918), he was a labor leader, abolitionist, politician and militant journalist. Although he was not one of the most prominent leaders of the abolitionist movement, he joined the Sociedade Libertadora Baiana (Bahian Liberation Society) and wrote articles that were published in the *Gazeta da Tarde* newspaper to raise awareness of the injustice of slavery. He left politics in 1899 and turned his attention to studies of Bahian folklore, art history, and culture.

A founding member of the Geographic and Historical Institute of Bahia (IGHB), Querino researched and wrote *A raça africana e seus costumes na Bahia* (The African Race and their Customs in Bahia)[2] at a time when "the Black" was seen more as a problem than a legitimate subject of study in his country. In the introduction, Querino quotes the words of a former director of the National Library (from 1853 to 1870):

[1] This chapter is a translation and adaptation of "'Velhos respeitáveis': notas sobre a pesquisa de Manuel Querino e as origens dos africanos na Bahia." *História Unisinos* 14, no. 3 (Sept./Dec. 2010): 340-344.

[2] Originally published in 1916, the text used in this study is the version edited and annotated by Artur Ramos in *Costumes africanos no Brasil* (1938).

More than half a century ago, the Benedictine sage, Fr. Camilo de Montserrat, surprised to find that there was little appreciation and no importance given to studies concerning the ways and customs of Africans among us, set the following course for Brazilian writers, which was *only embarked upon by the ill-fated professor Nina Rodrigues:* "It would be very convenient, before the complete extinction of the African race in Brazil, and, above all, before the most interesting and less commonly known varieties disappear, to obtain from the individuals who represent them information that it will soon be impossible or at least very difficult to acquire. Among the Blacks transported from Africa, there are individuals from regions in the interior of the continent which traveler has yet managed to reach, and who are not mentioned in any published report. It would also be possible to distinguish and study the different types, to verify their origins authentically, to question individuals about their beliefs, their languages, their ways and customs, and thus to collect from the *very mouths of Black people* as easily as it is certain that they speak the common tongue [Portuguese], information that travelers could only obtain at great cost, taking tremendous risks in costly expeditions and also subject to the most serious errors" (Querino 1938, 19-20; emphasis added).

However, Querino goes on to observe that it would not be possible to follow that course every step of the way:

> [...] because, among other reasons, we lack the indispensable requirements for a psychological study of the tribes that lived together for many years, and, above all, because of the passing of the Africans who, being enslaved here, *occupied a high social rank in their homeland, as a guide to the destinies of their tribe, or as repositories of the secrets of their religious sect* (Querino 1938, 20; emphasis added).[3]

He also describes his own work as "just a sketch, something of an attempt" (Ibid.).

[3] According to Costa e Silva (2000), this observation about the "high social rank" of some of the enslaved Africans in Brazil has been proven to be true.

Certainly, Nina Rodrigues provided a much more extensive and detailed study in *Os africanos no Brasil* (The Africans in Brazil), but that work was only published in 1932. Its author died in 1909, when the book was in press (Pires in Rodrigues 2008, 13).[4] Therefore, the first scholar to publish his findings on the ethnic origins of Africans in Bahia was Manuel Querino, at the V Brazilian Congress of Geography chaired by Theodoro Sampaio in Salvador in 1912 and in the annals of that congress, published in 1916.

Although they have not been reproduced in more recent editions, the first editions of *A raça africana* are illustrated with several photographs of African "types" and objects of material culture that have been analyzed by Christianne Vasconcellos (2008; see Chapter 6). Querino's work also stands out for the respectful manner in which he treats the Africans and their descendants. In fact, he goes so far as to observe:

> [...] I hereby register my protest against the disdainful and unjust way in which the African is disparaged, constantly accusing him of being ignorant and crude as [if it were] a congenital quality and not a merely circumstantial condition, common, in fact, to all non-evolved races (1938, 22).

Here, Querino directly confronts racial prejudice and demands respect for the Africans. More than that, he stresses their ability to "evolve" through education, like the ancient Greeks or any other civilization once oppressed by slavery.

Ethnic identity

The first specific reference in Querino's *A raça africana* to the ethnic identity of African cultural groups in Bahia – referred to as "tribes" – appears in the second chapter, "In Portuguese America," where the author provides the following list:

[4] The title of the multi-volume work of which *Os africanos no Brasil* is the volume I was *O problema da raça negra na América portuguesa* (The Problem of the Black Race in Portuguese America; Pires in Rodrigues 2008, 14).

Cambinda, Benin, Gêge, Savarú, Maqui, Mendobi, Cotopori, Daxá, Angola, Massambique, Tápa, Filanin, Egbá, Iorubá, Efon or cara queimada [literally, "burned face"], *Quêto, Ige-bú, Ótá, Oió, Iabaci, Congo, Galinha, Aussá, Ige-chá, Barbá, Mina, Oondô Nagô, Bona, Calabar, Bornô, Gimum,* the favorite or preferred people of the scouts, etc., tribes of which we still have some representatives here, as we can see in prints nos. 3, 4, 5, 6, 7, 8, 9, 10, 11, 12 (1938, 38-39; see prints in Chapter 6).

The author also makes the following observation in a footnote: "The term *Nagô* covers the following tribes: *Mina Iorubá, Ige-chá, Ige-bú, Efon, Otá* and *Egbá,* due to the vast expanse of the territory included in the lands on the Slave Coast. The Egba and Yoruba tribes, which are the most distinctive, were considered the oldest" (1938, 38).

As the author himself comments (1938, 40) and Artur Ramos observes in a footnote,[5] the names Querino provides sometimes designate African nations, localities or cities. However, as the works presented below demonstrate, far from being mistaken, this reflects the reality of the Africans themselves – people who often identified more strongly with their place of birth than with a "linguistic group" or "ethnic group" imagined or imposed by foreigners.[6]

In this chapter, I will analyze four of the terms used in Brazil to characterize a group or groups found on the Slave Coast[7] and the adjacent areas; that is, "Yoruba" and "Nagô" (Yoruba-speakers), "Jeje"

[5] "In this enumeration of African 'tribes,' Manuel Querino confused the names of nations and mere place names[...]." (Querino 1938, 38).

[6] According to the Benin-based historian Elisée Soumonni, an individual's place of birth could be much more important as a factor of self-identification and unification than the linguistic factor – that is, the fact that two people came from two different villages could be much more significant than speaking the same language (lecture given on 14 May 2009 for the Graduate Course in Ethnic and African studies at CEAO/UFBA, in Salvador, Bahia).

[7] The region called the "Slave Coast" comprises the countries now known as Ghana, Togo, the People's Republic of Benin and Nigeria, including not only the coast but also the interior, from the Bight of Benin to Gabon. The name originated from the transatlantic slave trade in the seventeenth century, but the region also exported and imported other "goods."

(Fon or Gbe-speakers) and "Mina." As we will see, some of the "tribes" Querino mentions fall under one "umbrella" term or another.

The "Yoruba" or "Nagô"

In *A raça africana,* Querino presents the following stereotypes of Yoruba speakers in Brazil: "Highly regarded in their own lands, *Iorubás, Egbás* and *Quêtos* were usually preferred in local positions. Those who adapted best to our civilization were: *Angola,* who gave rise to the trickster type, a prankster, the introducer of capoeira; *Ige-chá, Congo* and notably *Nagô,* the most intelligent of all, the best natured, the most valiant and hardworking..." (1938, 39-40). Ijesha and Egba women were said to be "the most affectionate, as to the function of motherhood," and were also reportedly distinguished by their "sculptural correctness; they did not have their faces cut with lines [scarification] and used to paint their lower eyelids blue, out of coquettishness or for embellishment."[8] Ijesha women were also considered to be good wet nurses and endowed with a "milder temperament" (1938, 98).

Querino provides a list of cultural groups which includes several considered to be "Yoruba" or "Yoruba-speakers": Egbado, Yoruba, Efon, Ketu, Ijebu, Ota, Oyo, Ijesha and Ondo. (As we will see, the term "Mina" can also include Yoruba-speaking groups.)

According to the Nigerian historian Biodun Adediran (1984), several sub-units with different customs and linguistic sub-groups have been identified in the region now known as "Yorubaland," chiefly the Iagba, Owo, Akoko, Equiti, Igbomina, Ijesha, Ife, Ilaje and Ondo, in the East; the Oyo, Owu, Egbado Awori and Ijebu in the Central Region, and the Sabe, Anago, Idaisa, Manigri, Isa and Ana in the West. Most of the Yoruba-speaking sub-groups are considered cultural groups, since all are politically centralized. Furthermore, each sub-group self-identifies and is identified with a specific name and has diacritics such as scarification and dialects (linguistic sub-groups)

[8] This stereotype is also applied to Jeje women in the same paragraph (Querino, 1938, 98).

specific to the Yoruba language. Even so, they share the tradition that all of them were once organized under the leadership of Ile-Ife in remote mythological times.

Sigismund Wilhelm Koelle and Samuel Johnson argued that the term "Yoruba" was an incorrect designation for returnees called "Aku" in Sierra Leone. Even so, as Koelle himself indicated, the term "Nagun" was also used in Sierra Leone to refer to the "Aku." There are indications that "Nagun" originally referred to the language spoken by these people. *Nagô* is the Jeje/Fon term for "Anago," which was also used to describe speakers of the Yoruba language and considered to be predate the term Yoruba as a designation for a cultural group. Another name used was "Olukumi" or "Lucumi" (Adediran, 1984).

Returnees used the designation "Nagô," which is still utilized in Brazil to refer to Yoruba speakers. As Robin Law observes, "Most likely, this meaning of the term came to be used in West Africa from 1830," (n.d., 111), when freedpersons returned to the Slave Coast and intensified the use of a Brazilian term that originated in Africa as "Anago."

The "Jeje"

Querino provides contradictory stereotypes about the "Jeje" in Brazil, who were said to have assimilated "local customs a little, or not at all. They were very fond of playing music and dancing and lacked the strength for farm work" (1938, 40). However, in the chapter entitled "Characteristic of the Different Tribes," the author says opposite: "Of the African tribes, the ones that best assimilated our civilization were the Angolas, Jejes, Congos and Minas" (1938, 99). Jeje women, "were distinguished by their sensuality, by their commanding poise and delicate and insinuating manners; for this reason they were even confused with the elegant Creole women." However, they also had "protruding buttocks, and perhaps served as a model for the *Hottentot Venus*" (1938, 99). They stood out among the African women who were "most adept at cooking" (1938, 98).

Although it is an umbrella term, most experts associate the word "Jeje" with the "Gbe-speakers" of the Slave Coast.[9] The etymology of the term Jeje is a mystery to J. Lorand Matory and many other scholars, including Brazilians and Brazilianists. However, they have produced several theories since the beginning of the twentieth century, when Nina Rodrigues established the "Brazilian etymological tradition of identifying the word 'ewe' – the name of the dialect spoken now in southwest Togo and southeast Ghana – as the origin of the term 'jeje'" (Matory 1999, 62-63). Matory notes that Nina Rodrigues associated the word "jeje" with the term "geng" or "gen" without knowing that "the pronunciation of the initial 'g' [...] is equivalent to the [hard] 'gue' in Portuguese...." (Matory, 1999, 63). Juana Elbein dos Santos attributes the origins of the word to the French colonial administrators, who are believed to have used it to designate cultural groups found in the Porto-Novo region. Pierre Verger posited that "Jeje" was derived from the term "aja," which designates the people who gave rise to the dynasties that ruled Aladá, Porto-Novo and Abomey, while Vivaldo da Costa Lima associates the term with the Yoruba word for "foreigner" (àjèjì) (Ibid.) or "war refugee." Nicolau Parés offers the alternative of "Adjaché," a locality near Aladá (2007, 14). According to Matory, the Africanist Suzanne Blier, author of *African Vodun: Art, Psychology, and Power*, agrees with this theory, spelling the name of the village "Adjadji" which is believed to be one of the cradles of the Aja-tado dynasty. Matory believes this to be "the most likely of the multiple possibilities" (Matory, 1999).

The "Minas"

The stereotypes for "Minas" were similar to those we saw in the section on the "Jeje" – well assimilated people; sensual women with "a noble bearing" (Querino 1938, 98-99). Quoting a "Brazilian publicist"

[9] According to Parés: "'Gbe' is the word shared by all these groups [Adja, Ewe, Fon or combinations of these terms] to designate language and, although it is not an autochthonous self-identification, it has the advantage of not being an 'ethnocentric' term that privileges the name of a subgroup to designate the whole" (2007, 14).

Querino also notes that the "*nega* Mina" (Mina Black woman) was considered an "excellent companion and a useful and faithful servant" (1938, 99).[10] He quotes that publicist's description of those women, which would now be considered prejudiced, if not racist, if viewed out of context.[11]

The term "Mina" is a reference to the Gold or Mina Coast, where the Portuguese built the Fort of São Jorge da Mina in 1482 on the site of an African village called Edina. The fort came to be known as "Elmina" during the Dutch occupation, which began in 1637. As of that year, "The connotation of the Portuguese location changed again, covering the eastern area of the Gold Coast" (Law n.d., 112). In the Gold Coast region, the term "Mina" as the designation of an cultural group referred to people from Elmina, but in other parts of Africa, the name also refers to people from the Gold Coast in general. There was also a "Mina" diaspora to the Slave Coast.

In the case of the diaspora in the Americas, "it is indisputable that, in some contexts, the term 'Mina' specifically indicates people from the Gold Coast" (Law n.d., 119). Even so, in Brazil, as Gwendolyn Midlo Hall observes – correctly, according to Law – in some contexts, Gbe-speaking groups also received that name. Therefore, a Fon temple in the northern Brazilian state of Maranhão was called the Casa das Minas and the vocabulary of the "general Mina language" compiled in Minas Gerais in 1741 is actually a lexicon of the Gbe language. One of the most interesting observations in Law's paper is that the term "Mina" could designate people from other African groups, such as the Oyo, who spoke Yoruba, but who, in "another case of bilingualism," also spoke the Gbe language (Law n.d., 122).

In Rio de Janeiro, the term "Mina" came to include all peoples from the West Coast of Africa, "from the Gold Coast to the east." In the eighteenth century, the "Minas" would be predominantly speakers

[10] Today, "*nega*" (feminine) and "*nego*" are terms of endearment in Bahia, having nothing to do with the color of the loved one's skin.

[11] The "publicist" observes that "Not having the intellectual strength to rise above the destiny of her race, she used all her emotional wiles to trap the white man and his people in the warmth of her soft, caressing bosom" (Querino 1938, 100).

of the Gbe language, but in the nineteenth century, Yoruba speakers predominated. However, in Bahia, where West Africans predominated, the "Minas" were just one group among many (Law n.d., 123).

Conclusion

According to Bernardino J. de Souza, secretary for life of the Geographical and Historical Institute of Bahia (IGHB), referring to Manuel Querino and Nina Rodrigues in 1928: "[they] are, to this day in Bahia, the two greatest scholars of the African race" (in Pereira 1932, 34). However, based on the paternalistic tone of Artur Ramos's notes in *Costumes africanos no Brasil,* the reader could be led to believe that Querino's work was not a valid source, as was once the case with many academics in the area of art history (Freire 2008; see Chapter 5). Although the vast majority of Brazilian authors fail to list Querino among the first researchers who unearthed the ethnic, linguistic and cultural roots of Africans brought to Brazil as slaves, we now know that, even if the book by the "ill-fated Nina Rodrigues" had not been published posthumously in 1933, we would still have valid clues for future research thanks to Querino's work. For example, in *A raça africana,* the Bahian scholar mentions the names of Yoruba-speaking groups that correspond to ancient civilizations and cities, many of which still exist in Nigeria and Benin.

As Freire observes about the works of this Bahian scholar in the field of art history (2006), Querino's work provides valuable information for researchers today in studies of the ethnic identity of Africans and slavery in Brazil. It is indisputable that, compared to the overwhelming majority of his contemporaries, Querino provided a very different perspective on enslaved Africans. As a former militant abolitionist and a "friend of the race," he made a point of highlighting the contribution of Blacks to Brazilian society and, above all, the dignity and value of the "venerable elders" from Africa and their descendants.

Bibliography

Adediran, Biodun. "Yoruba Ethnic Groups or Yoruba Ethnic Group? A Review of the Problem of Ethnic Identification." *África, Revista do Centro de Estudos Africanos da USP* 7 (1984): 57-70.

Albuquerque, Wlamyra R. *O jogo da dissimulação.* São Paulo: Companhia das Letras, 2009.

Blier, Suzanne Preston. *African Vodun: Art, Psychology and Power.* Chicago: Chicago University Press, 1975.

Bomfim, Manoel. *A América Latina, males de origem.* Rio de Janeiro: Topbooks, 2005.

Costa e Silva, Alberto da. "Portraits of African Royalty in Brazil." In *Identity in the Shadow of Slavery,* Lovejoy, Paul E. (ed.). London and New York: Continuum, 2000.

Freire, Luiz A.R. "Manuel Querino: O 'Vasari' brasileiro." Presentation at the National Seminar of the Life and Work of Manuel Querino (Seminário Nacional "Manuel Querino: Vida e Obra"), held at the Geographic and Historical Institute of Bahia (IGHB) on August 28, 2008.

———. *A talha neoclássica na Bahia.* Rio de Janeiro: Versal, 2006.

Law, Robin. "Etnias de africanos na diáspora: novas considerações sobre os significados do termo 'mina.'" *Tempo* 20 (2006): 98-120. https://doi.org/10.1590/S1413-77042006000100006

Matory, J. Lorand. "Jeje: Repensando nações e transnacionalismo." *Mana* 5 (April 1999): 57-80.

Nascimento, Jaime and Gama, Hugo (eds.). *Manuel R. Querino, Seus artigos na* Revista do Instituto Geográfico e Histórico da Bahia. Salvador: IGHB, 2009.

Parés, Luis Nicolau. *A formação do Candomblé, História e ritual da nação jeje na Bahia.* 2nd ed., revised. Campinas: Editora Unicamp, 2007.

Pereira, Gonçalo de Athayde. *Prof. Manuel Querino, Sua vida e suas obras.* Bahia: Imprensa Oficial do Estado, 1932.

Querino, Manuel. *O colono preto como factor da civilização brasileira.* Bahia: Imprensa Oficial do Estado, 1918.

————. *Costumes africanos no Brasil.* Preface and notes by Artur Ramos. Rio de Janeiro: Civilização Brasileira, 1938.

Rodrigues, Raimundo Nina. *Os africanos no Brasil.* São Paulo: Madras, 2008.

Vasconcellos, Christianne Silva. "O Uso de Fotografias de Africanos no Estudo Etnográfico de Manuel Querino." *Sankofa. Revista de História da África e de Estudos da Diáspora Africana,* 4 (December 2009): 88-111. Accessed 20 September 2021. <http://sites.google.com/site/revistasankofa/sankofa4>

Vianna, Antônio. "Manoel Querino" (lecture). *Revista do Instituto Geográfico e Histórico da Bahia* 54 (1928): 305-316.

8. CREATOR OF BAHIAN FOLK CUISINE

Jeferson Bacelar and Carlos Alberto Dória

Introduction

Manuel Querino was not an unknown in the life of Bahia. In addition to his work in the field of scholarship, he was a politician, activist and member of institutes and associations who identified with the life of Candomblé communities and Afro-Brazilian Carnival groups with religious links called *afoxés*. He died in 1923 and, 10 years later, was honored by the Bahia division of the Frente Negra Brasileira (Black Brazilian Front). In 1980, Jorge Calmon began the process of legitimizing him in academia through the publication of "Manuel Querino, o jornalista e o político" ("Manuel Querino, the Journalist and Politician" [see Chapter 3]). And that process has continued ever since: it has been kept going by articles, dissertations, theses and books, all recognizing the importance of his work, which values Black people's role in Brazilian society. In 2020, two books about his life and works appeared: 1) Sabrina Gledhill's *Travessias no Atlântico Negro. Reflexões sobre Booker T. Washington e Manuel Querino* (Black Atlantic Crossings: Reflections on Booker T. Washington and Manuel R. Querino), published by Edufba; and 2) one by the authors of this essay, entitled *Manuel Querino: criador da culinária popular baiana* (Manuel Querino: Creator of Bahian Folk Cuisine), published by P55. Entirely based on the latter book, this chapter basically addresses the recipes in Querino's study, *A arte culinária na Bahia* (Culinary Arts in Bahia), going on to demonstrate how the modern and the traditional appeared in his work, and present an analysis of Bahian cuisine. In the conclusion, we discuss the insertion of Bahia's cuisine into the "myth of Bahianity," and contrast it with the objective of preserving folk cuisine, identified to this day with the tastes of the Bahian working classes.

Querino's recipes

Cookbooks are nothing new. For example, when speaking of ancient Roman cuisine, we immediately recall the famous treatise by Apicius, from the late fourth century CE. Clearly, they play different roles, according to the time and the audience. Over the centuries, two types began to appear: one was popular cookbooks, mainly written by women, aimed at broader audiences, with the purpose of imparting knowledge of traditional cuisine, useful for the kitchen and the home, and intended for daily consultation. You could say that they presented themselves as the mediatic version of household recipe books. The second type includes haute cuisine cookbooks written by professional chefs, in which the existing gastronomic repertoire is codified and perfected while showcasing the author's competence and creativity. Of course, on the international level, France gained prominence, especially from the seventeenth century onwards. Paris became the "world capital" of gastronomy, with works produced by names ranging from La Varenne to Paul Bocuse (see Trefezer, 2009).

In Portugal, Domingos Rodrigues's book *Arte de cozinha* (2008, Art of Cooking) originally appeared in 1680. However, Brazil's first cookbook was *O cozinheiro imperial* (1887, The Imperial Chef), published in 1840. Finally, *O cozinheiro nacional* (2008, The National Chef) came out between 1874 and 1888. And right there in the preface, its anonymous author observes, "How great are the responsibilities this imposes on us": "We will not be slavishly copying the cookbooks that are popular in foreign bookstores," and "we believe we have undertaken a solemn commitment to present a cuisine that is in all things Brazilian." Without going into more detail about that work, one of us says that the book presents itself as a "collection of the best recipes from Brazilian and European cuisines." If we had more solid information about its practical importance in elite families, it could be used as a guide to understand what the Brazil's upper classes were eating in the last quarter of the nineteenth century and the first decades of the twentieth. Although we lack that information, the book does showcase at least one form of ideal dining (Dória 2008, 13).

In Bahia, Manuel Querino would introduce a "paper cuisine" through the recipes he collected. It is obvious, even simplistic, to say that every community cooks differently. In other words, a dish is explained by the chemistry with which it is produced, but we must capture the difference in the way it is prepared in comparison with others – whether those "others" are individuals, cultural groups or nations. The ethnic consideration of cooking presents us with several problems. After all, where does the recipe's ethnicity lie? Many misguided analysts immediately point out the origins of raw materials as the bearer and differentiator of that recipe's ethnic roots. They naively believe that, if it contains okra or palm oil, we are dealing with a recipe with an "African culinary heritage." Based on that reasoning, one could also say that, if it contains olive oil, it is Mediterranean. Thus, the inventory of raw materials is believed to suffice to reveal a recipe's significance to a given cultural universe. The second difficulty arises from the very process of transformation. The use of the pestle, for example. Is it an African or indigenous "trait," as we cannot establish its unique origins? And even cooking, in the strictest definition of the term, as exposure to a source of heat – how would we then explain Chinese cuisine, where various forms of cooking are combined in the production of a single dish?[1]

Both these difficulties show the limitations of the anthropology, sociology and history of cooking. We can only understand the establishment of culinary raw materials developed in Brazil as the expression of the dynamics of extensive world trade maintained by the Portuguese colonial enterprise, transacting in foodstuffs from Africa, Asia and the Americas, constantly deracinating them and adapting them to new habitats.[2] Thus, colonialism imposes an ongoing process of alienation, eliminating the ethnicity of anything, including food.

[1] In this regard, see Sabban, Francoise. "Le système des cuissons dans la tradition culinaire chinoise. » In: *Annales, Économies, Sociétés, Civilisations* 38, no. 2 (1983) and Minnaert, Ana Claudia de Sá Teles. *O Dendê no Wok: um olhar sobre a comida chinesa em Salvador, Bahia.* Salvador: Edufba, 2020.

[2] See Ferrão, José E. Mendes. *A aventura das plantas e os descobrimentos portugueses.* Lisbon: Fundação Berardo/ E. C. T. Fundação para a Ciência e a Tecnologia, 2005.

As a third difficulty, we must allow that a "recipe" is a relatively arbitrary category in a work process that has a given end, but no specific beginning, and that category is determined by technology and the social organization in which the act of cooking is part, in such a way that, when we change these elements, the recipe is reconfigured. As a rule, we are always adjusting the report on the recipe to the technological conditions of production, often calling this adjustment "modernization." And this brings us to the motivation behind Manuel Querino's cookbook.

The author is very clear: this collection of recipes arose from the fact that, during his travels, he found that the cuisine in his book had no parallels anywhere else in Brazil. Dishes that were "barbarously adulterated" in other states were, in *A arte culinária na Bahia* (1988, The Culinary Arts in Bahia), presented in the *façon* (manner) of that state. Working with the concept of a "food system,"[3] he starts out by describing several "purely African" dishes, based on their similarity with the "main foods that Africans prepared in abundance" – that is, as the food commonly eaten at the time, as he conceived it. To exalt Africanity, he praised it, including dishes that could already be relics in his time or exclusive to Afro-Bahian religious cuisine. Later, he discusses the "Bahian food system," which still exists today.

The temptation to resort to theories about racial mixture to "explain" this cuisine became almost obligatory for those who followed in the footsteps of Gilberto Freyre. Repeated ad nauseam, they make it seem that Brazil was a great melting pot of indigenous peoples, Blacks and whites. Those authors overlook the fact that, what truly interests us is the extra-culinary factors that recipes can involve. Even with a book as small as *A arte culinária na Bahia,* it is still necessary to analyze the cooking processes associated in the same dish, many of them already adopted from an existing cuisine, as we see in *ado* – powdered corn seasoned with palm oil and sweetened with honey. This

[3] In this regard, see Dória, Carlos Alberto. "Sistemas alimentares e sistemas culinários." In *A culinária materialista: a construção racional do alimento e do prazer gastronômico.* São Paulo: Senac São Paulo, 2009, 45-63.

way of preparing corn is typical of an indigenous dish of Guarani origin, now known as *fuba* (not to be confused with *fubá*, or cornmeal), which has fallen into disuse in the Brazilian Northeast, where it persisted for a longer time. How important is this record? It simply shows us the communication between different cuisines of the oppressed, leading us to question the master idea of the "culinary miscegenists" for whom ingredients of varied origins, combined according to European methods that "improved" the techniques of indigenous and Black people, gave rise to Brazilian cuisine. It is time, therefore, to recognize that culinary miscegenism has blurred the study of material transformation processes, reifying raw materials by viewing them as "ethnic" ingredients or failing to analyze technical processes according to their historicity and technological dating.

How cultures interpenetrated over the course of hundreds of years in the history of the peoples that were brought together in Brazil under the guise of colonialism is undoubtedly one of the most fascinating intellectual problems we face. In order to approach such a study, it is first necessary to dismantle the prejudices retained by the notion of "ethnicity" when applied to cooking and, *a contrario sensu*, to understand how the colonialists conquering various peoples, dispersed across the globe, gained the technical creativity to dominate nature, and developed, once and for all, new levels of civilization that history took care to disseminate throughout the world. The idea of a tripartite country (indigenous, Black and white) in no way helps to shed light on the history of the food production process, or of the domination of nature on this side of the Atlantic.

At some point, we must spend more time on the miscegenation thesis that Gilberto Freyre claims to have "corrected the social distance that would otherwise have remained enormous between the Big House and the slave quarters" (2003, 33) - an idea that can now be considered an affront to the facts and the political-ideological autonomy that Blacks have acquired in recent decades. It would be better to pay attention to the kinship between these ideas and the notion of "historical race," originally formulated by Gustave Le Bon at the turn

of the nineteenth to the twentieth century, and which influenced Brazilian intellectuals like Euclides da Cunha, through his readings of Ludwig Gumplowicz *(Struggle of the Races)* who wrote:

> The notion of race, today, can never, nor in any part, simply be a notion of natural history [....] Race is not the product of a simple natural process, in the sense that this word has had until the present; is a product of the historical process, which is also, in turn, a natural process. Race is a unit that, in the course of its history, was produced through the social process, and by it. Its initial factors [...] are intellectual: language, religion, custom, law, civilization, etc. The physical factor, the unit of blood, appears later on. And this powerful good is the cement that maintains that unity (Gumplowicz, n.d., 212).

In a more elaborate way, Gilberto Freyre does not fail to pay tribute to this view of the races and, therefore, of miscegenation. In fact, it was the divide between masters and slaves that made our cuisine very different from a racial "melting pot."

On the one hand, we have the elite cuisine, practiced by the slaveholders – initially according to the metropolitan model and, later, the French model of the "capital of the nineteenth century," inscribing it numerous times in the great Western tradition; on the other, there are the common people's cuisines, dispersed and lacking in uniformity, expressing the forced interaction of indigenous people of various different ethnicities with Blacks of different cultural origins, as well as poor Portuguese from different parts of Portugal, acting in accordance with different models of colonial exploitation (sugar, livestock, yerba mate, latex, etc.), resulting in an economy of poverty where any claim to cultural integrity has been dissolved. Bahia was no different, and the predominance of Blacks among the poor provides a good way to see how the transplanted peoples of Africa formed part of the coexistence that was responsible for a cuisine in which the original language of each cultural group could no longer be distinguished. In an unprecedented symbolic operation, it was necessary to invent "Bahian cuisine" to put

an imaginary Africa in the place of that which colonialism had chewed up and swallowed.

A modernizing vision of Black people and a traditional conception of cuisine in Bahia

Manuel Querino had nothing to do with the field of literary modernism, whether in São Paulo or Bahia – after all, that was not his area. His contribution to modernism, as one of us has written, would be precisely related to the racial issue, the fundamental problem in the construction of Brazilian nationality.[4] And prior to Modern Art Week, the arts festival that launched the modernist movement in 1922, Manuel Querino, participated in the 5th Brazilian Geography Conference in 1916. With his work *A raça africana e seus costumes na Bahia* (The African Race and its Customs in Bahia), he began to outline a different view of the presence of Blacks in the formation of Brazilian society, particularly in Bahia. Regarding African groups, he stresses that their "ignorant and rough" condition was common to all peoples subjugated by the tyranny of slavery. It was a lack of education that destroyed the value of the African, and despite that, descendants of the Black race have occupied exalted positions in all branches of human knowledge (Querino 1988, 23). With regard to Africa, he describes the customs of its groups: the Arabs as major slave traders, people's capture and the miserable voyage in the slave ships to Brazil (Ibid., 26-29). He recounts their arrival in Brazil, particularly in Bahia, giving the names which those groups received there – Cabinda, Benin, Jeje, Savalu, Maqui, Angola, Egba, Efon or *cara queimada* (burned face), Congo, Galinha, Hausa, Mina, Calabar, and so many others – and how they appeared from the behavioral point of view, attesting from the linguistic standpoint that Yoruba was the most important language, "due to the extent of its dominance on the Black continent" (Ibid., 31).

[4] See Dória, Carlos Alberto. O modernismo na "arte culinária" de Manuel Querino. *Estrelas no céu da boca: escritos sobre culinária e gastronomia.* São Paulo: Senac São Paulo, 2006, 215-229.

For Querino, without the Blacks, Brazil's colonization would be impossible, as they were the true economic factor, the creators of the country (Ibid., 32). It was the Africans, who were already disappearing, that were a mainstay of good customs, the Black race having changed the national character, influencing the country's institutions, letters, commerce and science (Ibid., 34).[5] In *O colono preto como factor da civilização brasileira* (The Black Colonist as a Factor of Brazilian Civilization), a reprint from the Annals of the 6th Brazilian Geography Conference held in Belo Horizonte, published in 1918, Querino reiterates and reinforces the arguments of *A raça africana*, anticipating Gilberto Freyre:

> From the coexistence and collaboration of the races in the making of this country comes this *mestiço* element of all hues, which produced this illustrious plethora of men of talent who, in general, represented that which is most select in the affirmations of knowledge, true glories of the nation (Querino 1988, 123).

And on the same page he presents a list of important names, such as the diplomat, politician and attorney Francisco Jê Acaiaba Montezuma, Viscount of Jequitinhonha, the novelist Machado de Assis, widely regarded as Brazil's greatest writer; the poet Cruz e Souza, the sculptor Chagas, *o Cabra*, the poet, philosopher, jurist and literary critic Tobias Barreto and the abolitionist writer and journalist José do Patrocínio, among others. In another publication, *Os homens de cor preta na história* (Black Men in History, 1923), he presents short biographies of more than three dozen Black men who stood out as intellectuals, doctors, pharmacists, teachers, religious, engineers and soldiers of various ranks (2009, 187-199). Finally, from another perspective, dissenting from the precepts of the academy of his time, Manuel Querino modernizes the understanding of the racial issue in Bahia and Brazil.

[5] The author is borrowing from Mello Moraes e Filho.

However, his perception of food would be different, possibly because of his race and class but also because he saw progress and modernization as a form of social and moral decay. After all, it was necessary to "appreciate the past, overlooking the intolerance of the present day" (Querino 1955, 179).

Lamenting the disappearance of the singers of modinhas, the alms collectors, the brothers of the Santíssimo and Espírito Santo confraternities, the barrel-organ player, peanut brittle and freshly cut sugarcane on a stick, he repeats the curse inveighed by the poet Augusto de Mendonça: "Maldito seja o progresso" ("Damn progress") (Querino 1955, 279). He reacts to changes in family life, particularly the ease "with which matrons and young ladies fill the streets" (Ibid., 114). He notes that "in those good old days, race horses, regattas and football matches did not yet exist" (Ibid., 206).

But let us move on to the subject of food. During slavery, the feast of the *mãe d'água* (mother of water, a divinity associated with Yemanjá) was held in Itapagipe, outside the old fort São Bartolomeu,

> now demolished, and on the 3rd Sunday of December, which was attended by more than 2,000 Africans. All the leaders of the terreiros [Afro-Brazilian Candomblé religious communities] of the city were present, under the supreme direction of Uncle Ataré, who resided in Rua do Bispo, in said neighborhood. [...] The feast lasted for fifteen days, in which batuque [Candomblés], efó, abará, ram, goat etc., with palm oil were found in abundance. (Querino 1955, 126-127).

In his description of the Lavagem do Bonfim, he cites a poem by Tomás Ribeiro, called "O judeu" (The Jew) which mentions "heavenly vatapá" and "spicy moqueca, which makes people catch fire, burn," and "of mocotó, some bones" (Ibid., 149 and 151). Popular sayings, still in use today, such as "Farinha pouca – meu pirão primeiro" ("When cassava flour is in short supply, make my porridge first") (Ibid., 154). Querino mentions the famous Saturday midnight mocotó in Bahia, and the most popular medical student of his time, who threw

a cat into the Coelho Branco's famous mocotó, which did not lack bay leaf to give it an aroma and Portuguese chorizo to challenge the palate, without forgetting the respectably spicy sauce. The owner lost his sales that night and, for a long time, his customers as well (Ibid., 206).

Querino complains about the new means of transportation, cars and motorcycles, but what interests us is the relationship he establishes between progress and food:

> And all of this is the work of progress. When it appears in a city, everything is transformed, the ways and customs of the elders disappear for novelties to reign supreme. We stop eating the classic Portuguese stew, roasted meat, boiled eggs and for dessert, molasses sprinkled with toasted cassava flour. Today, a man sits at the table and the servant serves him potage à la Reine pigeon salmis and *mâche* salad. He arises satisfied, after having masticated *pommes*; he drinks coffee with brandy and smokes a cigar made in Maragogipe, but which was sold to him as a Havana *puro* [....] All this is good. But I miss the days that have vanished in the maelstrom of time. (Querino: 1955, 274).

This is clearly a nostalgic view, but it is mistaken in several aspects, as there is nothing new in the dishes written in French that he mentions. Was it the pedantry of demonstrating that he wrote in French? Or did he copy them from a menu from a club where partiality for all things French was a registered trademark?[6] Let's look at the "novelties." Potage à la Reine was a soup prepared in the eighteenth century by La Varenne, introduced in *Le Cuisinier François* (Paris: Edition Scully, 1651). Of course, it has changed over the centuries, in terms of ingredients and preparation, going from Portugal to Brazil or taken there by French chefs who have always visited Bahia. Pigeon salmis, that is, a pigeon sautéed in fat and possibly cognac. Could it be that Bahians ate pigeon in the early twentieth century? If they did, it was a tradition, not a novelty. This can be seen in *Rigaud* and *Cozinheiro*

[6] Regarding this partiality for all things French in Bahia, see Azevedo, Thales. *A francesia baiana de antanho*. Salvador: Centro de Estudos Baianos da Universidade Federal da Bahia, 1958 (Publicação 110)

Nacional.[7] Mâche salad was made with lettuce. That really was a novelty – not the dish, but the fact that Bahians ate it; after all, as shown in the historical and folk literature of Bahian cuisine: "salad is rabbit food." *Pommes* or apples were expensive, imported, but nothing new for the more affluent classes. And saying that good Bahian cigars were passed off as Cuban was not a sign of progress but of affectation.

When discussing the dinners of yesteryear, he criticizes the Republic and the repression of folk culture. With a little money, a beautiful meal could be produced. He cites the inviting prices of foodstuffs, such as: a quart of flour, a pound of green meat (freshly slaughtered), which, after noon, was called *carne virada* (stale meat), cheaply priced; beef jerky, a soft drink – water, sugar and lime or vinegar; a piece of bread with butter and sugar. In the tavern, they bought onions, olive oil, a little vinegar, pork fat, mixed with cow butter, accompanied by a head of garlic, Flemish cheese, a bottle of French brandy – cognac – refined sugar and English ham. At the greengrocers, tomatoes, limes, coriander were purchased. He concludes with fig wine (Querino 1955, 237 and 238).

Querino describes one of these dinners. When the guests arrive, "the men have a small drink of gin or spirits as an aperitif; the ladies, however, [drink] a delicate glass of liqueur" (Querino 1955, 238).

The diners sit down to the feast. They eat, drink and jokes flow around the table. Suddenly, there is a toast to the lady of the house, followed by an addendum by another guest. A song ends in another toast, with all those present striking the with their knives beat on the rims of the plates and cups. After the song, a guest says, "I would like to say a word." "I will make a toast, good sirs, to the cook, for the agreeable pleasure she is giving us, with her highly appreciated delicacies" (Ibid., 239). And the toast to the cook ends in another song.

[7] See *Rigaud, Lucas. Cozinheiro Moderno ou Nova Arte de Cozinha*. Lisbon: Typografia Lacerdina, 1807, Chapter XI, Dos Pombos (Pigeons), 151-160. The author presents 18 pigeon recipes. *Cozinheiro Nacional* contains 21 pigeon recipes. *Cozinheiro Nacional, ou, Coleção das melhores receitas das cozinhas brasileiras e europeias*. Revised by Geraldo Gerson de Souza and Maria Cristina Marques. São Paulo: Ateliê Editorial: Senac São Paulo, 2008, 214-219.

Those who are seated at the table drink, eat and make small talk, but there is another group standing in wait, some of them half-starved. The host says he will serve the second table when those who have been served give up their seats. Those who were standing are seated. They eat, repeat their toasts, and then musicians appear playing the flute, guitar and even castanets.

In conclusion, referring to the entertainment, Querino says there was dancing, such as quadrilles, polkas, waltzes, and some *modinhas*, "never dispensing with samba, a vital circumstance, even in aristocratic functions, the original dance of our land, an obligatory note in entertainments" (Querino 1955, 240-243).

Clearly, Manuel Querino is describing the common people's customs in the "City of Bahia." Due to his social class, at most – particularly when it came to food – he only had access to *remediados:* families of modest means who were members of what we would now call the lower middle class. Even in his time, a member of the Bahian aristocracy remarked about his publications: "For some time now, articles entitled 'A Bahia de Outrora' have been appearing in the *Jornal de Notícias* newspaper written by Manuel Querino, describing a dinner in this city. Clearly this is a dinner of the lower class, the common people; plantation owners formed a higher class, even those who were not of noble birth. Among other things, the columnist says that a toast was raised to the cook. Now, there was not a single plantation owner or even a person of certain importance who did not have a slave cook, and toasts were not raised to slave women" (Bittencourt 1992, v.2, pp. 167-168). With her classism and racialism, she clearly "put everyone in their place." However, despite her prejudices, she was right – despite the clientelism of his day, Querino would never have had access to the family life of the Bahian elite. After all, to think that *mocotó* (cow foot stew) was a dish favored by the well-to-do, merely because university students ate it in the early morning after carousing through the night, was at the very least an anachronism.[8]

[8] Two assessments can currently be made with regard to mocotó. First, its glamorization or gastronomization in São Paulo, through the O Mocotó restaurant.

In short, Manuel Querino's "paper cuisine" is basically, with small additions – including African and Bahian dishes – extracted from the cuisine of the rank and file of Salvador. It was a traditional cuisine, invented but real, in the Barthean sense, not decorative, detached from reality or irreproducible. Querino was fully aware of his goals, as he knew that modernizing elements had long been present among the Bahians. The opening of the ports and the arrival of the Portuguese royal family in Brazil [in 1808] accomplished what Maria Odília Dias came to call "the interiorization of the Metropolis." Although it had a greater impact on Rio de Janeiro, it did not fail to reach Bahia. As Simmel has observed, the city air is liberating and brings change. Salvador was a major port where people and goods came and went; in short, it had national and international economic connections and interests. Could he have forgotten Portugal, Britain, France, the regions of the future Germany and even the various parts of Africa and their transnational relations with Bahia? In newspapers published throughout the nineteenth century, there are abundant examples of cutlery, tea and coffee sets, tin casseroles, crystal, china, raisins, plums, salmon, all kinds of tinned fish, English and German beer, English biscuits and puddings, jams from Lisbon, Portuguese peas and olives, Madeira wine, Port and Bordeaux, sherry, soups, cheeses, teas, sauces, cookbooks, and many more local and imported products. Querino was a journalist and frequent reader of newspapers, besides being a keen observer of the city's customs – did he not see any of this? We doubt it. He knew what he wanted and was doing when it came to food. "Arteiro" ("artful"), as they used to say in Bahia, he created a new Bahian cuisine.

Second, on the Fantástico program on 15 November 2020, where an employer lambasts his maid for saying she is going to make mocotó. He emphatically says that mocotó is food for the poor, in addition to being personally offensive towards the cook herself.

Bahian folk cuisine

Following a scholarly and original introduction by Bernardino José de Souza, who pioneered studies of the anthropology of food in Brazil, [9] Manuel Querino begins by explaining the origins of his work on Bahian cuisine. In his travels from Piauí to Rio de Janeiro, he observed that food systems differed fundamentally from those of his part of the country; moreover, somewhat ironically, they provided him with meals in the "Bahian style" (Querino 1988, 135). And he goes on to demonstrate, anticipating Freyre, that "Bahian cuisine, like the ethnic formation of Brazil, also represents the fusion of the Portuguese, indigenous peoples and Africans" (Ibid.).

For Querino, the Amerindians made "a modest and rudimentary contribution," leaving us "*pamonha* and hominy[10] made from corn, *beiju* and porridge prepared with cassava flour[11] or tapioca [...] *poçoca* or *paçoca*, a mixture of flour and roasted meat ground with a pestle, mate, Caruru or Cariru" (Querino op. cit., 135). He goes on to discuss "fishmeal" and corn meal, and fermented corn and cassava they made into a drink: *cauim*" (Ibid., 135-136). He then lists different types of game and reflects: "The contribution of the indigenous people was to let us know the elements, the raw materials, so to speak, that they used in the preparation of meals" (Querino, loc. cit.). And he observes that the poor backcountry folk of that time made extensive use of game and poultry, substituting beef, which enabled the "admirable physical resistance of the country folk" (Querino, loc. cit.). Clearly, he knew nothing about the history of Brazil's indigenous populations, nor did he value the background elements present in Bahian food, introduced by indigenous societies, as was the case with cassava flour, corn and sweet cassava, to a lesser extent.

[9] In this regard, see Dória, Carlos Alberto and Bacelar, Jeferson. "Uma introdução erudita e original." In *Manuel Querino: o criador da culinária popular baiana*. Salvador: P55, 2020, 157-163.

[10] As Querino explains in a note, "Hominy was boiled corn" (p. 163).

[11] As Querino also observes: "Since [bitter] cassava is poisonous, the indigenous people ground it or grated it and introduced the mass into a *tapiti* [or *tipiti*, cassava squeezer] to extract the poisonous prussic acid. Indigenous people called both sweet and bitter cassava *macaxeira*, without distinction" (Querino, loc.cit.).

Regarding the Africans, Manuel Querino observes:

> The Portuguese merchant, the capitalist, had them taught the mechanical arts, always keeping an African man or woman in reserve to work as a cook,[12] and thus the modern modifications were made in the arrangement of meals in the Portuguese style, with meat, fish, shellfish, poultry and domestic animals. The delicacies in which the Portuguese used olive oil, the African effectively added palm fruit oil or palm kernel oil. The *frigideira* was usually made with ground dried codfish, olive oil, lard and beaten eggs; the African improved it considerably, adding coconut milk to make that dish tastier, which is indisputable. (Querino, loc. cit.)

Without going into detail about his other thoughts on the subject, we would rather show what we consider to be his conclusions before listing his recipes:

> It is common knowledge, therefore, that Bahia has superiority, excellence, primacy in this country's culinary arts, since the African element, with its exquisite seasoning of exotic fertilizers, profoundly changed Portuguese delicacies, resulting in a product that is entirely Brazilian, tasty, pleasing to the most demanding palate, which excels the well-deserved fame of Bahian cuisine (Ibid., 136-137).

What we see here is that Manuel Querino anticipates Gilberto Freyre's basic proposition, that Brazilians were Portuguese, improved by the African presence; in this case, Portuguese cuisine modified by the African presence in Bahia would become the Brazil's greatest culinary

[12] When it comes to Bahian cuisine, the figure of the white woman, the mistress of the house, is completely invisible. What is overlooked is that the space of the kitchen is power relations. Therefore, to think that Black cooks, especially in wealthy houses, dominated that space, imposing their culinary tastes, is just a fantasy. They may have included some elements, added certain ingredients, but always under the supervision and command of the white mistress. On this subject, see Papavero, Claude C. "Mulheres, açúcar e comidas no Brasil seiscentista." *Caderno Espaço Feminino* 18, no.1 (2008): 59-88.

style. When presenting the food, he establishes a polarity between "purely African" dishes and the "Bahian food system."

Regarding purely African dishes

Manuel Querino begins by establishing that "These are the main foods of which the Africans made abundant use among us and are, today, prepared by their descendants with equal perfection" (Ibid., 138). Our interpretation is that, by highlighting the "purely African" dishes, he wanted to stress not the reproduction of what was done in Africa but what was eaten in the streets, in family homes, on a day-to-day basis, and some of the delicacies produced by Bahia's Candomblé communities.[13] For one thing, since Vilhena's time in the late eighteenth century, there had been a demand for them in the Salvador market, including from poor whites. Querino lists in alphabetical order and describes the recipes for twenty-one dishes, from aluá to palm wine: *acaçá, acarajé, arroz-de-hauçá, efó, caruru, ecuru, xinxim, bolas de inhame, feijão de azeite, dengue, ebó, latipá ou amori, abará, aberém, massa, ipeté, ado, olubó, oguedê, efun-oguedê* and *eran-pateré*.[14]

In this article, we will only make minimal observations about some recipes. Specialists consider arroz-de-hauçá (Hausa rice) to be typical of Bahian cuisine, at most the creation of a creative Hausa cook. It is difficult to determine whether caruru is of indigenous or African origin. Aluá is found in several parts of Brazil, from Maranhão to Ceará. Palm wine was replaced by cachaça during the colonial period. And, finally, the modernity of the semi-industrialized abará and the neopentecostal movement's "Jesus fritters" are part of life for Salvador's residents.[15]

[13] In our view, he adds to the list with products that are basically from the religious sphere. The sacred and the secular have always been intertwined in Yoruba and Gbe-speaking societies.

[14] All of these recipes have been analyzed in Dória, Carlos Alberto and Bacelar, Jeferson, op. cit.

[15] [Editor's note: Because of the strong link between acarajé and the Afro-Brazilian religion Candomblé, many neopentecostal acarajé sellers call them "Jesus fritters" or "Jesus acarajé."]

Some notions about Bahian foodways

To begin with, Querino reiterates the perspective that "Bahian cuisine came from the Portuguese food system, altered and improved by the Africans. Only Bahian cooks know the secret of making a meal tasty and therefore easy to ingest" (Querino, op. cit., 142).

It is a *baianidade* (Bahian identity) that is affirmed with magic and secrets, including the culinary kind, denoting the construction of singularity and superiority. Then, he starts to introduce some of the main dishes, properly from Bahia, not forgetting to point out "that in other states they are barbarously adulterated" (Ibid.). Just as he had done with purely African dishes, Querino lists thirty types of food and drink, in addition to desserts and fruit, along with their recipes. However, the recipe for a dish often involves the use of other products or ingredients, such as the poached fresh fish. The list is as follows: *feijão de leite* (refried beans), fresh fish moqueca, xaréu moqueca, egg moqueca, poached fresh fish, poached live crabs, shrimp *frigideira*, fish fillet, shrimp pie, *arroz de forno*, mocotó, sarapatel, stuffed turkey, chicken in brown sauce, chicken in white sauce, feijoada, roasted suckling pig, chicken vatapá, maniçoba, green corn hominy, sweet ambrosia, cashew fruit sweet, Bahia cake, delicious cake, English cake, *goma* (manioc starch) biscuits, banana liqueur, araçá liqueur, currant liqueur, umbu or imbu liqueur and genipap liqueur.

As we did with purely African foods, we will make minimal considerations about the Bahian food system here. Some curiosities that should leave the "Africanists" perplexed, such as considering dishes such as vatapá and moquecas to be Bahian – after all, just because it contains palm oil does not mean that a dish is African. Querino's feijoada, preferably with brown mulatinho beans, but without excluding black beans, is literally our present-day feijoada. Querino's idealization of mocotó presents it as a dish accepted by all ranks of society. Maniçoba, a traditional dish from the Amazon, has become popular in the Recôncavo, especially in Santo Amaro and Cachoeira. Unfortunately for residents of Salvador, especially the upper middle classes, it is an exoticism.

Conclusion

Manuel Querino is a unique character in the history of Bahian society. As an individual, in addition to living through significant episodes in the history of Brazil and Bahia, his complex life experience, participating in various social fields, makes him an exemplary figure among Blacks in Bahia. Using various tactics, some quite unorthodox, he achieved recognition obtained by a few, especially Black people, in the City of Bahia. He precedes Gilberto Freyre by a decade in his celebration of anti-racism and Black vindicationism. Like Freyre, he pays scant attention to the participation of indigenous societies. However, his modernist ideas notwithstanding, Querino was also a traditionalist, focused on valuing past ways of life. It astonished us that, except for Vivaldo da Costa Lima, no author had reflected on the scholarly preface by Bernardino José de Souza, probably the first utterance in Brazil about the anthropology of food. And, in his preliminary note, we clearly perceive Querino's proposition that, if, on the one hand, the Africans improved on Portuguese food, African cuisine was fundamental to the excellence of Bahian food.

The very fact that his book is entitled *A arte culinária na Bahia* (The Culinary Arts in Bahia) – and not "da Bahia" (of Bahia) – demonstrates his awareness that the repertoire he would be presenting basically represented Salvador, the "City of Bahia" and, at most, the back of the bay, better known as the Recôncavo, which were after all, interdependent social and physical spaces. Astutely, Querino would build up a body of work in several fields: the history of Bahia, pastoral dances, the cultural expressions of Bahia in the "olden days," the part that Africans and their descendants played in the life of Bahia, covering slavery, religions of African origin, and the important role played by Blacks in the formation of Brazilian society. And much more besides. However, nothing had previously been written by intellectuals about Bahian people's foodways. In short, with this work he was opening a new field of knowledge: cooking. It was not by chance: he, at least, in addition to conversations with his friend Bernardino José de Souza,

must have been aware of books like *Cozinheiro Imperial* and *Cozinheiro Nacional* (Imperial Cook and National Cook), as they were widely advertised in the local newspapers. Furthermore, his work was the result of his experience in Candomblé religious communities and in the social life of Salvador, in addition to careful empirical research.

Naturally, it should be added that *A arte culinária na Bahia* was preceded by private cookbooks produced by families and groups, which were a closely guarded secret. They may also have been present in the Candomblé communities. However, in general, as Goody asserts regarding country cuisine, preparation was based on "tradition," through direct observation, by watching and placing more emphasis on "the utilization of the contents of the cupboard in an improvisation upon certain *recettes de base* (basic recipes)" (Goody 1977, 140).

Evidently, Querino's work at the time had no impact on the ways of preparing Bahian cuisine. However, there is no doubt that he was the creator of Bahian "cuisine on paper." And progressively with the works that followed, produced by prestigious intellectuals from Sodré Vianna to Raul Lody, they found in him the path to be followed. We cannot say when the cookbooks began to be used by families and restaurants, but we do know that, when they start to be used, their origins lie in Querino.

We have never had a "court cuisine." What we did have was a cuisine of the upper echelons of society based on cultural colonialism in the field of gastronomy, under the aegis of France. The social stratification of the diet has always been visible, with the wealthy distinguishing themselves with expensive and rare imported products, supplemented with elements of the local cuisine. That is why they never created a cuisine of their own. However, the working class and lower middle class built up popular cuisine that resulted from constant hybridism, emanating from different groups and several generations – not the mythical three races – which has established itself and is, in a way, carried on to this day. It was what nourished Manuel Querino as he produced his study of "cuisine in Bahia." Essentially, he took the

basics of Bahian foodways from oral tradition, setting it down in written recipes.

In his preliminary note, he states that, when traveling from Piauí to Rio de Janeiro,[16] in addition to being interested in the food of each region, "nevertheless, they provided me with meals with the brand or style of Bahia, whenever I was told of its origin. Way back then, I came up with the idea of sketching the work I am now undertaking" (Querino 1988, 135). More than twenty years later, in a more direct and aggressive way, Darwin Brandão would say, "It is difficult, even impossible, to find restaurants in Rio or in any other Brazilian city that serve our good food" (1965, 22).

This recalls Jean-François Revel's observation that local cuisines do not travel because the products and ingredients used in their preparation remain in their place of origin. We agree, but as Revel himself points out, some local dishes appear in other places, always meriting adaptations due to the lack of original ingredients. Hence their adulteration. Becoming, he asserts, "insipid when trying to reconstitute it away from its sources" (Revel 1996, 34-36). In the case of Bahia some "palm-oil cuisine" dishes are a good example. Acarajé (black-eyed pea fritters) can be found in several parts of Brazil. However, we must be careful because the transformations can be exaggerated. For example, vatapá and caruru were reportedly found in Curitiba at the beginning of the twentieth century, as Débora Carvalho points out (2008, 319), originating from Bahia, according to Querino or could

[16] We believe that he was being unfair to Rio de Janeiro, as there was already a strong Bahian presence in that city during the imperial period, if not before. Albeit in a critical fashion, Manuel Antonio de Almeida (*Memórias de um sargento de milícias*. Jaraguá do Sul: Avenida Gráfica e Editora, 2005, 55-56) described the significant presence of Bahian women in the life of Rio between 1852 and 1855. Moreover, "The Bahian women of Rio, with trays set up on stands on the main roads, constituting important characters of the Bahian-Carioca culture, so especially strong in the federal capital throughout the Belle Époque, and even later" (Barros, Orlando de. *Corações de Chocolat. A história da Companhia Negra de Revistas (1926-1927)*. Rio de Janeiro: Livre Expressão, 2005, 28). Their importance in Rio's life is also clear as they became an indispensable part of revue theatre (Ibid., 25-31). And to this day they are one of the hallmarks of samba schools. Evidently, they must have great cooks who contributed components of Bahian cuisine.

they be similar to the "beef caruru" with approximations to the amalá, but without the palm oil or yam, or the "Bahia-style pork vatapá" recipe found in *O cozinheiro nacional* (2008, 81)? Are these semantic appropriations that Querino was trying to express about properly Bahian dishes "which, in other states, are barbarously adulterated?" (1988, 142). Or was his book another way of valuing the African presence in Bahian cuisine? Perhaps both are true.

Manuel Querino establishes a dichotomy between purely African dishes and dishes from Bahia, but we do not consider them to be antithetical but rather a complementary opposition. Far be it from Querino to take a multicultural or segregationist perspective. His intention, of course, in establishing the distinction was a way of valuing the African presence, as he himself pointed out when he wrote that the Africans altered Portuguese delicacies "with their exquisite seasoning of exotic fertilizers," generating a new, national, tasty product, ensuring Bahia's superiority in Brazilian cuisine (Ibid., 136-137).

The problem is that a superficial reading of Manuel Querino's work has led many intellectuals to see nothing but the African roots, with an inventory of various recipes, in which some delicacies have remained in Bahian cuisine. This is not wrong, but the dishes he described as "purely African" area clearly in the minority. The irony is that, the media and tourist industries alike believe that the mere presence of oil palm in a recipe makes it an African dish. This can be seen in the fish moqueca and vatapá, which are "sold" as African when Querino stated the opposite. Another mistake is to confuse Querino's cuisine with the vast cuisine of the Afro-Bahian religious world.

The products and ingredients used in the composition of Querino's Bahian cuisine, even those from a variety of locations, had already become mostly local or regional. Obviously, there were exceptions, such as olive oil, olives, Portuguese *chouriço* and some spices. Querino really did try to mark out the "territory in the pot."

A question that must be asked: what is the criterion for choosing "purely African" dishes? There are two possibilities: 1) they were present in the workers' diet, in short, they had a market; 2) to value the

gastronomic culture of African roots, he emphasized the relationship, adding dishes exclusive to Afro-Bahian religious cuisine. It is difficult to give a precise answer, especially in view of the great transformations that Bahian society has undergone. What can be said with precision is that only a few food products cited by Querino are present and incorporated into Bahian cuisine, while most of them are restricted to Afro-Bahian religious cuisine or have disappeared. In purely African dishes, cereals, tubers and vegetables predominate. Meat is rare, with the chicken "xinxim" and the meat in eran-paterê, and it can also appear as an added ingredient in dishes such as hauçá rice, efó and caruru, beef jerky and fish. The only crustacean present is shrimp, as a condiment, in pepper and in various dishes.

As with Portugal, our confectionery was largely found in the numerous convents found in the central area of the city of Salvador, each of which had its own speciality. The Africans had little to do with it. Sweetmeats and cakes are of Portuguese origin, probably with French and English influences, necessarily adapted with local products.

Beverages, basically artisanal liqueurs, are served at the June festivities.[17] Querino only mentions two beverages of African origin: aluá and palm wine. Only the first is still present, exclusively found in Candomblé communities.

The utensils used to prepare food are mainly pre-industrial, such as wooden spoons, mill stones, sieves or *urupemas* and wooden pestles and mortars. Except for mill stones, which were rare even in Candomblé kitchens, the remainder are still used by the working and lower middle classes. After all, the traditionalists might ask, how can you make good hominy without a wooden spoon or hot pepper sauce without a mortar and pestle? Querino also mentions ovens, tin trays, frying pans, roasting trays, forks, spoons and a solitary "American machine."

Obviously, Querino knew that there was a profusion of imported ingredients, food products, and table and kitchenware, in

[17] [The feast of St. John, which is a major holiday in north-eastern Brazil, particularly in the countryside and involves specific styles of music, costumes and food.- Ed.]

addition to being aware of what the wealthy classes ate, so his choice was conscious and political. Thus, he became the creator of a Bahian cuisine, a "cuisine on paper," ratifying the idea of cultural difference based on Africanity as a substantial element of its pre-eminence in Brazilian cuisine.[18]

Was his cuisine a fundamental component in the construction of the "myth of baianidade,"[19] with its *baianas do acarajé* (black-eyed pea fritter vendors), selling one of its iconic dishes, along with vatapá and moquecas steaming with palm oil. The Bahia that seeks modernity while not forgetting its traditions, salons and ladies, but progressively going on to African purity, miscegenation, the mystical and sensual land of happiness. However, Jorge Amado and his followers are largely responsible for establishing this baianidade, constructed, as Vasconcelos points out, "through an imagistic-discursive strategy that set it apart, sui generis […] as a land without equal."[20]

There is no denying that Querino is the founder of the cuisine that is embedded and develops in this myth. However, it would never have occurred to him that his cuisine would be used for the commodification by tourism of a "Black culture as a reified and folklorizing abstraction" (Pinho 1998, 117).

Yet another formulation must be given to Querino's cuisine: from his perspective, he laid the foundations for a cuisine that was opposed to global products and ingredients that never ceased to arrive in Bahia. If it is true that a few dishes would serve the affluent locals and privileged visitors, the majority of Querino's cuisine is still alive

[18] Bahia's identity as a preserve of Black, Africanised culture was already presente in Rio de Janeiro. See Gomes, Tiago de Melo. "Negros contando (e fazendo) sua História: alguns significados da trajetória da Companhia Negra de Revistas (1926)." *Estudos Afro-Asiáticos* 23, no.1 (2001): 68-69.

[19] Regarding the construction of the myth of *baianidade*, see Pinho, Osmundo S. de A. "A Bahia no fundamental: notas para uma interpretação do discurso ideológico da baianidade." *Revista Brasileira de Ciências Sociais*. São Paulo 13, no. 36 (1998): 109-120; Vasconcelos, Cláudia Pereira. "Você já foi à Bahia?" *Ser-tão-Baiano: o lugar da sertanidade na configuração da identidade baiana.* Salvador: EDUFBA, 2012, 87-118.

[20] Vasconcelos, Cláudia Pereira, op. cit., 90. See also Santos, Jocélio Teles dos. *O poder da cultura e a cultura no poder. A disputa simbólica da herança cultural negra no Brasil.* Salvador: EDUFBA, 2005.

among the working classes. At home, in bistros, in the streets, there are our daily beans, mocotó, sarapatel, egg moqueca, chicken in brown sauce or stew, fish moquecas, roast pork and several types of frittatas. Together with the "olive oil cuisine" of Portugal, in addition to the countless dishes incorporated from the traditional fare of the *sertão* (backlands), it is this cuisine keeps up the good fight against the overwhelming invasion of the ready meals from the multinational food companies. Food seen as poor, without the glamour and exoticism of the dishes of Bahian restaurants and the carurus with sparkling wines, stigmatized by the powers that be and ignored by the media. How long it will remain alive, we do not know, especially because the new generations in all social classes are seeking "modernity."

Bibliography

Almeida, Manuel Antônio de. *Memórias de um Sargento de Milícias*, Jaraguá do Sul, SC: Avenida Gráfica e Editora, 2005.

Azevedo, Thales de. *A francesia baiana de antanho, In Italianos na Bahia e outros temas*. Salvador: Empresa Gráfica da Bahia/Secretaria de Cultura, 1989.

Barros, Orlando de. *Corações de Chocolat. A história da Companhia Negra de Revistas (1926-1927)*. Rio de Janeiro: Livre Expressão, 2005.

Barthes, Roland. "Cozinha ornamental." In *Mitologias*. Lisbon: Edições 70, 1973.

Bittencourt, Anna Ribeiro de Góes. *Longos Serões do Campo. Infância e Juventude*. Volume 2. Edited and annotated by Maria Clara Mariani Bittencourt. Rio de Janeiro: Nova Fronteira, 1992.

Brandão, Darwin. *A cozinha baiana*. Rio de Janeiro: Editora Letras e Artes, 1965.

Calmon, Jorge. *Manuel Querino, o jornalista e o político*. Ensaios/Pesquisas, no. 3. Salvador: Universidade Federal da Bahia/Centro de Estudos Afro-Orientais, May 1980.

Carvalho, Deborah Agulham. "Cozinha especial e comida a qualquer hora dos serviços de proprietários e cozinheiros nas casas de pasto, restaurantes e afins (Curitiba, 1890-1940)." *Caderno Espaço Feminino* 19, no. 01 (Jan.-Jul. 2008).

Cozinheiro Imperial ou Nova Arte do Cozinheiro e do Copeiro em Todos os seus Ramos, 10th ed. Rio de Janeiro: Livraria Universal de Eduardo Henrique Lammert, 1887. Accessed 5 March 2021 <http://www4.planalto.gov.br/consea/publicacoes/culinaria/cozinheiro-imperial-1839/5-cozinheiro-imperial-1839.pdf>

Cozinheiro Nacional, ou Coleção das melhores receitas das cozinhas brasileiras e europeias: para a preparação de sopas, molhos, carnes.../ revised by Geraldo Gerson de Souza and Maria Cristina Marques. São Paulo: Ateliê Editorial/Editora Senac São Paulo, 2008.

Dias, Maria Odila Leite da Silva. "A interiorização da metrópole." In *id., A interiorização da Metrópole e outros estudos*. São Paulo: Alameda, 2005

Dória, Carlos Alberto. *A Culinária Materialista: a construção racional do alimento e do prazer gastronômico*. São Paulo: Editora Senac São Paulo, 2009.

Dória, Carlos Alberto. *Estrelas no Céu da Boca: escritos sobre culinária e gastronomia*. São Paulo: Editora Senac São Paulo, 2006.

Dória, Carlos Alberto. "A Cozinha Nacional antes da feijoada," in *Cozinheiro Nacional, ou Coleção das melhores receitas das cozinhas brasileiras e europeias: para a preparação de sopas, molhos, carnes.../* revised by Geraldo Gerson de Souza and Maria Cristina Marques. São Paulo: Ateliê Editorial/Editora Senac São Paulo, 2008.

Dória, Carlos Alberto and Bacelar, Jeferson. *Manuel Querino: criador da culinária popular baiana*. Salvador: P55, 2020.

Ferrão, José E. Mendes. *A aventura das plantas e os descobrimentos portugueses*. Lisbon: Fundação Berardo/E. C. T. Fundação para a Ciência e Tecnologia, 2005.

Freyre, Gilberto. *Casa grande & senzala*. Rio de Janeiro: Global Editora, 2003.

Gledhill, Helen Sabrina. *Travessias Racialistas no Atlântico Negro: reflexões sobre Booker T. Washington e Manuel R. Querino*. Salvador: Edufba, 2020.

Gumplowicz, Luis [Ludwig]. *La lucha de razas*. Madrid: La España Moderno, n.d.

Gomes, Tiago de Melo. "Negros contando (e fazendo) sua História: alguns significados da trajetória da Companhia Negra de Revistas (1926)." *Estudos Afro-Asiáticos* 23, no.1 (2001).

Goody, Jack. *A domesticação da mente selvagem*. Petrópolis: Vozes, 2012

Goody, Jack. *The Domestication of the Savage Mind*. Cambridge, New York and Melbourne: Cambridge University Press, 1977.

La Varenne, François Pierre de. *Cuisinier françois*. Paris: Edition Scully, 1651.

Minnaert, Ana Cláudia de Sá Teles. *O Dendê no wok: um olhar sobre a cozinha chinesa em Salvador, Bahia*. Salvador: Edufba, 2020.

Nascimento, Jaime and Gama, Hugo (eds.) *Manuel Querino e seus artigos na Revista do Instituto Geográfico e Histórico da Bahia*. Salvador: Instituto Geográfico e Histórico da Bahia, 2009.

Papavero, Claude G. "Mulheres, açúcar e comidas no Brasil seiscentista." *Caderno Espaço Feminino* 19, no.1 (Jan.-Jul. 2008).

Pinho, Osmundo. "A Bahia no fundamental: notas para uma interpretação do discurso ideológico da baianidade." *Revista Brasileira de Ciências Sociais*. São Paulo 13, no. 36 (1998).

Querino, Manuel. "A raça africana e seus costumes na Bahia." In *Costumes africanos no Brasil*. Foreword, notes and editing by Raul Lody. Introduction by Thales de Azevedo; 1938 foreword by Artur Ramos. Recife: Fundação Joaquim Nabuco – Editora Massangana, 1988.

Querino, Manuel. "O colono preto como factor da civilização brasileira." In *Costumes africanos no Brasil*. Foreword, notes and editing by Raul Lody. Introduction by Thales de Azevedo; 1938 foreword by Artur Ramos. Recife: Fundação Joaquim Nabuco – Editora Massangana, 1988.

Querino, Manuel. "Os homens de cor preta na história." In *Manuel Querino: seus artigos na Revista do Instituto Geográfico e Histórico da Bahia*, Nascimento, Jaime; Gama, Hugo (eds.). Salvador: Instituto Geográfico e Histórico da Bahia, 2009.

Querino, Manuel. "A arte culinária na Bahia." In *Costumes Africanos no Brasil* Foreword, notes and editing by Raul Lody. Introduction by Thales de Azevedo; 1938 foreword by Artur Ramos. Recife: Fundação Joaquim Nabuco – Editora Massangana, 1988.

Querino, Manuel. *A Bahia de outrora*. Foreword and notes by Frederico Edelweiss. Salvador: Livraria Progresso Editora, 1955.

Revel, Jean François. *Um banquete de palavras. Uma história da sensibilidade gastronômica*. São Paulo: Companhia das Letras, 1996.

Rigaud, Lucas. *Cozinheiro moderno ou Nova arte de cozinha*. Lisbon: Typografia Lacerdina, 1807.

Rodrigues, Domingos. *Arte de Cozinha (1680) Com 31 receitas atualizadas pela Chef Flávia Quaresma*. Rio de Janeiro: Editora Senac – Rio, 2008.

Sabban, Françoise. "Le system des cuissons dans la tradition culinaire chinoise." *Annales. Économies, Sociétés, Civilisations* 38, no. 2.

Santos, Jocélio Teles dos. *O poder da cultura e a cultura no poder. A disputa simbólica da herança cultural negra no Brasil*. Salvador: Edufba, 2005

Trefzer, Rudolf. *Clássicos da literatura culinária. Os mais importantes livros da história da gastronomia*. São Paulo: Editora Senac São Paulo, 2009.

Vasconcelos, Cláudia Pereira. *Ser-Tão Bahiano: O lugar da sertanidade na configuração da identidade baiana*. Salvador: Edufba, 2012.

9. REFLECTIONS ON PORTRAITS OF MANUEL QUERINO

Sabrina Gledhill[1]

In the 1970s, E. Bradford Burns published a bibliographical essay entitled "Manuel Querino's Interpretation of the African Contribution to Brazil," which is reprinted in Chapter 1 of this book. All indications are that Burns was the first English-speaking scholar to write about the life of Manuel Raimundo Querino and stress his pioneering stance in recognizing the African contribution to Brazilian civilisation. As the first Black scholar to provide his perspective on Brazilian history, wrote Burns, "He [Querino] presented his conclusions amid a climate of opinion which was at best indifferent, at worst prejudiced and even hostile" (1974, 82).

According to Burns, History – represented by its muse, Clio – owes much to Querino: "He preserved considerable information on the art, artists, and artisans of Bahia. No one can do research on any of those subjects without consulting his works" (Ibid., 83). The American historian's essay focuses on a work by Querino entitled *O colono preto como factor da civilização brasileira*, and includes a section that Burns himself translated into English. In his view, "Certainly one of Querino's chief contributions to national historiography was his insistence that the history of Brazil take into account its African background and the presence and influence of Blacks" (Ibid., 83).

Burns observes that, at the time he was writing his essay, Querino and his work were little-known in Brazil. "From time to time one or another scholar, such as Artur Ramos, pays homage to him. Still, he remains largely unknown outside his native Bahia and totally unknown outside of Brazil despite his considerable contributions to

[1] Originally published as "Reflexões sobre retratos de Manuel Querino." *SÆculum - Revista de História* no. 25. João Pessoa, July-Dec. 2011. 131-140. Accessed 24 August 2021. <https://periodicos.ufpb.br/index.php/srh/article/view/13997>

Brazilian and Afro-American (defined in its hemispheric sense) historiography" (Ibid., 84).

To illustrate the fact that Querino was not always an illustrious unknown, Burns observes that, although he died "in the same poverty into which he was born" in 1923, Bahia mourned the scholar and activist's passing and, in 1928, his portrait was hung in the gallery of distinguished Bahians at the Instituto Geográfico e Histórico da Bahia (Geographic and Historical Institute of Bahia, IGHB).

On 13 May 1928, the 40th anniversary of the signing of the law that abolished slavery in Brazil, the IGHB held a ceremony in which "the portrait of the renowned salvager of traditions was placed in the gallery of honor," accompanied by a speech given by a fellow member of the institute, the writer and folklorist Antônio Viana, speaking in the stead of the "worthy writer and journalist José Teixeira Barros" (Vianna 1928, 305-316). Viana observed that Manuel Querino "will continue to be admired in the memory of posterity for the integrity and honesty with which he pursued his research. He was exemplary in the performance of his duty and unsurpassed in modesty, which did even more to emphasize his worth, of which today's tribute is serene judgment" (Vianna 1928, 316).

According to the secretary for life of the IGHB, Bernardino de Souza, in a letter reprinted in Gonçalo de Athayde Pereira's biography of Querino, the Afro-Brazilian scholar's portrait was "unveiled together with that of the Brazilian sage Nina Rodrigues, in the Gallery of our illustrious men" (Pereira 1932, 34). To underscore the esteem in which Querino was held by his contemporaries and colleagues, Bernardino observes, "It is well known that, so far in Bahia, they are the two greatest scholars of the African race. I constantly receive requests for information about their work from Rio, São Paulo and other states in Brazil" (Ibid.). However, according to Pedro Calmon, there was a significant difference between the two men being honored on that occasion:

It is curious to note that, being an Africanist, [Nina Rodrigues] was not an Africanophile. On the contrary, he sprinkled his works with pessimism, annotating his essays with sober comments, not wanting to perpetrate the policy of praising the ethnic element he studied or have the originality of overcoming other social influences. It would be up to Manuel Querino to insist, not only on defending but on the spiritual redemption of the Black as a factor of progress; *he himself [was] one of those splendid Black artists whose personal example dissipates prevalent preconceptions about the inferiority of the race* (Calmon 1949, 154, emphasis added).

In his preface to the collection of works by Querino entitled *Costumes africanos no Brasil* (African Customs in Brazil), Artur Ramos observes that, "unveiling his portrait together with that of the great master Nina Rodrigues, Casa da Bahia paid him a fitting tribute" and cites the words of Bernardino de Souza quoted above (Querino 1938, 12).

In his essay entitled "Manuel Querino, O Jornalista e o Político" (Manuel Querino the Journalist and Politician), translated in Chapter 3, Jorge Calmon refers to the same portrait to give his reader an idea of the character of the man it portrayed:

Now, let us briefly look at the kind of man he was: his appearance, his way of being. His portrait hangs in the Historic Institute of Bahia [IGHB]. In fact, it was placed there, in its gallery of honor, five years after his death, in recognition of his contributions to the arts and culture and to that institution. This portrait shows us a man with a poised and confident mien, his face slender and well composed, his firm, pensive gaze expressing intelligence and constant curiosity (Calmon 1984; see Chapter 3, 43).

The portrait of Querino that illustrates a commemorative edition of that essay (Calmon 1995) tallies perfectly with Calmon's description – a "poised and confident mien," "his face slender and well composed" and "firm, pensive gaze" – leading the observer to conclude that it is the portrait in question (see the frontispiece).

According to Trachtenberg, since the dawn of photography, back in the day of daguerreotypes:

> The look was all-important, and what to do with the eyes, the key problem... Sitters were encouraged and cajoled to will themselves, as it were, into a desired expression – in short, a role and a mask which accord with one's self-image.... The term "expression" came to represent the chief goal of the portrait: a look of animation, intelligence, inner character (1989, 26-27).

Professional photographers argued that capturing the subject's image in a portrait was the equivalent of capturing their character. The photographers adopted the concept that the individual's external appearance was a reflection of his character and established a "sentimental repertoire of expressive poses" (Ibid., 28). For example, there was a pose for lawyers and others for clergymen and orators. Poets should be shown sitting at a desk. "In fact, the conventional poses addressed social more than categories, identifying character with role."

In an essay on photographs of enslaved Africans and Brazilians taken in the nineteenth century by Christiano Jr., Manuela Carneiro da Cunha observes:

> In a portrait, one can be observed passively or actively, alternatives that are frankly linked to the relationship between the portrayed and the portrayer. Whoever commissions a photograph shows himself, makes himself known, spreads himself, his attributes and properties out on the paper, as he would like to be seen, as he sees himself in the mirror. He is the subject of the portrait.... The slave is observed, not presenting himself. He is seen in ways that depersonalize him in twofold fashion, showing him either as a type or as a role (1988, xxiii).

The few known contemporary portraits of Manuel Querino (as far as we know, there are only three, two photographs and an engraving)

always show him with a serious expression and a formal, sometimes assertive pose Unlike Machado de Assis and other eminent Afro-Brazilians, for example, Querino made no attempt to "whiten" his likeness. On the contrary, he made a point of demonstrating that he and many illustrious Brazilians were *homens de cor preta* (Black men). For example, the plates that illustrate the first edition of *Artistas bahianos* (1909) contain several photographs of white, Black and brown artists. The illustrations in the second edition include just two portraits – both of Black men. One is an engraving of a portrait of the author (see Chapter 6) and the other is a sketch portraying the poet, historian and soldier Ladislau da Silva Titára (1801-1861), whose work inspired the lyrics for Anthem to the Second of July (now the official anthem of the state of Bahia), when he was a second-lieutenant serving the Army General Staff Corps and veteran of the struggle for Brazil's independence. Titára is shown in uniform with four medals on his chest, topped by the medallion of the Order of the Rose.[2]

Another Afro-Brazilian who used this tactic was Francisco Dias Coelho, the "Black colonel from Chapada Diamantina," Bahia. According to Moiseis de Oliveira Sampaio:

In photographs, the image presented changed according to the social class for which it was intended. For the poorest, his photographs were distributed showing him wearing his National Guard uniform, seated on a throne-like chair with a poised and imposing expression.... For the elite, the photos were different. He is shown wearing a suit, apparently well tailored, with a straight tie, also showing poise, with a more serious and solemn expression, but which in no way resembles the photograph of taken in uniform, except for the subject himself. For the recipients of this photo, the image conveyed

[2] The Order of the Rose *(Ordem da Rosa)* was a Brazilian order of chivalry created by Emperor Pedro I in 1829 and discontinued after Brazil became a republic in 1889. Querino, Manuel. *Artistas Bahianos (indicações biographicas)*. 2nd ed. Improved and carefully revised edition. Salvador: Officinas da Empreza "A BAHIA," 1911.

that the subject was one of their own, also cultured and wealthy, although the photograph did not deny his color.[3]

In this regard, Colonel Dias Coelho can also be compared to Booker T. Washington, who produced countless photographs of himself (studio portraits, newspaper and magazine photos, prints, etc.) for two target audiences – whites and Blacks. According to Bieze, Washington was well aware of the Victorian tastes of the white philanthropists he dealt with. For them, he sought to project the image of an intellectual endowed with sensibility and good taste. For the Black audience, he projected an air of power and authority (Bieze 2008, 52).

Querino used pictures of Black people to illustrate his works with the aim of projecting a positive image of Africans and their descendants to combat the negative portrayals produced by photographers like Lindemann, Christiano Júnior, and others, as well as demonstrating the contribution of "Black colonizers" to Bahian and Brazilian culture.[4] In a way, photos of Querino were also used and adopted for two audiences – white/mixed-race intellectuals on one hand and Blacks and workers on the other. In 1923, *Renascença – Revista Ilustrada* published the photograph shown below with the following text:

PROF. MANOEL RAYMUNDO QUERINO – Marking the 30th day since the death of this distinguished artist, who did so much honor to his colleagues that his good friends paid a posthumous tribute at the "Centro Operário" [Workers' Center] with several speakers and a large audience. On that occasion, the portrait of the honouree was unveiled in

[3] Sampaio, Moiseis de Oliveira. O coronel negro: Coronelismo e poder no norte da Chapada Diamantina. Dissertation (MA in Regional and Local History), UNEB: Salvador, 2009, 78.

[4] Gledhill, Sabrina. "Representações e Respostas: Táticas no Combate ao Imaginário Racialista no Brasil e nos Estados Unidos na Virada do Século XIX." In: *Sankofa*. Revista de História da África e de Estudos da Diáspora Africana, vol. IV, no. 7, July 2011, 44-72; Vasconcellos, Christianne Silva. "O Uso de Fotografias de Africanos no Estudo Etnográfico de Manuel Quirino." In: *Sankofa*. Revista de História da África e de Estudos da Diáspora Africana. No. 4, Dezembro 2009, 88-111.

a rich frame in one of those rooms, and an elegant polyanthea with the bust of the illustrious deceased was distributed.

In addition to being of sincere character, Prof. Manoel Raymundo Querino, was a man of worth in Bahian letters, and for this reason he held an esteemed place in society. The working class, which has always been an integral part of world progress, bears in its memory of the deceased an emblem of how much they deserve in the organization of society.

"Renascença" unfolds hands full of flowers on the tomb of its late fellow countryman.[5]

An analysis of this portrait and the one that was hung in the IGHB's gallery clearly shows that these photos were taken at the same time – Querino is partially bald, with grey hair and moustache and dark eyebrows – probably at the studio that once belonged to Lindemann, then directed by a mixed-race photographer, Diomedes Gramacho.[6] Even so, there are subtle differences between the two portraits. The IGHB portrait (frontispiece) only shows Querino's head and shoulders, while the image published in *Renascença* also used in José Roberto Teixeira Leite's *Pintores negros do Oitocentos* (Black Painters of the Nineteenth Century, 1988), portrays Querino with his arms folded and his head slightly inclined in a posed that reflects power and authority. In no way does it fit Artur Ramos's and Pinto de Aguiar's description of the scholar, labor leader and militant journalist as a "humble Black teacher."[7]

[5] According to Bacelar, quoting the newspaper *Diário da Bahia,* Querino received "natural flowers" from the Black Movement in 1933, when they were placed on his tomb in the sacristy of the Igreja de N.S. do Rosário dos Homens Pretos de Salvador during the celebrations of the anniversary of Abolition on 13th May, in a "veritable pilgrimage of the tombs of professors Maxwel Porphirio, Ascendino dos Anjos and Manuel Querino" (Bacelar, Jeferson. *A hierarquia das raças*. Rio de Janeiro: Pallas, 2001, 148).

[6] I would like to thank Cláudio Luiz Pereira and Jaime Nascimento for this information.

[7] Respectively, in Querino, Manuel. *Costumes africanos no Brasil*. Foreword and notes by Artur Ramos. Rio de Janeiro: Civilização Brasileira, 1938, 12 and Querino, Manuel. *A raça africana e os seus costumes*. Salvador: Livraria Progresso Editora, 1955,

Manuel Raimundo Querino (Leite 1988, 89)

That portrait was also published in the *A Tarde* newspaper to illustrate the centennial of Querino's birth on 21 June 1951. No wonder it was precisely this image that was chosen to illustrate the cover of the book *Manuel Querino, Seus Artigos na Revista do Instituto Geográfico e Histórico da Bahia*, a collection of articles published in the journal of the Geographic and Historic Institute of Bahia edited by Jaime Nascimento and Hugo Gama (Salvador: IGHB, 2009).

11. Pinto de Aguiar's foreword to the 1955 edition summarizes the essay by Artur Ramos published in the 1938 edition.

**Cover of the collection of Querino's essays
edited by Nascimento and Gama (2009)**

The likeness of Querino painted by Catarina Argolo, commissioned in 2000 by the Liceu de Artes e Ofícios, of which he was a founding student and where he later taught, was inspired by the IGHB portrait, although the subject's complexion is a bit darker, his hair a bit greyer, and his expression even more assertive. Another portrait, by Graça Ramos (see Chapter 5, p. 75), was clearly inspired by the engraving that illustrates the second edition of *Artistas bahianos* (see Chapter 6, p. 131), and the subject looks humble, almost sad. This painting is part of the collection of the Escola de Belas Artes of which Querino was also a founding student, graduated as an artist and teacher

of geometric design, received two silver medals and came close to obtaining a degree in architecture.[8]

The cover photo for *Manuel Querino entre letras e lutas,* by Maria das Graças Andrade Leal, is the same one used to illustrate Querino's posthumous book on Bahian cuisine, *A arte culinária na Bahia.* In that portrait and the one used to illustrate *Artistas bahianos,* the sitter's pose and gaze are very different from the IGHB, Centro Operário and Sociedade Protetora dos Desvalidos portraits. Taken nearly ten years earlier, the photo used to produce the engraving that illustrates *Artistas bahianos* shows Querino with salt-and-pepper hair, also with a receding hairline, and wearing a pin-striped suit. The portrait used by Leal and the publishers of *A arte culinária* was clearly inspired by that image.

According to Trachtenberg, when daguerreotypes were in vogue, photographers were advised to have their subjects look *"vaguely at a distant object"* to avoid a blank expression or "the pained scowl of a direct, frontal look into the camera" (1990, 26). It is possible that this aesthetic was still dominant when Querino's first photograph was taken. It may be due to the still-incipient stage of the art of photography in the 1910s in Bahia. In any event, instead of facing the viewer, as he does in later photographs, Querino gazes at a distant object – possibly a horizon to be expanded – which robs his expression of the self-possession and authority of a forward-looking gaze. He looks more like a dreamer than a leader and activist (as in the case of the Centro Operário/SPD portrait) or an intellectual (as in the case of the IGHB portrait).

The numerous images of enslaved or freed Blacks engaged in humble professions, produced in the nineteenth century by photographers like Lindemann and Christiano Júnior, helped create the stereotype that Black people at that time were impoverished and

[8] According to his autobiographical entry in *Artistas Bahianos,* Querino "did not take the 3rd year exam due to the lack of lecturers to teach the subject of resistance of materials and stability of constructions. Due to this circumstance, he did not receive a degree in architecture. He also attended classes on the anatomy of human body forms, aesthetics and art history, plaster copying and oil painting" (Querino, Manuel. *Artistas Bahianos.* 2nd ed. Salvador: Officinas da Empreza "A BAHIA," 1911, 147).

marginalized. The expressions of their subjects range from vague to long-suffering. They are dressed in plain or African-style clothes. Whites viewed this image of Bahia as insulting because, according to the anonymous author of a note titled "Unworthy Advertising" published in *Bahia Ilustrada* (Vol. V. No. 39, June 1921), it was generated by people who were "envious of the greatness of Bahia who, seeking to belittle it, paint it with the blackest colors in the eyes of those who truly do not know it." The author concludes that the portraits of Blacks and *caboclos* produced by Lindemann's studio "seek to show profound backwardness in Bahia when the truth is that this glorious State is now one of the most beautiful and populous in the entire country" – with "muscular, brown, beautiful types, or whites or even tawny."

On the other hand, Black people in intellectual and scientific professions – and there were many, as Querino himself demonstrated in "Os homens de cor preta na História" (1923, 353-363)[9] – went to the photographers' studios to produce images that reflected their "right to personhood" (Wallis, 1955, 55). The use of *cartes-de-visite*, followed by *cartes-cabinet*, in the nineteenth century popularized the custom of commissioning portraits of individuals and families to mark rites of passage such as births, graduations and funerals. Millions of such images were produced in photographic studios around the world.

In the Afro-Brazilian religious communities known as Candomblés – Manuel Querino not only studied the religion but was a high-ranking lay member of the Terreiro do Gantois[10] – as Lisa Earl Castillo observes, portraits were used to recall memories of the ancestors, who play an important role in their cosmology. "The strong appreciation for antique portraits in Candomblé can be understood as stemming from this physical link to the material presence of the deceased. But this reverence stands in sharp contrast to the distaste, in

[9] Querino, Manuel. "Os homens de côr preta na Historia." *Revista do Instituto Geográfico e Histórico da Bahia*, Salvador 48 (1923): 353-363.

[10] Lima, Vivaldo da Costa. "Sobre Manuel Querino." In *A anatomia do acarajé e outros escritos*. Salvador: Corrupio, 2010, 94.

the oldest and most prestigious Candomblé terreiros, for other types of photos, including images of trance, so beloved by ethnographers and tourists" (2009, 18). Through these images, we can look in the eyes of people who lived in times long past. Querino himself included studio portraits of two of the high priestesses (ialorixás) of Gantois in the illustrations for *A raça africana* (1917).

For all these reasons – the fact that there are so few photographs of Manuel Querino, let alone images of Black intellectuals from the early twentieth century, and the value of these portraits as "icons of memory" – it was profoundly disappointing to find that the famous portrait unveiled by Viana's lecture and described by Burns and Calmon was not included in the inventory of the IGHB collection conducted in the 1970s. It had been removed from the gallery, and its fate is unknown. Today, we must rely on reproductions like the one in the frontispiece of this book to see for ourselves how Querino looked in that photograph, and how highly he was esteemed by his confreres and colleagues.

Postscript

Possibly in response to the complaint, often repeated in public lectures and in print, that Querino's portrait had vanished from the IGHB's "gallery of illustrious people," the outgoing president of the Sociedade Protetora dos Desvalidos (Society for the Protection of the Destitute; SPD), Ourisval J. de Santana, on 29 May 2014, presented the institute with a framed copy of the portrait of Manuel Querino donated to the SPD in April 1933 by the artist who originally painted it, Hyppolito João Almeida.

Bibliography

Bieze, Michael. *Booker T. Washington and the Art of Self-Representation.* New York: Peter Lang, 2008.

Burns, E. Bradford. "Manuel Querino's Interpretation of the African Contribution to Brazil." *The Journal of Negro History* LIX, no. 1 (Jan. 1974): 78-86.

Calmon, Jorge. "Manuel Querino, o jornalista e o político." Ensaios/Pesquisas, no. 3. Salvador: Universidade Federal da Bahia/Centro de Estudos Afro-Orientais, May 1980.

Calmon, Jorge. *O vereador Manuel Querino.* Salvador: Câmara Municipal de Salvador, 1995.

Calmon, Pedro. *História da literatura bahiana.* 2nd ed. São Paulo: Livraria José Olympio Editora, 1949.

Cunha, Manuela Carneiro da. "Olhar Escravo, Ser Olhado." In *Escravos brasileiros do século XIX na fotografia de Christiano Jr.,* Azevedo, Paulo Cesar de, and Lissovsky, Mauricio (eds.). São Paulo: Ex Libris, 1988.

Earl Castillo, Lisa. "Icons of Memory: Photography and its Uses in Bahian Candomblé." *Stockholm Review of Latin American Studies* 4 (March 2009): 11-23

Pereira, Gonçalo de Athayde. *Prof. Manuel Querino, sua vida e suas obras.* Salvador: Imprensa Oficial do Estado, 1932,

Querino, Manuel. *A raça africana e os seus costumes:* Memória apresentada ao 5° Congresso de Geographia. Bahia: Imprensa Official do Estado. 1917.

Querino, Manuel. *Costumes africanos no Brasil.* Foreword and notes by Artur Ramos. Rio de Janeiro: Civilização Brasileira, 1938.

Trachtenberg, Alan. *Reading American Photographs: Images as History, Mathew Brady to Walker Evans.* New York: Hill and Wang, 1989.

Vianna, Antônio. "Manoel Querino." *Revista do Instituto Geográfico e Histórico da Bahia* 54 (1928): 305-16.

Wallis, Brian. "Black Bodies, White Science: Louis Agassiz's Slave Daguerreotypes." *American Art* 9, no. 2 (Summer 1995): 39-61.

ABOUT THE AUTHORS

JEFERSON BACELAR – Researcher at the Universidade Federal da Bahia (UFBa) Centre for Afro-Oriental Studies (CEAO) and Professor at the UFBa Graduate Program in Ethnic and African Studies. He is the author of more than a dozen books, including *A hierarquia das raças: negros e brancos em Salvador* (The Hierarchy of the Races: Blacks and Whites in Salvador, 2008), as well as countless scholarly articles published in Brazilian and international journals. He has recently turned his attention to the anthropology of food.

E. BRADFORD BURNS (1933-1995) – Professor Emeritus at UCLA and the author of several books on Latin America, including *A History of Brazil* (1993), which highlights the contributions of Manuel Querino. He joined the UCLA History Department as an assistant professor in 1964. Other than a brief period at Columbia University (1967-1969), where he had obtained his PhD in 1964, he spent the remainder of his career at UCLA, retiring as a full professor in 1993.

JORGE CALMON (1915-2006) – Professor of History of the Americas at UFBa, later Professor Emeritus. Twice a State Deputy in Bahia, Brazil, State Justice Secretary during the administration of Bahia Governor Lomanto Júnior (1963-1967) and a Councilor on the State Court of Auditors. Elected to the Bahia Academy of Letters, chair no. 23 in 1965, he was for many years the editor-in-chief of the newspaper *A Tarde*.

CARLOS ALBERTO DÓRIA – PhD in Sociology from Unicamp, São Paulo, with a specialism in culinary history and culture. He has written several books in that field, particularly *Formação da culinária brasileira* (The Formation of Brazilian Cuisine, 2014) and *A culinária caipira da Paulistânia* (The Rural Cuisine of Paulistânia, 2018). In all his works, he seeks to establish a materialistic view of the culinary aspect of Brazilian culture.

SABRINA GLEDHILL – MA in Latin American Studies from UCLA and PhD in Ethnic Brazilian and African Studies from UFBa. Member of the Geographic and Historical Institute of Bahia (IGHB) since 2009. The author of *Travessias no Atlântico Negro: reflexões sobre Booker T. Washington e Manuel R. Querino* (Black Atlantic Crossings: Reflections on Booker T. Washington and Manuel R. Querino). Translator of over 30 scholarly books, including *Divining Slavery and Freedom: The Story of Domingos Sodré*, by João José Reis, and *Francisco de Paula Brito: A Black Publisher in Imperial Brazil,* by Rodrigo Godoi.

ELIANE NUNES *(in memoriam)* – BA in Art Education from the Universidade Federal de Pelotas (UFPel). Specialism in Cultural Heritage (UFPel); specialism in the Minas Gerais baroque (UFOP); MA in Iberian-American History (UNISINOS) and, at the time of her death, a PhD student in History at UFBa. Professor of Art History at UFPel.

CHRISTIANNE SILVA VASCONCELLOS – MA in Social History from UFBa (2006). Dissertation title: "O circuito social das fotografias da Gente Negra. Salvador 1860-1916" ("The Social Circuit of Photographs of Black Folk. Salvador 1860-1916"). PhD in Comparative Constitutional Law (Universidad Nacional de Colombia).

ILLUSTRATIONS

Front Cover and Frontispiece

Portrait of Manuel Querino

Source: Calmon, Jorge. *O vereador Manuel Querino*. Salvador: Câmara Municipal de Salvador, 1995.

Back cover photos

Estampa VII – Typo Igê-chá
Estampa XI – Typo Igê-chá

Source: Querino, Manuel. *Costumes africanos no Brasil*. Preface and notes by Arthur Ramos. Rio de Janeiro: Civilização Brasileira, 1938.

Chapter 3

Portrait of Manuel Querino. Oil on canvas. Painted by artist and professor Graça Ramos, PhD, in 2005, the year the UFBA School of Fine Art (EBA) paid tribute to the first historian of Bahian art by hanging his portrait in the EBA gallery. 1.10 m x 0.80 m. Photograph by Rosa França. Reproduced with the artist's permission.

Chapter 5

Estampa III – Representante da tribu Igê-chá
Estampa IV – Representante da tribu Iorubá
Estampa V – Representante da tribu Igê-chá. Descendente de família real
Estampa VI – Typo Benin
Estampa VII – Tpo Igê-chá
Estampa VIII – Typo Iorubá
Estampa IX – Oondó Igê-chá Igê-chá
Estampa X – Typo Gêge

Estampa XI – Typo Igê-chá

Estampa XII – Representante da tribu Igê-chá

Estampa XII-a – A antiga mãe de terreiro do Gantois. Typo Egbá

Estampa XIII – Os Ourixás

Estampa XIV – A Cascata da Sereia. 2a parte – Pegi, Santuário, Candomblé do Gantois

Estampa XV – Altar mór do Pegi

Estampa XVI – Santuário de Humoulu

Estampa XVII – A dansa das quartinhas. Festa de Ochóssi

Estampa XXIII – Creoula em grande gala. A mãe do terreiro do Gantois. Pulcheria Maria da Conceição

Estampa XIX – Candomblezeiros em grande gala

Estampa XVIII – Ganhadores no canto

Estampa XX – Ganhador africano

Estampa XXI – Ganhadeira africana

Estampa XXII – Ganhadeira africana

Source: Querino, Manuel. *Costumes africanos no Brasil.* Preface and notes by Artur Ramos. Rio de Janeiro: Civilização Brasileira, 1938.

Portrait of Manuel Querino (ca. 1911)

Source: Querino, Manuel. *Artistas bahianos.* 2nd ed. Bahia: Officinas da Empresa "A Bahia," 1911.

Chapter 9

Manuel Raimundo Querino
Photographer unknown. Jorge Amado Collection.

Source: Leite, José Roberto Teixeira. *Pintores negros do Oitocentos.* São Paulo: MWM/KNORR, 1988, 89.

Cover of *Manuel R. Querino: Seus artigos na* Revista do Instituto Geográfico e Histórico da Bahia, ed. Jaime Nascimento and Hugo Gama. Salvador: IGHB, 2009. Reproduced with the editors' permission.

APPENDIX

Timeline for Manuel Querino

1850 Brazil definitively abolishes the slave trade de jure and de facto after decades of British pressure exerted through the Royal Navy

1851 On 28 July, Manuel Raimundo Querino was born in Santo Amaro da Purificação, Bahia, in the Brazilian Northeast. His birth mother (shown on his death certificate) was Maria Adalgisa, and his foster parents were freeborn and both were probably Black – Jorge Calmon identifies them as the carpenter José Joaquim dos Santos Querino and his wife, Luzia da Rocha Pita (see Chapter 3)

1855 A cholera epidemic kills one or both of Querino's foster parents; he is taken to the city of Salvador, where Manuel Correia Garcia – a state deputy for the Liberal Party, educator and historian – becomes his guardian

1865 The Triple Alliance War begins; Manuel Correia Garcia co-founds the Instituto Histórico Provincial (Provincial Historical Institute)

1868 Querino leaves Bahia and travels in the Northeast, possibly seeking to escape the draft, but is "recruited" in the province of Piauí. Because he is both literate and slightly built, he becomes a clerk at his battalion's headquarters in Rio de Janeiro and rises to the rank of squadron corporal

1870 Triple Alliance War ends; Querino signs the Republican Manifesto calling for the end of imperial rule in Brazil

1871 Free Womb Law frees children born to enslaved women, with certain restrictions. Querino returns to Bahia, demobilized early through the influence of his powerful patron, Manuel Pinto Sousa Dantas, the leader of the Liberal Party in Bahia and later Prime

Minister of Brazil. Querino begins working as a painter and decorator in Bahia and gets involved in local politics

1872 Querino takes night classes at the Liceu de Artes e Ofícios (Arts and Crafts Lyceum), studying the humanities. He received honors in French studies and full marks in Portuguese

1874 Querino helps organize the Liga Operária Baiana (Bahian Workers' League)

1876 His political career begins; the Liga Operária Baiana is officially established on 26 November

1877 Querino helps found and build the Academia de Belas Artes, later the Escola de Belas Artes (School of Fine Art), becoming one of its first students after his teacher and mentor, the Spanish artist Miguel Navarro y Cañizares, breaks with the Liceu

1878-83 He marries Ceciliana do Espírito Santo (year unknown)

1880 A plaque honoring the founding students of the Congregation of the Academia de Belas Artes da Bahia (ABAB) is unveiled on 20 May. Querino's name is among them

1881-84 Querino studies Architecture at the Escola de Belas Artes

1882 He graduates in industrial design

1885 He teaches geometric design at the Liceu de Artes e Ofícios da Bahia and the São Joaquim Orphanage School; becomes a member-benefactor of the Liceu; joins the abolitionist movement alongside Frederico Marinho de Araújo, Eduardo Carigé and others

1887 His son Manuel Querino Filho is born in July

1887-88 Querino founds the abolitionist newspaper *A Província*

1888 Slavery is officially abolished in Brazil on 13 May

1888-95 Querino becomes a civil servant, working at the Public Works Department and designs the city of Salvador's trams

1889 A coup overthrows Emperor Pedro II and the First Republic is declared

1889-90 His son Paulo Querino is born in 1889 or 1890

1890-91 Querino's first term as city councilman

1892 Querino founds the newspaper *O Trabalho* to give voice to the labor movement

1894 The Instituto Geográfico e Histórico da Bahia (Geographic and Historical Institute of Bahia; IGHB) is founded - Querino is a founding member, later a benefactor

1894 His daughter Alzira Querino is born

1894-97 His first wife, Ceciliana, dies (year unknown)

1896 Querino works at the State Department of Agriculture until his retirement in 1916

1897 He marries his second wife, Laura Barbosa Pimentel

1897-99 His second term as city councilman

1899 Querino leaves politics and devotes himself to the study of Bahian art history, folklore and Black Vindicationism, among other pursuits

1900 Board member of the "Pândegos da África" carnival group

1903 Publication of the geometric drawing textbook *Desenho linear das classes elementares*

1908 His son Manuel Querino Filho dies

1909 Publication of *Artistas bahianos* and *As Artes na Bahia*

1911 Publication of a second textbook, *Elementos de desenho geométrico,* and the second edition of *Artistas bahianos.*

1914 *Bailes pastoris* published

1916 *A Bahia de outrora* and *A raça africana e os seus costumes na Bahia*

1918 "O colono preto como factor da civilização brasileira"

1921 His daughter Alzira Querino dies

1922 Second edition of *A Bahia de outrora*

1923 The *Revista do Instituto Geográfico e Histórico da Bahia* (no. 48) publishes an article by Querino entitled "Os homens de cor preta na História" (Black Men in History)

Manuel Querino dies on 14 February, survived by his widow, Laura, and two of his four children. Several newspapers publish his obituary

1928 *A arte culinária na Bahia* is published; on 13 May, the IGHB hangs his portrait in its gallery of notables.

1933 The Frente Negra (Black Front) pays tribute to Manuel Querino, leaving flowers on his tomb in the sacristy of the Church of N. S. dos Homens Pretos in Salvador, Bahia

1938 Artur Ramos edits an anthology of his main works gathered in *Costumes africanos no Brasil* (African Customs in Brazil)

1951 The centenary of Manuel Querino's birth is celebrated in Rio de Janeiro and Bahia

Editora **Funmilayo Publishing**

Printed in Great Britain
by Amazon